Beyond the Horizon

Beyond the Horizon
Communications Technologies: Past, Present and Future

Stephen Lax

UNIVERSITY
UP *of*
LUTON PRESS

British Library Cataloguing in Publication Data
A catalogue record for this book is available from the British Library

ISBN: 1 86020 514 3

Published by
John Libbey Media
Faculty of Humanities
University of Luton
75 Castle Street
Luton
Bedfordshire LU1 3AJ
United Kingdom
Tel: +44 (0)1582 743297; Fax: +44 (0)1582 743298
e-mail: ulp@luton.ac.uk

Cover Design by Creative Identity, Hertford, UK.
Typeset in Weiss, Frutiger and Blur
Printed and bound in Great Britain by Bookcraft (Bath) Ltd.

Contents

1 Introduction

> We have always held to the hope, the conviction, that there was a
> better life, a better world, beyond the horizon.
>
> *Franklin D. Roosevelt, 1940*

In the 1830s electricity allowed messages to be sent for the first time further than the eye could see, beyond the line of sight, indeed, beyond the horizon. One hundred years later, presidents and other visionaries continued to proclaim a belief in a better future, and technological progress was the means of getting there.

Today we hear a similar message – the information age is upon us, with digital highways humming with bits of data. Once more we are told there is the prospect of a new epoch of understanding, indeed a better world. Most of these worries and judgements are based on perceptions of the increasingly powerful electronic technologies which allow speech, text and images to be transported around the world at very high speed – the new communications technologies. While we hear a great deal of speculation about the technologies, we rarely hear a clear definition of what they actually are. What exactly is the Internet? Why is a digital system supposed to be better than an analogue? How is it that we can now have so many television channels? And why not more? This book is an attempt to answer these questions. It offers a clear, easily understood explanation of present-day electronic communications technologies, from the telephone to networks such as the Internet.

There is no question that the technology of communication is changing very quickly. The pace of that change is matched easily by the increasing number of articles and references to it. For some, the technology finally offers the dream of a new kind of society, something akin to the imaginary Global Village promoted by Marshall McLuhan in the 1960s, where information becomes freely

1

available to all, rich and poor, black and white alike. If it is as easy and as cheap to send a message to the other side of the world as it is to your next door neighbour, and for a reply to be sent back, then who would deny that we are at the dawn of a new age of communication? But is it really that easy, and is it so cheap? Or is the reality more worrying – does the new technology threaten us, at best, with hundreds of TV channels showing the same old repeats, or worse still, does it mean that ever more information will be gathered about us and used to restrict our long-cherished liberties (as well as send us even more junk mail).

These are clearly not just technical considerations, yet technological constraints underlie them. An insight into the workings of some of these systems therefore gives a better understanding and assessment of these speculations, and helps shed some of the mystique with which information and communications technologies are sometimes surrounded. The popular image of these technologies being stumbled upon, almost by accident, by dabblers and inventors is of course far from the truth. The telephone, for all its functional simplicity, is a highly complex system which relied on a number of earlier technological developments for its successful emergence, not to mention significant financial backing and state intervention. The idea of broadcasting, with its mysterious waves carrying sound and pictures silently through the ether, was not necessarily the obvious consequence of previous technological developments, but one which fitted with the social patterns of the time and so steered further development in that direction. So, in studying what is actually involved in the various technologies of communication, one realises how many emerging techniques have relied heavily on and evolved from previous developments, but at the same time have not necessarily been pre-destined by those developments. This is as true today as it has ever been, and while it is certainly a misrepresentation to identify single individuals with the development of previous technologies (eg Bell with the telephone, Marconi with radio) today's emerging technologies more than ever before follow in the wake of corporate and governmental strategic decision making and marketing considerations.

So what of the 'Information Age'? Many 'ages' have been named after individual technologies – the steam age, the space age and so on – suggesting that the emergence of a particular technological development might be responsible for instigating a new epoch of human history. The information age is harder to place since it does not depend on a single technological application – some say it began in the 1960s, others argue that it started with the electric telegraph 150 years ago. This disagreement alone should raise questions as to whether any technology, communications technology included, on its own is capable of bringing about a fundamental break with the past. Information has been gathered throughout human history, and in increasing quantities over recent centuries. Did the early days of the telegraph represent a significant break with the semaphore which went before it? Or, to further confuse matters, which telegraph do we mean, Cooke and Wheatstone's or Morse's?

So a study of the operation of the technologies involved will provide a valuable insight into communications systems, but it does not provide a complete understanding. The political and social context in which they evolved and the subsequent use to which they were put form a major part of that understanding. These themes are introduced in the various chapters specific to each technology; the final chapter discusses the role of technology in society more generally, offering a critique of some of the views that the new communications

technologies will be the cause of a major shift in the way that society is run.

This is not a technical book or guide – there are no equations or wiring diagrams! Instead the different communications technologies are explained in terms of their historical development and with an introduction to their social function. Each chapter deals with a specific technology and is introduced in chronological sequence. Some of the technical concepts which underlie communications systems are highlighted and described separately from the main text to maintain fluency, and can be referred to separately if desired. However these descriptions are also placed in historical context by being located in the chapter which relates to the technology in which they first found application.

No single book can cover the whole debate over the role of communications technologies. However, what the technologies are, what they can do and how they do so are often aspects which are overlooked. I hope that this book will therefore serve as a useful contribution to that debate.

2 The Telephone

When the telephone was being developed, (both Alexander Graham Bell and Elisha Gray applied for a patent on the same day in 1876) a variety of applications was envisaged. This was a new technology which potentially combined the benefits of two mid-nineteenth century communication devices: the long-distance communication property of the electric telegraph and the speaking tube's facility for person-to-person communication using speech rather than code. Edison saw it merely as an extension of the existing telegraph network, with offices where the public (few of whom he imagined, would be able to afford their own telephone) could record and receive voice messages (Pool, 1983, p.31). Telegraph operators believed only they would have the requisite skill for the telephone's operation, so the existing practice of telegraph offices would persist, with the new instrument serving merely as a means for operators to relay messages between one another (Flichy, 1995, p. 85). While both of these predictions foundered early on in the telephone's history, one alternative use which did continue for a while was as a broadcasting device (predating radio broadcasting by more than two decades), the most sustained example being Telefon Hirmondo in Budapest, which, for a period of almost 30 years from 1893, broadcast news and entertainment similar to a radio station of today to around 6,000 subscribers (Marvin, 1988, p.227). However it appears that Alexander Graham Bell himself had early on identified his own intentions for the telephone. Pool *et al* quote Bell's letter, written in 1878 'To the capitalists of the Electric Telephone Company' (1977, pp.156-157):

> It is conceivable that cables of telephone wires would be laid under ground, or suspended overhead, communicating by branch wires with private dwellings, counting houses, manufactories, etc., uniting them as desired, establishing direct communication between any two places

in the city ... I believe in the future wires will unite the head offices of telephone companies in different cities, and a man in one part of the country may communicate by word of mouth with another in a distant place.

This surprisingly accurate prediction describes two-way, point-to-point communication, the main way in which the telephone has been used for over 100 years. In fact it is only relatively recently that the telephone network has begun to be used extensively for purposes other than conversations. Now, with current debate about the Internet and so-called Information Superhighway (see Chapter 10), the use of the telephone network for non-telephony purposes is again the focus of discussion.

What is a telephone network?

If a telephone system is to be of any use it should be possible to make a call from any single telephone to any other telephone. To connect each telephone to every other by an individual wire would achieve this, but this task is impossible – interconnecting just one thousand telephones in this way would require half a million lines and a public network, ie one to which the public has access and which therefore involves a vast number of interconnections (there are more than 25 million telephones in the UK alone) certainly can not be connected in this way. Instead a switching system is used. A switched network allows calls to be sent through the network via a number of different routes from point to point. Hence the telephone system is known as a Public Switched Telephone Network, or PSTN.

In the early days of telephony, operators at the exchange manually performed the switching function by physically connecting the caller's line to the destination. The first exchange operators were boys and young men. By the end of the 1880s, most operators were young women. Young describes a number of contemporary explanations for this change. The *Pall Mall Gazette* in 1884 commented that 'The female voice is always clearer'. Other explanations included the tendency for boys to indulge in 'pranks like swapping over numbers and cutting off subscribers' compared with the 'docile manner, manual dexterity and reliable attitude' of young women (Young, 1991, pp. 25-27). This assumption of docility was clearly misplaced: operators in the UK became organised in the Women's Trade Union League in the early 1900s, forming the National Association of Telephone Operators in 1905. Strikes, 'something unheard of in the public service', took place in France between 1906 and 1909 over operators' working conditions (Young, 1991, p. 64). Young hints at another possible explanation for the change to a female workforce. There were clear economic advantages to the telephone companies of employing women operators, as the alleged 'female' qualities were 'comparatively cheap'.

For many years, to make a telephone call it was possible to call the operator and to specify its destination by giving just the name of the recipient; as the service grew, however, the use of telephone numbers became the norm, though rarely exceeding two digits in length. With the development of the Strowger electro-mechanical exchange, patented in 1889 in the United States, the first automatic switching came into use. According to legend (eg Stratford, 1984, p. 9) local undertaker Almon B Strowger felt impelled to develop his automatic switching

exchange on learning that the local operator was diverting his business calls to a rival company run by her husband! The potential elimination, or at least reduction in role, of the telephone operator was not universally welcomed, shifting responsibility for recording and dialling of telephone numbers away from the telephone company and onto subscribers. Flichy identifies the social patterns of telephone ownership as a part of this resistance. Most telephones were in the ownership of the wealthier upper classes, who were used to having servants to deal with that sort of thing, and the operator had hitherto fulfilled that role. Flichy compares the introduction of subscriber dialling and automatic exchanges with a similar reluctance towards the installation of automatic starter motors on private cars when, after all, 'there were chauffeurs to turn the crank!' (1995, p.121).

The most recent telephone exchanges are, of course, digital electronic devices which allow much faster and reliable switching as well as a number of subscriber facilities (eg call diversion, call waiting) which were not available with the older mechanical exchanges.

How the telephone works

The telephone system requires a transmitter to send the message, a receiver through which to hear it, and a transmission channel to carry the signal. The communication is two-way and so the telephone contains both a transmitter (microphone or mouthpiece) and receiver (earphone or earpiece). To confuse matters, the handset (the bit you hold when making a call), which contains both of these devices, is commonly referred to as the receiver. The transmission channel is made up of the wires and radio and microwave links which make up the telephone network. The telephone apparatus itself also has other essential components such as a bell (or electronic equivalent), contact switches activated by taking the receiver off the hook, and a dialling function (usually push-button).

When a call is made, lifting the receiver off the hook activates the circuit connecting the line to the local exchange. It also disconnects the 'bell' ringer circuit. Dialling sends a sequence of pulses, or nowadays a sequence of different tones, by which the exchange can identify the number dialled. The exchange then uses these numbers to locate a free route for the call, either to another line connected to the same exchange (a 'local' call) or along trunk lines to another exchange, and then to a line attached to that exchange (a 'national' or long-distance call). That activates the ringing circuit in the destination telephone (assuming it is not already in use). Once the destination receiver is picked up, the circuit is complete and the call can go ahead, and, of course, the meter starts recording the duration of the call for subsequent billing. This is a complex set of processes for just one telephone call, but is handled relatively quickly by the computer programmes used in digital exchanges.

Sound, electricity and the telephone

One of the key problems in the development of the telephone was to be able to represent the human voice by an electrical signal. Electromagnetism describes the interaction between electricity and magnetism, and had been demonstrated early in the nineteenth century. A number of people had produced various electromagnetic devices over the preceding decades, beginning with the electric telegraph in the 1830s. Bell and Edison were able to draw on this knowledge to

Electromagnetism

Electromagnetism describes the relationship between electricity and magnetism, and is shown in Figure 2.1. This relationship makes it possible to represent movement by electricity, and also to use electricity to re-create that movement.

Sound is movement. It begins with a succession of tiny vibrations of air molecules. These vibrations literally have a knock-on effect, making nearby air molecules vibrate in sympathy, and the continued repetition of this process produces a 'sound wave' which travels at high speed (typically more than 300 metres every second). To convert these sound wave vibrations into electricity a flexible plate is held near to the sound source, and a coil of wire and a nearby magnet are attached. The tiny movements which the vibrating molecules impart to the plate are turned into small electric currents in the coil. Different types of sound produce different types of molecular movement – high and low notes produce rapid and slower rates of vibration respectively; loud and soft sounds result in either relatively large or small movements of air molecules. The electrical signal which comes out of the wire coil will, ideally, faithfully represent all of these variations due to its direct response to the impact of the molecules on the plate. This is the basis of the operation of a microphone, specifically a moving-coil microphone (Figure 2.2); there are other designs of microphone, but their function, turning sound into an electrical signal, is the same.

A transducer which operates in the opposite way to the microphone, ie which uses its electrical signal to set up a sequence of vibrations of air molecules, is the common loudspeaker (Figure 2.3). An electrical current representing sound information flows through a wire coil which is attached to the speaker cone. A magnet surrounds the coil. This magnet interacts with the magnetic field produced in the coil in response to its changing current and the result is a changing force on the coil which makes the loudspeaker cone vibrate back and forth. The sound which emerges should be a faithful reproduction of the original sound at the microphone which produced the electric current.

Figure 2.1

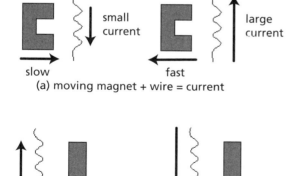

small current

slow

(a) moving magnet + wire = current

large current

fast

(b) wire + electric current = movement

Electromagnetism
(a) If a magnet is moved towards or away from a wire an electric current flows. The size and the direction of the current records how the magnet moves.
(b) If a current flows in a wire the magnetic field produced can move a metal object towards or away from it. Again the speed and direction of that movement depends on the nature of the electric current.

Figure 2.2

Input = sound **Output = electricity**
(Air movement) coil

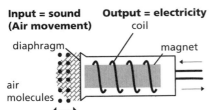

Figure 2.3

Input = electricity
Output = sound

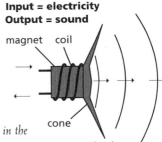

Figure 2.2 Microphone. (left) The impact of the air molecule vibrations on the diaphragm create vibrating electric currents in the wire coil as it moves back and forth about the magnet.

Figure 2.3 Loudspeaker. (right) This time oscillating electric currents exert a force on the magnet, which makes the cone vibrate, producing sound. The faster the electrical oscillations, the higher the frequency of the sound.

help in the development of the microphone which was eventually used in the telephone. Electromagnetic principles were essential to the development of the electrical machines which began to replace steam power in industry later in that century, but before then found their first communications application in the telegraph. The conversion of sound to electricity (and vice-versa) for the operation of the telephone depended on these same electromagnetic principles (see *Electromagnetism* box).

Sound information – making sense of speech and music

A sound is a series of vibrations of air molecules, which travels through space as a sound wave. These vibrating molecules cause a membrane in the ear, the eardrum, to vibrate in sympathy and this vibration is converted in turn into tiny nerve impulses in the inner ear which travel to the brain. The brain interprets these nerve pulses, and this is how we hear sound. The ear-brain combination is incredibly sensitive to a vast range of different sounds: the difference in power levels between the quietest sound we can hear (the threshold of hearing) and the loudest before it becomes painful (the threshold of pain) is a ratio of around 100 billion to one. This huge range exceeds the sensitivity of practically any technological instrument.

Sound can vary in both quantity and quality. The way in which this variation is generated is detailed on page 11. In brief, a sound can be loud or soft in volume and it can display a whole range of tonal qualities. But what is the difference in the molecular vibrations that give rise to the different sounds? If the rate at which the vibrations occur is rapid (for example more than a thousand vibrations per second), this is perceived as a high pitch (or, more technically, a high frequency). A slower rate of vibration produces a low frequency sound. All sources of sound contain a range of frequencies, and this range is referred to as bandwidth.

The volume of a sound on the other hand depends on the size of the vibrations of the air molecules and not on the rate of vibration. A loud sound is perceived when the air molecules are making large movements as they vibrate, whereas a small amount of movement produces a quiet sound, irrespective of the actual frequency of that sound (though our perception of loudness does depend to an extent on the frequency).

The significance of bandwidth

All information signals have a particular bandwidth (see p. 12), for example the bandwidth of music is around 19,950 Hz, or approximately 20 kHz (see Appendix 1 for an explanation of symbols such as kHz).

Some other common bandwidths are given in Table 2.1. These figures illustrate two useful points. The first is that images (as in the example of a colour TV signal) have a much higher bandwidth than sound signals (more than 250 times greater than the full range of music). The second is that the so-called commercial speech used in telephony is less than one-third of the bandwidth of 'real' speech. This is achieved by deliberately removing the lowest and highest speech frequencies, leaving just the middle frequencies. This results in an acceptable quality of sound, which is still intelligible to the point where it is often quite possible to identify a person from their voice on the telephone. Nevertheless there is a loss of quality as a result of removing some of the frequencies; this is demonstrated clearly by comparing a voice heard on the telephone with a radio broadcast (particularly an FM station) which includes almost all the frequency components.

The advantage of reducing the bandwidth of an information signal lies in the limited capacity of various transmission media. Copper telephone cables can only carry a certain range of frequencies, the range depending on the construction of the particular cable. Radio waves can be used to carry a number of speech or music signals by means of techniques known as modulation and multiplexing, but these radio frequencies are in great demand. So reducing the bandwidth required for transmission of a signal means a greater number of signals can be squeezed into a given cable's capacity or radio frequency space.

Transmitting calls – baseband, modulation and multiplexing

As we have seen, speech occupies a range of frequencies between 100 Hz and 10 kHz and a microphone is able to turn this into an electronic signal containing exactly the same frequencies. The obvious next step would be to transmit the electronic signal down a wire (after filtering out high and low frequencies in the case of telephony), which means connecting the electronic output from the microphone to a cable (after some amplification process). This is called baseband transmission ie the transmission of the signal using exactly those frequencies which the microphone produces (ie the 'base bandwidth', hence the term 'baseband'). All the receiver then has to do is collect the signal at the other end of the cable, and convert it into sound at the loudspeaker.

Table 2.1 The bandwidth of some common signals

Signal type	Min. frequency	Max. frequency	Bandwidth
speech	100 Hz	10,000 Hz	9,900 Hz or approx. 10 kHz
'Commercial' speech	300 Hz	3,400 Hz	3,100 Hz
music	50 Hz	20 kHz	20 kHz
colour TV	0 Hz	5.5 MHz	5.5 MHz

Sound waves and bandwidth
The quality of sound

The quality of a sound is contained in its pitch. This is governed by the rate or frequency at which the air molecules vibrate. A fast vibration frequency produces a high note, and relatively slow vibrations produce a low note. Most people can control their vocal chords to produce frequencies between around 100 vibrations per second up to a maximum of around 10,000 vibrations per second. (The unit given to the number of vibrations per second is the Hertz, abbreviated to Hz; so the frequency range of the human voice can be expressed as 100 Hz to 10,000 Hz.) Music, on the other hand, covers a broader range of frequencies, as low perhaps as 50 Hz and as high as 20,000 Hz. Most people's hearing is insensitive to sounds outside this range anyway, so there would be little point in designing musical instruments to produce much sound beyond these limits!

The quantity of sound

The quantity of sound is a function of the size of the molecular vibrations. It is possible, for example, for the molecules to be vibrating very quickly, but only moving a small amount in each vibration, or alternatively to be vibrating slowly but moving a relatively large distance. The size of the molecular vibration determines the size of vibration imparted to the eardrum and thus the nature of the nerve signals sent to the brain. So the first example, a series of small, fast vibrations, would be perceived as a quiet, high note, whereas the latter large, slow vibrations would be heard as a loud, low note. It is not quite this clear-cut however; our hearing is more sensitive to some frequencies than to others. For example, the same amount of sound energy (in the form of molecule vibrations) is perceived as louder if it is in the middle frequencies than at some of the extreme high and low frequencies. This relationship varies between individuals, changes as we get older, and can be altered by continual exposure to particular sounds (for instance noise experienced at work). Despite this complexity, it is possible to draw general conclusions: the quality of a sound is contained in its frequency of vibration and the quantity in the size of those vibrations.

Sound characteristics

This distinction can be taken further. When a 'pure' note is played on a musical instrument, a characteristic frequency of sound is produced. This is determined by the design of the instrument and the way in which it is played. In general, the larger the instrument, the lower the range of notes it can produce. When a violin plays the note A above middle C, for example, it produces a 'pure' sound wave of frequency 440 Hz, but also some other frequencies, known as harmonics (or 'overtones' to musicians) which are multiples of this fundamental frequency; there is a certain amount of sound produced at 880 Hz, some at 1,320 Hz and so on. When a piano, rather than a violin, plays the same note, it sounds different – we know that it is a piano and not a violin, even though they are both playing the same note. Certainly it also produces these same frequencies (the 440 Hz fundamental plus the harmonics), but each instrument generates different amounts of each component resulting in a characteristic difference. So a sound can be considered to be made up of a number of different frequency components, containing different quantities of each of those components. This 'frequency spectrum' may be displayed in a graph as shown in Figure 2.4.

[continued on next page. ☞

Real sounds and bandwidth

In general, music and speech are not produced as a continuous sound containing just a few characteristic frequencies; they are constantly changing in both quality and quantity. Indeed, without change it would not be possible to convey meaning. So sound information contains the whole range of frequencies available to it; in the case of speech, all frequencies between 100 Hz and 10,000 Hz are present, in constantly varying quantities (see Figure 2.5); music contains the whole of its broader range of frequencies. The size of the range of frequencies present in an information signal is its 'bandwidth', and, like frequency itself, has the units Hertz. So human speech has a bandwidth of 9,900 Hz (the range between its minimum and maximum). The bandwidth of music, with a minimum of 50 Hz and a maximum around 20,000 Hz, is more like 19,950 Hz.

A sound wave can be converted directly into an electronic signal using a microphone. Since the electronic signal faithfully follows the pattern of the air molecule vibrations, the resulting electronic signal contains exactly the same frequencies as the sound which produced it, and so it also has the same bandwidth. In this state the 'vibrations' are in fact rapid variations in electric voltage or current, and they are now suitable for transmission down a copper cable. At the receiving end, a device such as a loudspeaker receives the electronic signal, still containing all the frequencies of the original sound, and this signal makes the loudspeaker cone vibrate in sympathy. Thus the pattern of vibrations of the loudspeaker cone produces a faithful reproduction of the original sound.

This technique is perfectly adequate in small, dedicated systems such as public address systems or closed circuit television. However, if a wire is being used for baseband transmission of one speech signal, there is no way another speech signal (which contains frequencies within the same range) can also be transmitted at baseband down the same wire at the same time, since the two signals would get completely mixed up. So if baseband transmission were used in telephony, every telephone conversation would need its own wire for transmission. In 1991 there were over 540 million telephones installed in the world, a figure that increases every year. It is obviously not possible for each telephone to have its own line connecting it to each and every other telephone. The need for a means of sharing the network of lines between many calls was identified long ago; Alexander Graham Bell was one of many people working on ways of sending several telegraph messages down a single wire even before the development of the telephone.

Figure 2.4

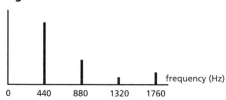

A typical frequency spectrum, showing the size of the fundamental frequency (440 Hz) and smaller amounts of the harmonics. This spectrum might be produced by a well tuned musical instrument playing a single note. Variations in the relative quantities of the different harmonics can change the sound even though the same frequencies are present.

The process of sending a number of calls simultaneously down the same channel (or cable) is called multiplexing, and one way of multiplexing calls together is to use a modulation technique, whereby a baseband signal is carried on a higher frequency wave, known as a carrier wave (see box opposite).

Modulation and Multiplexing
Modulation

If a telephone conversation occupies frequencies between 300 Hz and 3400 Hz, there is no reason why these should not be translated upwards to higher frequency electronic signals and transmitted, for example, as a range of frequencies between 10,300 Hz and 13,400 Hz; they could then be re-translated back to the baseband at the receiver by subtracting the 10,000 Hz shift from all the frequencies. The same bandwidth is carried (3,100 Hz), it is just as easy electronically to transmit these higher frequencies, and this translation allows a large number of telephone conversations to be carried down one wire. Another call, for example, could occupy frequencies from 5,300 Hz to 8,400 Hz; yet another between 15,300 Hz and 18,400 Hz; all of these frequencies could be transmitted simultaneously down a single line. It is an easy task to build a receiving circuit which selects only a particular range of frequencies, so the three calls travelling together down one cable can be separated at the receiver and diverted to their individual destinations. In effect, the information signal has been translated by being carried on another, higher frequency wave. This process is known as modulation. The high frequency carrier wave is modulated by the lower frequency information signal. At the receiving end of the system, the upwards translation of frequencies is simply reversed; this is called demodulation. The removal of the carrier frequency returns the original baseband signal.

The modulation used in telephony is a particular type of amplitude modulation: single sideband, suppressed carrier amplitude modulation (SSB-SC AM for short!), which prevents the signal's modulated bandwidth from being any greater than its unmodulated bandwidth, a problem which is associated with simpler forms of modulation, AM or FM. Consequently the modulated bandwidth is the same as the baseband channel width at 3.1 kHz. This reduction in modulated bandwidth makes more efficient use of cables, but does so at the expense of requiring more complex (and therefore costly) equipment for demodulation.

Multiplexing

The use of a common transmission medium for simultaneously conveying more than one signal, as described above, is known as multiplexing. All media such as cables or radio waves have a limited range of frequencies which they can successfully carry. This determines the channel capacity of the medium. So taking an example of a cable which can only carry frequencies up to 100 MHz, it could only transmit a few colour TV signals (each TV signal being several MHz wide), but many more sound or music channels since these have a much smaller bandwidth. In the telephone system, since the signal's bandwidth is reduced by removing high and low frequencies, yet more channels are available. Each telephone call is allocated a channel which is 4 kHz wide. Allowing a 4 kHz channel width for signals which have a bandwidth of just 3.1 kHz ensures there are gaps between adjacent channels to prevent any possible overlap. So the first channel might be allocated frequencies from 0 to 4 kHz; the second would occupy 4 kHz to 8 kHz the third 8 kHz to 12 kHz and so on. This is known as frequency division multiplexing (FDM), in which each channel is allocated its particular frequency slot in the medium; the process at the receiver, described in the previous section, where the channels are separated, is known as demultiplexing.

Figure 2.5

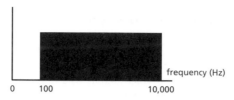

A frequency spectrum showing all the frequencies contained in the different sounds that make up speech. The relative quantities of the many frequencies change continuously as the different sounds are produced.

Wiring up the telephone network
Telephone cables

Different types of cable are used at different stages of the telephone network, according to the varying requirements of the network. A telephone line which connects a single subscriber to the local exchange (known as the local loop) is often simply a pair of wires twisted together, known unimaginatively as a 'twisted pair'. These have a limited bandwidth – they are unable to carry signals with frequencies much above 100 kHz. For sending signals through the rest of the network, modulation and multiplexing are used to save on cable space and cost, and mean that when a line is not being used by one subscriber (which is most of the time for domestic users) the line can be used to connect another. Using higher frequencies for the carriers requires the use of higher capacity cables. Co-axial lines (or 'co-ax') can accommodate frequencies in excess of 100 MHz, and so are used in the trunk lines between telephone exchanges. (Co-ax is the type of line used to carry the 8 MHz bandwidth signal picked up by a TV antenna to the TV set – this signal is too broad to be carried by a twisted pair.) The use of modulation and frequency division multiplexing allows a single co-ax telephone line to carry hundreds of calls simultaneously.

Optical fibres

A combination of pulse code modulation and time division multiplexing (described opposite) is necessary for transmitting telephone signals down the most recent type of cable, the optical fibre. Optical fibres are very fine strands of extremely pure glass (Figure 2.6), and if light is shone in at one end it travels down the fibre and emerges at the other. They were first demonstrated in the mid 1960s, but the technology to mass-produce fibres of sufficiently high purity glass took several years to develop and it is only since the mid-1980s that optical fibres have been in general use. The light can travel great distances in the fibre compared with signals in copper co-axial or twisted pair wires. These latter can only carry signals a few kilometres before the size of the signal has diminished (this is known as attenuation). The attenuation means that repeater stations are required every few kilometres to re-amplify the signal. An optical fibre, however, can carry signals without a regenerator (the optical fibre's equivalent of a repeater) for up to 100 kilometres. To connect a telephone signal to an optical fibre, the signal is used to modulate the light: PCM produces on/off electronic pulses, and so the light source (a tiny semiconductor laser or light-emitting diode) which is attached to the end of the fibre is switched on and off by the coded signal in the same way that an electrical voltage is switched on and off for a copper cable.

Pulse code modulation and time division multiplexing

The increasing use of digital signals in telephony makes use of a quite different form of modulation and multiplexing. Pulse code modulation (PCM) is a modulation technique which represents the speech waveform as a sequence of electronic digital (on or off) pulses. Decoding these pulses at the receiver allows reconstruction of the original speech message. The sequences of pulses are generated 8,000 times per second ie at intervals of one eight-thousandth of a second (125 microseconds), yet only take a few millionths of a second (2 or 3 microseconds) to transmit. So there are relatively long gaps of time during which nothing is happening, waiting for the next sequence of pulses to be generated. During these gaps, it is possible to send a short pulse sequence from another call, or in fact from several calls. Provided that each call segment is slotted into the gaps in turn, it is possible for a receiver to separate each segment and reconstruct the different calls. This is called time division multiplexing (TDM) since each call (or channel) is given its own time slot rather than its own frequency (as with FDM). The fast switching speeds available with recent electronic equipment mean that the circuitry for operating this type of multiplexing is generally simpler than is required for FDM.

The frequency of the infra-red light used in optical fibres is around 200,000 GigaHertz (1 GHz is 1,000 MHz). The highest frequency that copper co-axial cables can carry is around 1 GHz and so optical fibres offer much greater channel capacity, easily carrying several thousand telephone channels on a single fibre. They do not cause interference (crosstalk) and, more importantly, are less susceptible to interference from electrical sources than copper cable (the optical fibre's near immunity to the electromagnetic pulse produced by a nuclear explosion compared with the extreme vulnerability of copper cable explains the interest of the military in the early development of optical communications); they are not vulnerable to corrosion; again, compared with copper cables, optical fibres are compact and lightweight. For all of these reasons, optical fibres are now normal specification for telecommunications companies, particularly for trunk lines where the large capacity is especially valuable.

The expansion of telecommunications networks
National networks

When telephony was first introduced in the United Kingdom, as in the United States its growth was rapid, in contrast with other European countries; Moore (1989, p. 232) points out that in 1906 there were more telephones in the UK, with its population of 42 million, than in eleven other European countries with a combined population of 288 million. Since multiplexing techniques were not as advanced then as they are now, large numbers of telephone wires were required and great 'spiders webs' began to appear in towns and cities (much as Bell had anticipated in 1878). Nowadays telephone cables are laid underground, particularly in urban areas, with often the final distribution to individual homes being the only section which has lines strung from 'telegraph' poles.

In the early days of the telephone the major proportion of ownership and usage was by far for businesses. Of 300 lines in Pittsburgh in 1879, 294 belonged to 'professionals' (Flichy, 1995, p.86), a pattern repeated in the UK: 19 of the 23 lines in Newbury in 1901 were for businesses and, of the remaining four,

Figure 2.6

An optical fibre

three appear to be installed in the homes of the owners of those businesses; just one, rented to 'Captain Partridge of Battledene', appears to be for purely private use (Stratford, 1984, p.9). This reflected the expectations of the telephone companies. The use of the telephone for chat rather than business was considered at best wasteful or at worst useless. The Nebraska 1914 telephone directory pointed out: 'Business or long distance calls shall at all times have preference over social talk.' (Flichy, 1995, p.89). Nevertheless, patterns of social usage evolved. In rural US communities, early use of the telephone was divided more or less evenly between business and social function, and its social function began to be increasingly recognised (Fischer, 1992).

International networks: submarine communication

It was not long after the development of electrical communication that transatlantic communication was envisaged. The electric telegraph was becoming well established as a land-based network and the first transatlantic, undersea telegraph cable was laid in 1858. It worked for just one month before failing in the hostile environment! The ocean-going vessel Great Eastern made a more successful attempt in 1866. The much lower frequencies and quality requirements of the telegraph signal allowed it to be transmitted more easily than telephony over long distances. To carry a telephone signal over these distances, repeaters are needed to amplify the signal at regular intervals. These repeaters must be designed to operate reliably at great depths under the ocean for long periods of time. This technology did not become available until 1943, almost 70 years after the emergence of the telephone, when the first submerged repeater was installed in an Irish Sea cable. The first transatlantic cable for telephony, TAT-1, was laid in 1956 between Scotland and Newfoundland. It consisted of two co-axial lines,

with 118 repeaters, one every 44 miles, and could carry just 36 channels. It was taken out of service in 1978. The first optical fibre transatlantic cable, TAT-8, was laid in 1988 and connected the UK and France to New Jersey. It had repeaters 41 miles apart and a capacity of 40,000 channels. The latest, TAT-9, which came into service in 1992, is of course also an optical fibre cable, with a 115,000 channel capacity.

International networks: telecommunication satellites

The science fiction author Arthur C Clarke, while a flight lieutenant in the RAF, famously predicted in a *Wireless World* article in October 1945 that it was theoretically possible to launch three telecommunications satellites which would permit communication between all points on earth. It was over ten years before this prediction showed any signs of becoming reality. In 1957, the Soviet Union launched the first Sputnik satellite. This was the Cold War period and the 'Space Race' was on! The United States launched *Echo* and *Telstar* in 1960 and 1962 respectively. These were low earth orbit (LEO) satellites. They orbit the earth in much less than 24 hours, and thus are only visible from a particular point on the earth's surface (eg a satellite earth station) for a few hours per day, and the receiving dish must track the path of the satellite as it speeds across the sky.

A satellite which is launched to a distance of some 36,000 km (22,200 miles) from the earth's surface above the equator rests in what is known as a geostationary orbit. *Syncom*, launched in 1963, was the first geostationary satellite. In this orbit it travels through space at a speed of 11,000 kilometres per hour (7,000 miles per hour) and takes exactly 24 hours to complete one whole orbit. Since the earth also completes one rotation in 24 hours, from a position on the earth's surface the satellite appears stationary and is therefore able to be transmitted to and received from a fixed point on earth. So receiving dishes no longer need to track the satellite, but can be mounted in a fixed orientation. A single geostationary satellite has a coverage of over one-third of the earth's surface, hence Clarke's requirement of three satellites to cover the whole earth (Figure 2.7). (Only the polar regions are invisible to satellites orbiting above the equator – they are served by further satellites in different orbits.)

Figure 2.7

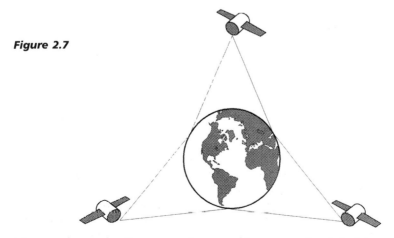

Three geostationary satellites positioned appropriately can cover the whole of the earth, with the exception of the polar regions

Satellite communication is made between two earth stations which in turn are connected to the telephone network. So a call between, say, London and San Francisco might well travel by cable (or possibly terrestrial microwave) from London to an earth station (Goonhilly in Cornwall), from the earth station via an 'uplink' to a satellite, then a 'downlink' to an earth station somewhere in the United States and finally by landline to its final destination (Figure 2.8). The two-way satellite link involves four journeys of 22,000 miles, each of which introduces a delay of up to one-eighth of a second, so any conversation might have a perceptible half-second delay between its two sides. For this reason, long distance calls do not use more than one satellite link, otherwise the delay becomes unacceptable (in fact, the transatlantic link in this particular example could well be accomplished via undersea cable).

Figure 2.8

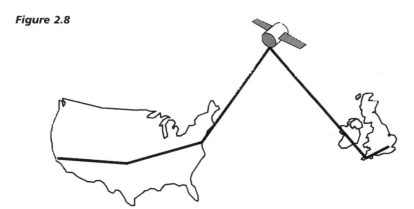

An international communications link involves a combination of land and satellite elements.

The satellite links use high frequency microwaves as carriers which are modulated by the telephone signal. The satellite carries a number of 'transponders' (transmitter-responders), which receive the uplink, amplify the signal and then re-transmit the signal back to earth on a carrier of different frequency.

The satellite age and the 'dawn of global communications'

The emergence of satellite technology greatly increased the capacity for international communication. International organisations were set up to launch communications satellites. For example, one of these, Intelsat (INternational TELecommunications SATellite organisation), had a membership of more than 120 nations in 1993, with more than 2700 earth stations accessing its nineteen satellites. Each satellite carries around forty transponders and has a capacity for several thousands of telephone circuits as well as a few television channels. There are now several hundred satellites circling the earth in geostationary orbits. Clearly the communications capacity of satellites, like their coverage, greatly exceeds that of an undersea cable.

The same technology that brought high capacity satellite links for telephony made international television link-ups possible; Intelsat's Early Bird satellite routinely carried television across the Atlantic from 1965. This rapid expansion in

instant geographical coverage was felt by many as a new age of communication, leading some, perhaps most notably Marshall McLuhan (1964), to claim the new electronic communications technologies heralded a fundamental change in the way human society would be organised, reducing the world to the dimensions of a village. Others, taking a more pessimistic view, foresaw the inevitability of the powerful nations of the world extending their influence further around the globe and thus consolidating that power – what has been referred to as 'cultural imperialism' or even 'Coca-Colonisation' – appealing to a kind of anti-techno-logical utopianism. Ironically, while claims like McLuhan's were subjected to much criticism in subsequent years, the recent interest in computer-mediated communications, such as the Internet, has led popular magazines such as *Wired* to reproduce some of McLuhan's thirty year-old views as, once again, prophetic visions of the future.

However, commentators such as Williams (1990) or Carey and Quirk (1970) recognised the social and political contexts in which the technology developed as being of more significance than the technology itself. This debate is not new; analysis of the role of communications technology in serving powerful national or corporate interests is as old as the technology itself (eg see Inglis, 1990, p.27); Carey (1989, p. 209) quotes an anonymous author, writing in 1857:

> It may ... be doubted whether any more efficient means could be adopted to develop the resources of India, and to consolidate British power and strengthen British rule in that country, than by the forma-tion of the proposed system of railways in central Asia and the car-rying out of the proposed telegraph communication with Europe.

A number of recent developments have revived this debate. Technologies such as digital telecommunications switching, rapid progress in computer processing capac-ities and the transmission capabilities of optical fibres have, once again, enabled some to claim that the world will be made smaller by the 'communications revo-lution' (1990s version). For example, US Vice President Al Gore, addressing a con-ference in Buenos Aires in 1994, is quoted by Tracey (1994) as saying:

> ... we now have at hand the technological breakthroughs and eco-nomic means to bring all the communities of the world together. ... To accomplish this purpose, legislators, regulators , and business people must do this: build and operate a Global Information Infrastructure. This GII will circle the globe with information superhighways on which all people can travel. These highways – or more accurately net-works of distributed intelligence – will allow us to share information, to connect, and to communicate as a global community. From these connections we will derive ... a greater sense of shared stewardship of our small planet.

Questions concerning the 'impact' of communications technology and cultural imperialism have recently seen a resurgence following the publicity given to the Internet, the advent of direct TV broadcasting by satellite in the 1980s and the increased commercialisation of the television industry. These issues will be cov-ered more fully in following chapters.

Mobile communications

Most people have experience, whether as user or as victim, of the mobile phone. Since the early 1980s, when there were virtually no personal mobile phones in

use and very localised coverage for those few that did exist, their numbers increased as they became elevated to a lifestyle statement for the so-called yuppies in the economic boom of the mid-1980s. The number of mobile telephone subscribers in 1993 was around 1.8 million in the United Kingdom alone with more than 90 per cent of the population within range of a moblie telephony service (Central Office of Information, 1994, p.49).

Mobile communications makes use of radio waves to carry speech (and data) signals and includes not only mobile telephony but also maritime and aircraft communication, the mobile radio systems used for instance by taxi companies and vehicle fleet operators, and simple paging systems. All of these technologies have to operate within the constraint of a limited number of radio frequencies available for mobile communications use (see Chapter 3). One of the most recent developments designed to overcome this problem is the development of cellular radio systems on which modern mobile telephony is based.

The history of cellular radio has its origins in attempts to provide comprehensive telephone communications in areas of sparse population. (Ironically, the most rapid increase in the development of the technology in fact took place in order to provide mobile telephony services in densely-populated urban areas.) In sparsely-populated areas or in difficult terrain it is extremely costly to install a terrestrial network of underground or even overhead cables to supply access to a telephone network. Radio communication, using a transmitter to send a signal through space as a transmission medium, involves only the cost of transmitter and receiver stations. However, the limited number of radio frequencies available makes it impossible to give each call its own radio frequency while allowing access throughout the network. The cellular system divides the geographical area up into a network of adjoining cells (Figure 2.9). Each cell has a low power radio transmitter and receiver system (a base station), whose range covers just that cell. The base stations are connected to the PSTN, so that mobile telephones may make calls to and receive calls from 'ordinary' telephones. A mobile call made in a particular cell is allocated a radio frequency by the base station at the time the call is made. Because of the limited geographical range of the radio signal, that same frequency can be re-used without any danger of interference in any other cell with the exception of the adjacent cells.

If a mobile telephone is in use and approaches a cell boundary, the base stations of adjacent cells monitor that phone's signal and, if reception becomes stronger in the adjacent cell rather than the original, the call is automatically reallocated to a new frequency in the new cell, without any interruption to the call.

Of course since mobile telephony is now established with access to the PSTN, other facilities have become available such as mobile fax and, with the use of a modem, mobile data communication. Public pay telephones which make use of the cellular system are in use on trains. The existing analogue radio systems are gradually being replaced by digital phones and exchanges which not only provide clearer reception but also allow the same phone to be used in most European countries.

Cellular radio telephony and telephone access

The attention which has been focused on 'wireless' radio telephony by its use in mobile phones has caused governments and industries to consider the possibility of using radio telephony as the basis for large parts of the PSTN in those

Figure 2.9

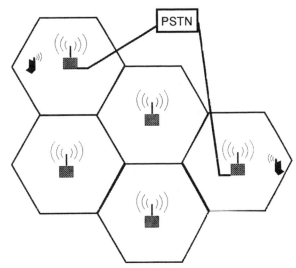

Cellular telephony. Each cell has a base station consisting of a radio transmitter and receiver. A mobile telephone in that cell transmits and receives signals from the base station in that cell, which in turn connects to the PSTN for connection to an 'ordinary', fixed telephone, or to another base station for calls to another mobile telephone.

countries which currently have an underdeveloped telephone infrastructure. In April 1994 the new government of South Africa inherited the legacy of apartheid, which included wide disparity in telephone access across racial groups: while 66 out of every hundred white South Africans had telephones, that figure was only 13.8 among the rural Black population (Winsbury, 1994). It has now licensed two cellular operators, Vodacom and Mobile Telephone Networks, to cover 70 per cent of the population within four years. The intention is to provide wireless, cashless 'community' payphones with voice mail facilities for each user who pays for calls by means of a charge card, which can be recharged at outlets such as local shops. According to Clem Doherty of Asia-Pacific Telecommunications, the cost of providing a radio-based service is $170 per subscriber compared with $2,500 for a wireline (Winsbury, 1994). In a supplementary article Berendt (1994) describes how the payphones are being installed in retail outlets such as shops and bars and in civic centres and churches. She notes:

> In the last few weeks, the informal township, Chris Hani, received five cellular payphones as part of MTN's [Mobile Telephone Networks] project. To get some idea of the significance of this for the community, it is worth noting that Chris Hani currently has no electricity, water or roads. But now it does have telecommunications, operated by a 12 volt car battery.

Some commentators contend that examples such as this suggest that it is possible with modern technology for underdeveloped countries to leapfrog the traditional communications development route of rail or road communication followed by telecommunications. When a telecommunications system is installed in a community like Chris Hani before a decent water supply, it must surely raise questions as to how priorities for structural development are determined.

Mobile communications and news journalism

While the launch of communications satellites more than thirty years ago made international telephone and television communication possible, news journalists now have the use of compact satellite broadcasting equipment for voice-only or picture communication. These 'flyaway' satellite systems can be flown around the world and carried overland in a jeep. The system can be set up in the field in a short time, with its own power supply, and a reporter and crew can then use its leased satellite access to make contact with a news service or TV station. This link-up can be broadcast live, or recorded for subsequent editing.

The use of these satellite systems gives the reporter increased independence from the traditional broadcasting and telecommunications infrastructure of the host country, and can allow news to be reported from 'behind the lines' in environments such as war zones, which may well have a damaged or, at least, unreliable communications infrastructure. Examples of this development in news journalism were seen during the Gulf War, when these technologies were perceived as conferring a distinct advantage on those agencies which possessed them (Zelizer, 1992, MacGregor, 1995).

3 Radio

What is now referred to as radio was, in its early days, almost always called 'wireless' and the description betrays its origins. The notion that sound (and TV pictures) can be carried invisibly and inaudibly through the air is nowadays so familiar as to be unquestioned. The original idea, often misleadingly attributed to Guglielmo Marconi, depended on thirty years or so of previous work by a number of people, few of whom had any conception at the time as to how they might be used. 'Hertzian waves', later known as radio waves, were found to travel through the air without the need for the wires upon which telegraphy and telephony depended. They could be transmitted and received using relatively simple circuits.

With these developments taking place at the same time as the establishment of telegraphy and telephony as means of communication, it was naturally anticipated that radio would also be used for point-to-point communication, to fulfil the same function as telegraphy and perhaps telephony but without the need for wires – 'wireless telegraphy', in fact. Nowadays its principal role is for reception of radio broadcasts, and it is the most ubiquitous of all items of electronic communications equipment; analysis of UNESCO figures for 1991 reveals that there were over 2 billion radio receivers (for broadcast reception) around the world, compared with 831 million TV receivers and 540 million telephone lines (United Nations, 1994). In addition, of these three forms of technology, the distribution of radio receivers between rich and poor countries, though certainly uneven, is somewhat less so than the other two. The other uses of radio, however, for example two-way communication by the emergency services, in radio telephony or in PA systems should also not be overlooked. Whatever role one is considering for radio, it nevertheless relies on the same fundamental principles.

The birth of broadcasting and the growth of radio

Before the establishment of radio broadcasting in the 1920s, Marconi had suc-
cessfully persuaded the British military to use his wireless method for Morse code
communication, and later sold the service to shipping companies for ship-to-
shore communication. In the US a growing number of amateur radio enthusiasts
began to communicate with each other, transmitting as well as receiving radio
waves over greater and greater distances, in some cases transmitting speech and
music rather than mere Morse code pulses. Thus, in effect, broadcasting was
beginning, since anyone equipped with a receiver could pick up these transmis-
sions, although of course the broadcasters were many and varied and received
by a relatively small audience.

The first regular *public* broadcasting in the UK began on 14th November
1922, two years after it had begun in the US. The British Broadcasting Company
was established by the Post Office and Government as a consortium of leading
manufacturers of receiving equipment. The Post Office would provide part of
the Company's funds out of revenue from the issue of licences for the use of
receivers. The intervention of the Government was designed, in part, to over-
come competing interests between the receiver manufacturers, who wanted to
begin broadcasting in order to stimulate sales, and groups such as the armed
forces, who, as Williams notes, regarded broadcasting (as had already been prac-
tised for some time by the Marconi Company for the benefit, primarily, of ama-
teur enthusiasts) as a 'frivolous and dangerous' use of radio (Williams, 1990, p.32).
A further incentive for government regulation was to avoid the excesses of com-
mercialism which had been seen in the US where broadcasting was almost com-
pletely provided by receiver manufacturers and reliant on advertising revenue.
Indeed in the years that followed, the US was alone in the world in allowing
its radio broadcasters to be entirely privately owned.

Crisell reports the public response to the advent of UK broadcasting (1994,
p.19):

> The population reacted to the new medium with prodigious enthusi-
> asm. In 1923 the Post Office issued 80,000 licences, but probably four
> or five times as many sets were in use: in 1924 1 million licences were
> issued, but up to 5 million sets were in use. In three more years the
> number of licences doubled, and by 1939 9 million sets existed under
> licence. By 1928 radio audiences were never less than 1 million and
> often as high as 15 million.

The BBC operated as a company until 1926. It suffered financial difficulties and
interference from other commercial interests: the Newspaper Proprietors
Association (NPA) had persuaded the government to prohibit radio broadcasts
of news bulletins before 7 p.m. In 1925 the Crawford Committee proposed that
the BBC should become a public corporation, a position favoured by the BBC
itself, but the Royal Charter was not granted until 1st January 1927. In the midst
of this process, the role of the state in the functioning of the BBC was illus-
trated during the 1926 General Strike.

During the strike, no newspapers were published and the NPA temporarily
dropped its ban on BBC news reporting. The BBC was under strong pressure
from Cabinet ministers and others to report the pro-government view (a role
fulfilled adequately by the strike-hit newspapers in normal times), and its response
included denying access to speakers who held opposing views, including Labour
leader Ramsay MacDonald (Briggs, 1961, p.376). At the end of the strike, radio

valve company Ediswan (manufacturers of 'the valve that made broadcasting possible') published an advertisement in *Wireless World* which was headed 'The Nation's Gratitude' and claimed: 'The whole nation emerged from industrial chaos with feelings of thankful relief and deep gratitude to Broadcasting. As Mercury the Messenger served the gods in fable, so Wireless served the nation in fact'. It finished with the useful reminder, 'The first Thermionic Valve was produced in the Ediswan Laboratories' (reproduced in Bussey, 1990, p.56). The BBC's managing director, John (later Lord) Reith resented the government's direct interference, while recognising that there were less formal ways in which the state could rely on broadcasters. During the General Strike he wrote in his diaries that the Cabinet 'want to be able to say that they did not commandeer us, but they know they can trust us not to be really impartial' (quoted in Negrine, 1994, p.112).

This early illustration of the link between the new technology of broadcasting and ideology ie its propaganda potential was repeated elsewhere, notably in Nazi Germany where mass production of cheap radio receivers meant that by 1939 over 70 per cent of German households possessed a radio, a figure higher than anywhere else in the world. Coupled with state-run broadcasting and compulsory community listening, radio was seen as a powerful propaganda weapon in the Nazi campaign; Goebbels described radio as the 'spiritual weapon of the totalitarian state' (Zeman, 1973, p.48).

Since its inception therefore, commentators have acclaimed radio as a powerful means of shaping the development of societies even when the visions of those societies are very different. Leon Trotsky identified the issue of access to communication and argued for the unifying potential of radio in consolidating the revolution in Russia. In 1926 he addressed the Soviet Union Congress of the Society of Friends of Radio. He described radio as 'the cheapest form of communication' and argued that 'We cannot seriously talk about socialism without having in mind the transformation of the country into a single whole, linked together by means of all kinds of communication' (Trotsky, 1927, pp.259-260). Ironically, similar potential for the unification of a vast nation was claimed (although without any reference to socialism!) by advocates of the US broadcasting system in comparisons with European models (Moore, 1989, p.243).

McLuhan pointed to the technology itself rather than the message (1964, pp.306-307):

> Plato, who had old-fashioned tribal ideas of political structure, said that the proper size of a city was indicated by the number of people who could hear the voice of a public speaker. ... radio, because of its ease of decentralized intimate relation with both private and small communities, could easily implement the Platonic political dream on a world scale.

Radio receivers

Most listeners heard the first radio broadcasts through a pair of headphones attached to a crystal receiver. Even by 1927 50 per cent of listeners were still using crystal sets (Bussey, 1990, p.60). It is easy to see why; in 1924 a crystal set could be bought complete with aerial and headphones for £3 to £4, or cheaper if it was built from a kit; the cheapest valve receivers retailed at around £12. Crystal sets could only serve one or, with the addition of an extra pair of headphones, two listeners. Amplifier units could be bought to add to the set enabling it to drive a loudspeaker.

In the years following 1926 prices fell, and increasing numbers of valve sets were purchased. Manufacturers were beginning to build complete, self-contained receivers with all the components hidden inside a cabinet, including a loud-speaker. With the use of a loudspeaker listening patterns altered; it became possible for people to listen to the radio in groups, or to listen while doing other things with the radio on in the background. These radios, unlike crystal sets, possessed a tuning control in readiness for regional broadcasting in the UK, allowing listeners to select either the National Programme or the Regional Programme. Increasingly they were operated by mains electricity, although there were also several battery-powered 'portable' radios on the market. As Bussey points out however, some of the early so-called portable receivers would 'turn the scales at half-a-hundredweight!', in other words weighing much the same as a large sack of potatoes (1990, p.65). By 1929 the increasing number of broadcasts from within the UK and abroad required a more sophisticated system of selectivity (the process of tuning to a single frequency on which a station is carried) and crystal sets became practically unusable.

In 1947 the first transistor was demonstrated but it was not until the 1960s that their development was sufficiently advanced to allow them to replace the valves in radio circuits. In comparison, transistors are tiny, consume very little power, do not get warm and moreover do not need to warm up before operating. They are also cheaper (see opposite). These attributes allowed manufacturers to produce compact, genuinely-portable transistor radios powered by small batteries. At a time when television viewing was rapidly replacing radio listening in many households, this portability and lower cost gave the radio a new lease of life. The emergence of these new transistor radios became part of an increase in consumerism and consumption in general which characterised the late 1950s and early 1960s. The enhanced portability and mobility dovetailed with the optimism of the period and its notions of prosperity and liberty; radios were fitted in cars, in some ways the ultimate symbol of individual mobility, affluence and freedom. Group listening gave way to individual listening (which increased sales of course) and by the end of the 1970s there was almost one receiver for every man, woman and child in the UK. The radio was even more likely to be used as background entertainment while the listener was pursuing other activities; it was around this time that the launch took place of a number of pirate radio stations which played continuous pop music, ideal, some might say, for background listening. The radio thus began to emerge as a medium which was distinct from television. Meanwhile as television audiences continued to grow and its technology continued to develop, the BBC was forced to address the different roles of the two media, resulting in the development of network radio with its themed stations (Crisell, 1994, pp.29-33).

How radio works

Radio waves form one segment of a whole range of waves, including light, heat and X-rays, which together make up what is known as the electromagnetic spectrum. All electromagnetic waves (sometimes known as 'electromagnetic radiation', from which the word radio comes) share the same physical structure – they consist of vibrating, or oscillating, electric and magnetic fields. In the same way that a magnetic field can exert a force on a compass needle, causing it to turn, so both magnetic and electric fields can exert forces on electrons (the particles

Transistors and solid state electronics
Transistors

Transistors are electronic devices made from semiconductor materials such as silicon. They are designed so that their ability to conduct electricity can be controlled by a small electrical signal, so they are ideal for amplifying a weak signal source such as that picked up by a radio aerial or from a microphone. In effect, they do the same job as valves did in the earliest amplifiers.

The transistor was developed, primarily at Bell Labs in the United States, during the late 1940s, having made use of technical advances demanded by the Second World War. Compared with valves, low-pressure glass tubes containing a small heating element, transistors were small, did not get very hot, did not use up much electrical power and were not fragile. They were thus ideal for portable, battery operated electrical equipment, but as their development continued they came to replace valves in almost all applications, except for very high frequency or high power systems.

Integrated circuits

The same semiconductor used in transistors can also be used to make other electronic components such as resistors and diodes. Since a number of these components would be connected together in the construction of a conventional electronic circuit, it became possible as production techniques advanced during the 1950s and 1960s to put all the components and their interconnections together on a single piece of silicon. So the whole circuit was built into what became known as an integrated circuit, or silicon chip. Present technology enables thousands of components to be integrated into a piece of silicon measuring just a few square millimetres.

From an equipment manufacturer's point of view, it meant production was easier and cheaper, since it was only necessary to install a chip or two to build a circuit rather than having to assemble the whole circuit from individual components. On the other hand, from the buyer's perspective, repairing such equipment meant replacing chips ie whole circuits rather than the hitherto cheaper alternative of replacing individual components, although integrated circuits tended to be more reliable than circuits constructed from components.

Microprocessor

To complete the evolutionary history, brief mention should be made of the microprocessor, the first versions of which were produced in the early 1970s. This is an advanced integrated circuit which combines a vast number of components into a digital electronic circuit which can be programmed to perform a sequence of operations. As such microprocessors form the basis of computer equipment and are also found in a range of technologies such as washing machines and car engines.

which make up an electric current), making them move. What distinguishes radio waves from other sorts of electromagnetic radiation is their frequency range — waves with frequencies as low as about 1 kHz (1000 oscillations per second) up to around 100 GHz (100 billion oscillations per second) fall into the category of radio waves. This may seem like a huge range of frequencies, yet it forms only a small section of the whole spectrum of electromagnetic waves, and there never seems to be enough radio frequency space available to satisfy demand.

Radio waves travel at the speed of light (300,000 km every second) through empty space, air, walls and, like light, they can be reflected or refracted (bent). They can be transmitted and received relatively simply: to receive a radio wave one requires a length of wire. A length of metal rod or wire contains lots of electrons, and any radio waves around cause those electrons to move. Since the waves are oscillating back and forth, the movement they impart to the electrons consists of identical oscillations. A circuit attached to that wire (which is known as an aerial or antenna) picks up that movement as an electric current. Together these components comprise a basic radio receiver.

The reverse process is also possible. If an electronic circuit is connected to a length of wire, forcing the electrons to move back and forth in that wire, it radiates electromagnetic waves. The frequency of those waves is the same as the frequency of the electronic signal driving the electron oscillations. This is a radio transmitter circuit.

To make an electric current in a circuit oscillate at the very high speeds necessary to produce radio waves was difficult in the early days of radio, but by creating a small gap in a circuit and forcing electricity to jump the gap, producing a spark, this intermittent electrical conduction effectively produced the oscillations required. Spark generation of radio waves is no longer necessary (it has been superseded by continuous wave generation, described below) but it still affects radio reception; badly suppressed vehicle ignition systems, domestic electrical appliances and thunderstorms all produce electrical sparks (either small, or huge in the case of lightning) which in turn, generate radio waves which can be heard on a receiver as interference (crackles and buzzes).

Point-to-point communication

The earliest application of radio, for point-to-point communication, was relatively easy to effect (from a theoretical standpoint at least!) once reliable spark transmitters were available. The spark transmitter produced a burst of radio waves which radiated out from the transmitter. An antenna within range of the transmitter received the radio waves and turned those into a buzzing or clicking sound signal in a pair of headphones. By switching the spark generator on and off for short bursts, it was possible to send signals in the form of Morse code, which would be picked up almost instantaneously at the receiver. A skilled operator would then decode the received signals into a message. By 1897, Marconi had transmitted messages over a distance of 20 km, and by 1901 he could send messages beyond the horizon and right across the Atlantic.

However this technique is not suitable for transmission of speech and music. Speech and music contain frequencies between around 50 Hz and 15 kHz, whereas radio frequencies are generally much higher than these. So it is not possible to convert sound waves directly into their equivalent frequency radio waves for broadcasting.

Broadcasting

Instead, the techniques of modulation are used to carry the sound frequencies on higher frequency carrier waves. This only became possible with the emergence of reliable continuous wave (CW) generators after the First World War, replacing the earlier spark generators. CW generators produce a constant radio wave of a specific frequency, which is used as the carrier wave. Modulation has two effects: firstly, the higher frequency radio waves are more easily transmitted

and received by small antennas than lower baseband frequencies; second, by modulating a number of separate carrier waves with different sound signals, several sounds can be broadcast at once. The receiver contains a variable tuning circuit which the listener can adjust to select the particular signal which is wanted. This is, in effect, a form of frequency division multiplexing (FDM). Without it, only one audio channel would be available as all sound, speech and music, occupies the same baseband range of frequencies, and it would not be possible to transmit several different messages at the same frequency. This is illustrated in Table 3.1. Modulation results in a range of frequencies being transmitted for each station. All of these frequencies (as well as those of all other broadcasts) are picked up by the receiver's antenna. By adjusting the tuning circuit in the receiver just one set of frequencies is selected.

Table 3.1 The frequencies of two radio stations

	Broadcast frequency (carrier frequency)	Approximate range of frequencies transmitted
BBC World Service	648 kHz	633 to 663 kHz
Radio 5 Live	693 kHz	678 to 708 kHz

This also shows why there is space only for a limited number of radio stations; the frequencies allocated for broadcasting must be separated to allow for the sidebands and channel selection. Without this, some of the Radio 5 Live frequencies would be picked up when the radio was tuned to the World Service, and vice versa.

Types of modulation

Two methods of modulation are used in broadcast radio: amplitude modulation (AM) and frequency modulation (FM). These are described on page 30. AM was the technique used in the earliest days of broadcasting, and is reasonably efficient in its use of the scarce radio spectrum. On the other hand, FM is more complicated and is inefficient in its use of the spectrum. What, then, is the reason for its use?

Nowadays almost all radio receivers have both MW and VHF bands ie can receive AM and FM broadcasts. This was not always the case – the extra complexity of FM circuitry meant the cheaper receivers were MW and LW only. But the quality of an FM station is noticeably superior to an AM, as a comparison of AM and FM broadcasts will quickly reveal, especially in the evening. Much of the BBC's output was therefore simulcast (ie the same station simultaneously broadcast on the two different systems, AM and FM). The decreasing cost of semiconductor technology has all but eliminated this price differential. The coverage of FM broadcasts has also increased over the years. These two developments led the UK government in the last few years to restrict simulcasting. Recent (successful) campaigns by listeners' groups to dissuade the BBC from ending its LW Radio 4 service demonstrates that simulcasting is not yet superfluous.

Nevertheless the sound from an FM broadcast is indisputably clearer and less corrupted by background noise and interference than AM reception. This is a direct consequence of the method of modulation. Noise tends to occur at all frequencies – taken as a whole, its effect is to distort the amplitude of any electronic signal. As shown on page 30 it is in the amplitude that an AM broadcast

Modulation for radio transmission

The amplitude modulation (AM) technique is illustrated in Figure 3.1. The carrier's amplitude, or size, is varied (or modulated) by the size of the sound signal. The resulting transmission has a 'core' frequency equal to that of the carrier, but the modulation effectively spreads the range of transmitted frequencies. In the case of AM, two frequency 'sidebands' are generated, each equal in width to the base bandwidth of the modulating signal (see Figure 3.2), so the broadcast bandwidth is 30 kHz, twice the base bandwidth. At the receiver the demodulation circuits recover the sound signal from the carrier and this then is used to drive the loudspeaker.

Frequency modulation also uses the sound signal to modulate a high frequency carrier wave, but in this case the modulating signal varies the carrier's frequency rather than its amplitude (see Figure 3.3). Thus the amplitude of the broadcast wave remains unchanging, but the varying frequency results in a much greater increase in the signal's modulated bandwidth. Instead of just two sidebands a series of sidebands is produced. The bandwidth of the FM signal broadcast in the UK is 200 kHz, almost seven times that of an AM broadcast.

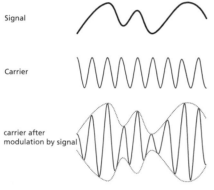

Signal

Carrier

carrier after
modulation by signal

Figure 3.1.
Amplitude Modulation. A high frequency 'carrier wave' can be used to carry the information signal. The carrier wave's height, or amplitude, is modulated by the information signal. The amplitude of the carrier wave varies to take on the shape of the information signal. At the receiver a demodulation system monitors the varying amplitude of the modulated carrier wave to recover the information signal.

Figure 3.2.
The bandwidth of the amplitude-modulated carrier signal is twice that of the original, baseband signal. It consists of two sidebands, centred around the

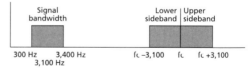

Signal bandwidth

Lower Upper
sideband sideband

300 Hz 3,400 Hz
3,100 Hz

f_c −3,100 f_c f_c +3,100

carrier frequency. Since the two sidebands are mirror images of one another, it is possible to transmit just one sideband and reproduce the other at the receiver, thus reducing the frequency range required for transmission. This technique is called Single Sideband Amplitude Modulation.

Signal

Carrier

carrier after
modulation by signal

Figure 3.3.
Frequency Modulation. The frequency of the carrier wave is changed, or modulated, by the size of the signal. The amplitude of the modulated wave remains unchanged.

contains all its information; an FM broadcast carries information only in the frequency of the signal, and none in its amplitude (indeed, the amplitude does not vary at all). Thus, since noise affects the amplitude rather than the overall frequency pattern of a signal, it has a far greater effect on AM than FM. This is the principal reason for the use of the otherwise inefficient FM method. FM stations are also less susceptible to interference from adjacent channels than AM broadcasts.

The much larger bandwidth of FM broadcasts necessitates the use of higher carrier frequencies to provide sufficient channels. Hence FM is confined to the VHF band (for many years, 88 – 97.6 MHz, but now higher frequencies, extended in 1995 up to 108 MHz, have now been made available). The lower frequency MW and LW bands are allocated for AM. This explains the recent tendency to label radio band selectors and dials AM and FM rather than the previous MW, LW and VHF.

Simplicity or complexity – choosing a modulation technique

It would, in fact, be possible to economise on the use of the radio frequency spectrum by transmitting just one of the modulated carrier's sidebands since both sidebands are mirror-images of one-another. This method is used in telephony; with its technique of single sideband, suppressed carrier amplitude modulation, the channel bandwidth allocated for the *modulated* telephone signal is the same as the original message bandwidth (3,100 Hz) plus a guard band, making a channel width of 4 kHz in all. If radio used the same system as the telephone, the bandwidth required for each signal would be halved, potentially allowing the broadcast of twice as many radio stations. Transmitting a smaller range of frequencies and no carrier wave also reduces the power needed to transmit each message.

On the other hand, to recover the original speech signal requires a reconstruction of the 'missing' sideband and also of the carrier wave and this involves more complex and costly circuitry. At the inception of radio broadcasting the desire to encourage the growth of a mass audience meant it was necessary to keep the costs of receivers down to a minimum, and double sideband amplitude modulation (DSB-AM) could work with relatively simple receiver circuits. The cheap costs of radio reception compared with the telephone is one of the main reasons why the telephone never succeeded in becoming a source of mass entertainment, despite early attempts (Pool, 1983, pp.81-82).

Radio wavebands

The section of the electromagnetic spectrum that is called radio is itself divided up into smaller segments, known as bands. One or two of these might be familiar: the short wave band (SW) and the medium wave (MW) and long wave (LW) bands. All of these bands can be used for transmitting radio signals, though they have rather different characteristics from each other. The first spark transmissions used for communication between land and ships at sea operated within the SW and MW bands. Current UK national radio broadcasting makes use of the MW, LW and very high frequency (VHF) bands, now known more popularly but confusingly as the AM and FM bands. Table 3.2 lists all the radio bands. Note how different bands are used for different purposes, and not just for 'radio' transmission but for television and the telephone too.

Table 3.2 Radio wavebands

Radio band	Designation	Also known as:	Used for:
3–30 kHz	Very low frequency VLF		World-wide navigation
30–300 kHz	Low frequency LF	Long wave LW	AM broadcasting; navigation; radio beacons
300 kHz–3 MHz	Medium frequency MF	Medium wave MW	AM broadcasting; aeronautical navigation
3–30 MHz	High frequency HF	Short wave SW	Long distance broadcasting; maritime and aeronautical communication
30–300 MHz	Very high frequency VHF	'FM band'	FM broadcasting; mobile communication eg emergency services
300 MHz–3 GHz	Ultra high frequency UHF		TV broadcasting; mobile telephony
3–30 GHz	Super high frequency SHF	Microwaves	Satellite links; terrestrial microwave communication; radar

Global and local radio: the characteristics of different frequency bands

A radio wave might travel between transmitter and receiver in any of a number of ways. The most obvious is in a straight line if the receiver is in view of the transmitter, but as Marconi showed almost one hundred years ago there are other means by which communication beyond line-of-sight is possible. The particular ways in which radio waves propagate depend on their frequency.

Some of the earliest transmissions used frequencies in the medium frequency (MF) and high frequency (HF) bands (often known as medium wave and short wave – see Table 3.2). These travel in what are known as sky waves. Figure 3.4 shows the propagation paths used by different radio waves. It can be seen that the reflection of the sky waves allow the radio signal to travel beyond the limitation of line-of-sight. The propagation paths are:-

(a) Surface waves: these propagate by 'hugging' the surface of the earth – a process known as diffraction. This is most effective for lower frequency waves (ie longer wavelengths) which bend more than higher frequencies. The lower frequencies also bend round obstacles more readily than the higher frequencies. So most parts of Great Britain are covered by just a single LF (long wave) band transmitter, located at Droitwich. For similar reasons LF transmissions from other countries can be clearly received in the UK.

(b) Sky waves: as mentioned above, these also reach beyond the horizon. A multi-layer region of the atmosphere extending between around 40 km and 400 km above the earth's surface, known as the ionosphere, is made electrically active by ultra-violet sunlight, and can refract or reflect radio waves. Again its effect depends on the frequency of the wave. Low frequency and medium frequency waves may undergo a single reflection to travel large distances. However these frequencies (particularly the MF range) are badly attenuated as they pass through the lower regions of the ionosphere en route to the reflecting layers, and so do not propagate very far during the daytime. At night, when the sun's light has gone, this lower layer disappears, so there is no attenuation and MF transmissions propagate further. This explains why it is possible to pick up more MF ('AM') stations at night, especially from further afield. High frequency (short wave) radio transmissions may go through several reflections to make a multiple hop path, travelling great distances. These are largely unaffected by the attenuation problems suffered by MF waves and therefore propagate day and night. These frequencies are used for international communication, for example by the BBC World Service, to broadcast around the world.

(c) Space waves: at still higher frequencies, VHF, the ionosphere has no effect, and VHF waves travel straight through without any reflection. So VHF transmission takes place by means of line-of sight space waves. These very high frequency waves do not diffract well round obstructions and so a relatively large number of high power transmitters, around 40, are needed for universal UK coverage of national BBC stations, compared with ten for MF and just three for LF transmissions.

Local broadcasting

This limited range of VHF transmission allows broadcasting to be localised if the transmission originates at just one transmitter, though the range of the signal is dependent not just on the propagation mode but also on the transmitter power.

Localised programming was established soon after the launch of radio broadcasting, though not without some technical difficulty. When the BBC began radio broadcasting in the 1920s, switching to its powerful, Essex-based 5XX national transmission station in 1924, crystal receivers did not posses the variable tuning which allows reception of different signals. This did not matter, there was only one station being broadcast in Britain. The new long range LF wavelength used by 5XX, however, while ensuring coverage of virtually the whole population,

Figure 3.4

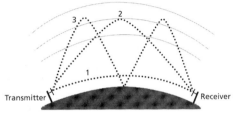

Transmitter Receiver

Communication beyond the line of sight. Radio waves do not always travel in straight lines. Depending on their frequency they can bend around the surface of the earth (1) or be reflected off the upper atmosphere, either once (2) or twice or more (3).

resulted in interference with reception of Continental stations. To establish regional broadcasting, the BBC introduced five lower power transmitters, operating on the MF band, located in the different regions; the high power LF transmitter (which was moved to Droitwich in 1934, where it remains) was retained for national coverage. By 1934, 98 per cent of the population could receive the National Programme while 85 per cent were able to receive both the National and a Regional Programme, provided that they had replaced their receivers with selective or tuneable equipment (Bussey, 1990, p.23).

Localised broadcasting allows frequency re-use. If the range of a transmission is limited, then the same frequency can be used for transmission of a different station in another area, as long as the two areas of coverage do not overlap. For example, at least four BBC local radio stations, Bristol, Lancashire, Suffolk and York, all broadcast on 95.5 MHz, avoiding interference because of their geographical separation.

Local radio nowadays includes 39 local BBC radio stations (all broadcasting on the VHF band) and more than 170 independent local radio (ILR) stations. In addition the Radio Authority has issued something like 490 'restricted service licences' which are issued for up to 28 days, offering very local broadcasting (eg a small town or part of a city) often to cover a local arts festival or similar (Central Office of Information, 1993, p.42). The Radio Authority is to license a further number of channels (at least 30, and some estimates suggest over 100), prompting debate about the viability of such a large number of stations competing for a share of an audience which, if anything, is in decline (Buckingham and Atkinson, 1995). The UK Government in mid-1995 announced new rules on cross-media ownership, which amongst other changes, raised from 20 to 35 the limit on the number of local radio licences which may be owned by a single company. This added to concern amongst campaigners for local community radio about access to the newly available low-power licences in the 105–108 MHz VHF band (Harcup, 1995).

Multipath transmission: fading and mobile reception

As has been seen, radio transmissions might reach a receiver by a variety of routes, and all of these paths may operate at the same time. This is known as multipath propagation, and it can give rise to problems such as fading, where the reception breaks up or is lost altogether. For example, a medium frequency broadcast might be received by a single reflection off the ionosphere as well as by a surface or space wave. The actual distances travelled by the two waves are different and so each arrives at the receiver at slightly different times (this is known as being 'out of phase'). The signal from one route interferes with that from the other. The effect varies as the relative strength of the contributions from each path changes.

Fading is a particular problem in a number of cases. Listen to a MF broadcast at night, when the reflected sky wave path comes into effect, and fading is particularly evident. A long distance, multiple hop HF transmission might receive its signal simultaneously via both a two hop path and a three hop path, which, again, causes out of phase reception. A mobile receiver, for example a radio in a moving car, might receive its signal via direct, space wave transmission and through additional reflections off buildings or hills. Again these different out of phase sources produce occasional fading because of the continuous variation, as

the vehicle moves, in the relative contribution of the primary signal and its reflections. Technical improvements can be made to the receiver circuitry to alleviate some of the effect, but it can not be eliminated. The advent of digital audio broadcasting (DAB) is designed particularly to improve mobile reception and greatly reduce the problem of fading.

DAB overcomes this by retrieving the data via any available path or combination of paths and by making use of digital error correction techniques. The advantage of DAB for mobile reception in particular is apparent from the BBC's intention to develop its DAB services initially along motorway corridors, 'which may in turn affect the pattern of interest in providing local digital radio' according to Government's digital broadcasting proposals (Department of National Heritage, 1995). DAB also allows the audio signal to be accompanied by data signals, so that the receiver can display information such as the station title, programme schedule, traffic information or even song lyrics! The BBC began DAB broadcasts in the London area in the autumn of 1995.

The role of radio has evolved significantly in the 100 years since its early development. From its original function as a successor to the telephone it was then to become part of the emergence of broadcasting, later changing again as television broadcasting became widespread. Digital broadcasting demonstrates that radio will continue to develop its role as a mass medium.

4 Television

Television, although sixty years old, is the most recent, radically new mode of communication. It is almost ubiquitous: it is the most widely-owned communication technology after the radio, 99 per cent of UK households possessing at least one set in 1993, compared with 90 per cent with a telephone; it is the most extensively used technology – 94 per cent of the population watch television at some time during the week, and on a typical day, 80 per cent of the population watch for an average of four hours every day. It is probably the most talked-about and written-about medium. Yet sixty years on the technological principles by which it works have not fundamentally altered. With the new forms of delivery by satellite and cable, the vast increase in the number of channels promised (or threatened) by digital broadcasting, and widescreen and high definition becoming more fact than conjecture, only recently has the technology of television begun to attract renewed attention.

A brief history of television

It is not really possible to define when television emerged as a feasible technology. In this respect it is like almost all other technologies, except that television appeared, in many ways, as a culmination of a number of somewhat disparate innovations in communications technology. Electrical technology was harnessed to a communications application, the telegraph, in the early nineteenth century. Photography developed separately at around the same time; pictorial records could be chemically fixed by the middle of the century, and shortly after, image reproduction for inclusion with newspaper reportage established the photographic picture as a means of communication of information.

Photography had also been used for the scientific study of animal and human movement by means of multiple exposure of pictures in rapid sequence, which

demonstrated, for example, that contemporary artists' representations of galloping horses had been in error.[1] This multiple-shot technique of the 1870s was followed shortly after by mechanical devices, such as Eadweard Muybridge's 'Zoopraxiscope' (Hecht, 1993, p.262), which allowed these sequences to be viewed in rapid succession, giving an impression of reproduction of the movement. They worked by exploiting exactly the perceptual feature of the eye-brain complex which now allows us to watch the moving pictures of television (and cinema). This is known as the 'phi phenomenon'; if a number of images, in slightly different positions from one another, are viewed in rapid succession (around twenty or more times per second) the image appears to be in continuous motion rather than in a sequence of fixed positions. This effect has been exploited in children's cartoon 'flick books'. For public consumption, machines like the Kinetoscope were manufactured, consisting of a wooden cabinet housing a shutter arrangement which allowed a sequence of frames in a continuous film loop to be viewed through a lens. They were used for entertainment in sideshows or in 'peep-show' galleries, the first of which appeared in the UK in October 1894 (Barnes, 1976, p.12). They could only be viewed by one person at a time; it was still a few years before the emergence of public performances of projected films.

Meanwhile, other developments moved along in parallel. The telegraph system of wire communication had begun to be used additionally for 'telephotography', transmitting images (of text initially, but later of a photograph as a matrix of dots) through wires, and a successful text-transmission system operated between Paris and Amiens in 1862. The telephone, which offered 'real-time' voice communication, appeared in 1876 as a 'natural' advance on the telegraph, although by the 1880s and 1890s it was still used primarily by businesses and wealthy individuals. All of these developments led, perhaps naturally, to the idea that it should be possible to send moving pictures through wires, and several proposals were made during the last decade of the nineteenth century, though none were really practicable at that time. Nevertheless, it was clear that the search was now on for some means of transmitting moving pictures.

What was also clear was that at the turn of the century, although there were a number of investigations and technical advances in the area, there was no real sense of public investment in promoting the development of the technology. A number of 'pioneers' made contributions: Nipkow, Rosing, Campbell Swinton and of course Baird; but the various small groups worked separately. Williams suggests that while social conditions favoured the development of telephony and radio (for 'wireless telephony' purposes rather than for broadcasting, an idea which was not pursued at that time) as a natural extension of transport and business communication, the conditions for social communication were not yet established which might have encouraged television (1990, pp.17-18). Motion pictures were still seen, primarily, in side shows rather than in theatres. It was after radio had begun to be used for broadcasting rather than point to point communication that the development of television technology received renewed impetus.

The first practical results were achieved by using mechanical means (eg the 'Nipkow disc') for scanning the image, a necessary technique for recording an image by sweeping across it in a sequence of lines, and reconstructing the image

1 A well-known example is Gericault's *Horse-racing at Epsom*, painted in 1820, and the error is discussed in Gombrich (1978, p.10).

line-by-line at the receiver. In 1923 Vladimir Zworykin, working in America, had patented an electronically-scanned camera tube. There was much competition between the various systems, and it is certainly not clear who can be claimed as producing the 'first' television transmission. However, 'On Monday morning, 30th September 1929, Baird stood modestly in a corner of the studio in Long Acre and witnessed the inaugural broadcast of television carried out through the B.B.C. transmitter 2LO for half an hour' (Tiltman, 1933, p.151), although it was also noted in a contemporary record that the BBC did not embark on the project with unrestrained enthusiasm (Robinson, 1935, pp.44-45). The system was crude, relying on mechanical scanning, but experiments continued until 1935, by which time other companies like EMI had come up with their own all-electronic systems, promising higher definition and greater reliability. In 1935 a government committee of inquiry, the Selsdon Committee, recommended that the BBC should begin public television broadcasting, and a year later regular transmission began from Alexandra Palace in north London.

By this time Baird had improved his system's definition and it now scanned the picture with 240 lines. However, EMI (who had by now joined forces with the Marconi company) had a system offering 405 lines. The BBC transmitted each system on alternate weeks on a trial basis, but the lower definition and unreliability of Baird's system resulted in it being dropped within three months and the Marconi-EMI system was adopted as the UK standard, with 405 line transmissions continuing until 1985.

Good reception: the growth of the new medium

In September 1939, less than three years after its commencement, television broadcasting stopped with the outbreak of war. It resumed in June 1946, though still only offering coverage in and around London. Regional transmission was underway by the end of 1949, and over 80 per cent of the population could theoretically receive pictures of the 1953 Coronation. In fact the audience for this spectacle was 20 million, a huge figure given that there were just two and a half million TV sets in ownership (Geddes and Bussey, 1986, p.11). Two years later, in September 1955, the first commercial station was launched, requiring the installation of a new receiver and aerial for its reception.

In 1964, the BBC began broadcasting an additional channel. BBC2 was available only as a 625-line system rather than the previous 405-lines, thereby offering enhanced definition. However, the increased bandwidth necessary for transmission of the bigger signal required the use of a higher range of radio frequencies, UHF instead of VHF. Yet another new receiver and yet another aerial were needed to receive the new BBC2 transmissions, while BBC1 and ITV remained on the previous 405-line, VHF system. So, for reception of all three channels, new receivers had to be 'dual-standard' sets which could be switched between the two systems. Negrine identifies this time as the beginning of a period of restructuring in British broadcasting, with emphasis shifting from a notion of 'public service broadcasting' to the more competitive, segmented 'market driven' philosophy of today (1994, p.87).

Once again, any recently-acquired TV receivers were soon rendered obsolete with the advent of colour TV in July 1967. Colour broadcasts were transmitted only on the 625-line system and so appeared initially only on the minority interest BBC2 channel. Only in 1969, when BBC1 and ITV joined BBC2 on this

system, did colour reception become more widely seen. Now, new receivers could be designed to a single, 625-line standard requiring only a single UHF aerial and less complex tuning circuitry. It is not surprising that this period of rapid development (and recurring obsolescence) of equipment, saw the emergence of a rapidly-growing market for TV rental, as opposed to purchase.

Since this period, technical progress has been more incremental and less visible. Developments in tube technology and the use of integrated circuits have made sets relatively cheaper and more reliable; new services such as teletext (the text-based information services such as Ceefax) and NICAM stereo audio broadcasting are perhaps the changes most noticeable to the viewer. Latest developments, including widescreen and high-definition television and digital broadcasting may well indicate the beginnings of a period of more significant change.

Selenium, scanning and synchronisation: how television works

Light, electricity and television

For audio communication sound waves are turned into electrical signals by a microphone and then transmitted, sometimes through wires and sometimes on the back of a higher frequency radio wave. The light from a picture, however, can not be directly converted into an electrical signal for radio or wire transmission – the frequencies in light are too high. Instead an indirect method is used. This makes use of a group of materials which change their electrical properties (usually their ability to allow electricity to flow, known as resistance) in the presence of light. The first observation of this effect was in 1873 in a material known as selenium, which was used at the time for its electrically resistive properties. In that particular application, the inconsistency of selenium's resistance in varying light conditions was a severe failing of the material. Later, it was put to advantageous use: by using this material as a resistive element in an electrical circuit, the amount of electricity which flows in that circuit is directly related to the amount of light falling on the selenium – the brighter the light, the more electric current flows. The result is a light measuring circuit.

This technique, however, measures the *total* quantity of light, since the electric current depends on the total resistance of the material. To obtain meaning from pictures we see shape and depth made up of distinct light and dark areas rather than an overall brightness. If a picture image is focused on a slab of selenium, some parts of the slab are brightly lit (so having a low resistance), other parts are dark (with a high resistance). To record the image correctly, the brightness at each part of the image must be measured. Two possible solutions are conceivable: the first would be to break the single piece of selenium up into a large number of tiny pieces, arranged in a grid pattern, each forming an element in its own electrical circuit so that the current in each circuit would give information about that part of the image; a second method, which would require only one electrical circuit, would involve scanning the image, recording light from just one part of the image at a time, sweeping across the image in a succession of lines.

Scanning

The earliest experimenters chose this second option as the easier method, and used spinning discs containing a series of holes. As the disc spun the holes traced lines across the image and the light passing through the hole was measured. This

was actually quite a complicated arrangement and several different mechanical scanning techniques were tried, all with limited success. Improvement came with Zworykin's electron beam tube (or 'cathode ray tube') which made use of an electronic scanning technique, and was a forerunner of the tube cameras still used today (see below).

Figure 4.1

TV camera tube

Electronic scanning

The arrangement is shown in Figure 4.1. A beam of electrons forms part of the electrical circuit and this beam is directed at the image on the target plate (which is made of a material with similar properties to selenium). The beam is scanned across the target plate by deflecting coils. The amount of electricity which flows via the beam and target plate depends on the resistance of the target plate at the point where the beam falls at that moment. This resistance is in turn governed by the brightness of the light on the plate. If the beam falls on a brightly lit area of the image, the plate's resistance is low and so lots of electrons can pass through it; if the area is dark, its high resistance prevents the passage of electrons. So as the beam scans in a line across the image, the electric current rises and falls according to the variations in image brightness along that line. At the end of the line the beam returns to the beginning (called 'flyback') and moves down, then scans a new line below the previous one. This is repeated until the whole image has been covered (this is one 'field'), when the beam then returns to the top of the image ('field flyback', see Figure 4.2). By now the image will have moved to a slightly different position, and the beam starts a new scanning process. So the electronic signal consists of a series of voltages varying between 'white' level and black, punctuated by gaps during the beam flyback at the end of each line, with a further gap when the beam flies back from the bottom of the image at the end of each field.

Only about 90 per cent of the area scanned by the camera beam is displayed on the receiver tube, known as the 'action area'. This avoids displaying any of the distortion which can occur in the edges of the scanned area of the camera.

Synchronisation and the television picture tube

To use this scanned electronic signal to reconstruct a picture in a television receiver, two things are needed: first, obviously, some means of turning electrical signals back into light on the screen ie a reversal of the recording process; and secondly some means of keeping track of whereabouts the electron beam is in the image at any particular time.

The first of these requirements is fulfilled by substances known as phosphors. These emit light when they are struck by a beam of electrons. A television screen

Figure 4.2

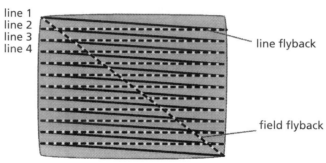

line 1
line 2
line 3
line 4

line flyback

field flyback

The beam scanning pattern

is coated on the inside with a phosphor, and an electron beam similar to that in the camera tube is aimed at it. The more electrons that hit the screen at a particular point, the brighter the light that is emitted. If the beam scans across the screen in exactly the same pattern as the camera beam scans its image, the brightness generated at a particular point on the screen will correspond with the brightness of the image measured by the camera. Provided that the beam in the receiver tube is always at precisely the same point on the same line as the beam in the camera tube (the second of the two conditions mentioned above) the picture produced on the TV screen should look much the same as the image on the camera's target plate. This conformity is achieved by including synchronisation signals in the form of electrical pulses to the receiver with the picture information, identifying the start of lines and fields (see Figure 4.3). The combined picture signal and synchronisation pulses are referred to as the composite video signal.

Interlaced scanning and blanking

Rather than scanning the whole image one line at a time a technique known as interlaced scanning is used. The first field scans all the odd-numbered lines (first, third, fifth etc.) then, at the end of this odd field scan, the beam flies back to begin the even field scan, beginning with the second line, then the fourth and so on. Interlaced scanning gives a more evenly illuminated TV screen. Without it, if the scanning started at the top of the picture and worked its way down

Figure 4.3

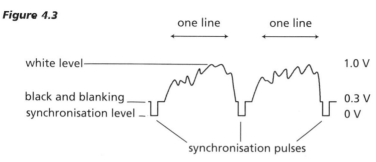

one line one line

white level ──────────── 1.0 V

black and blanking ── 0.3 V
synchronisation level ─ 0 V

synchronisation pulses

The TV signal. The diagram shows the electronic signal which might be produced by two line scans. As the image is scanned the signal varies between maximum, white level and minimum, black level according to the brightness of the image. A synchronisation pulse indicates the beginning of each line.

line-by-line, by the time it reached the bottom of the frame the top of the screen might well have started to dim (this was a particular problem in the early days of phosphor coating technology, when many of the standard techniques for TV were established).

Interlacing means that there are two fields for every complete image, or 'frame'. The field scan rate, or field frequency, is tied to the frequency of mains electricity (50 Hz in Europe, 60 Hz in North America), so the frame rate is 25 frames per second (or 30 frames per second in North America). For reconstruction of the image on the TV receiver picture tube, the same scanning pattern is used as for the camera tube, so the frame rate is again 25 Hz (or 30 Hz). Showing successive frames at this rate is sufficient to give the impression of a smooth, jerk-free motion picture. Scanning fields at twice the frame rate prevents flicker in the image. Flicker arises when the time between re-illumination of the screen (screen 'refresh') is longer than the eye's persistence of vision (the time during which an image remains 'visible' after the source has gone). A flashing light or a screen which refreshes at a rate of 50 Hz or more is normally perceived as flicker-free (although flicker can be detected at this rate when the illumination is particularly bright or viewed in peripheral vision – try looking at a bright TV screen out of the corner of your eye).

During beam flyback (at the end of both lines and fields) the beam is switched off. This is known as 'blanking'. In fact, although the number of lines per frame is 625 in the European system, only 575 are used for picture information; 50 lines per frame, or 25 per field, are blank lines, carrying no picture information at all. Some of these blank lines are used to carry teletext information for receivers which have decoding equipment. These do not form part of the vision signal however.

Lines and image definition

The reproduction of photographs in newspapers uses a half-tone process in which the image is made up entirely of black and white dots, the greater the density of black dots compared with white, the darker is the shade of grey produced. Only by looking very closely, or with the aid of a magnifying glass, can this optical 'deception' be seen. The eye-brain complex has a limited resolution, or acuity. When two objects are small and close together, or a long distance away, they can not be seen as separate. The tiny black and white dots of the newspaper photograph thus merge into grey. The individual lines which make up a TV picture are similarly not visible provided that either the screen is not too big or the viewer is sitting sufficiently far from the screen. The optimum viewing distance is quoted in terms of the height of the screen and for a 625-line system is reckoned to be seven times the screen height. Any closer and the lines may become visible. Compare this with a computer monitor: the computer user generally sits much closer than a TV viewer, and so the resolution must be higher.

High-definition TV (HDTV) achieves its superior picture quality simply by increasing (to 1,250 under the European standard) the number of lines in a frame, squeezing more into the screen. Consequently the optimum viewing distance is between three and four screen heights, implying that either TV screens can be made bigger, or the viewer will be able to sit much closer!

The limited acuity of the eye is also vital to the operation of colour TV systems (see later section). In fact it is these various 'defects', the limited ability of

our eye-brain complex to resolve detail, or to detect rapidly changing light levels and the gaps between sequences of frames, that actually make TV viewing possible. A bird of prey typically has a visual acuity which is four times better than a human's; this may allow it to spot its prey from a great height, but it would have real problems watching TV!

Transmission of the TV signal

The amount of information contained in the composite video signal requires a large bandwidth for transmission. The baseband for the video is around 5.5 MHz and this signal is carried on a UHF radio frequency carrier. This large baseband places great demand on the available radio spectrum and therefore, in conjunction with other considerations such as the need to keep the cost of receiver equipment down, influences the choice of modulation technique (see below).

The old 405-line system (and the current North American 525-line system) required a smaller bandwidth because of the smaller quantity of information contained. The change to a 625-line system coincided with a change in frequency band used for transmission. The UHF band, with frequencies around ten times higher than the previously used VHF band, allowed more space for the increased bandwidth. As explained earlier, it was necessary to continue the VHF transmissions alongside the new UHF transmissions – after all, it would not be permissible to render obsolete the vast majority of existing receivers overnight. The need to maintain broadcasts for users of older equipment while introducing a new service was also important when the next major development appeared in 1967.

Modulation for television

Frequency modulation can not be used for television because of the huge bandwidth which would result. Even double sideband AM, as used in AM radio broadcasting, is considered too large (it would require an 11 MHz channel for the video alone, reducing still further the number of TV channels available). On the other hand, single sideband AM, the technique used in telephony, while saving on bandwidth, would require a more complex (and therefore more expensive) receiver to demodulate the signal (see pages 30–31). A compromise is vestigial sideband amplitude modulation (VSB-AM), in which one complete sideband is transmitted along with a small section (a 'vestige') of the other. The receiver circuits can then be less complex. So the modulated video signal's upper sideband (5.5 MHz) and a vestige of the lower sideband (1.25 MHz wide) is transmitted, giving an overall bandwidth for the video signal of 6.75 MHz.

In addition to the vision signal, the audio (sound) signal must also be transmitted. The overall transmission-reception system is shown in Figure 4.4. The baseband of the audio signal, at about 15 kHz, is very small compared with the video signal, so FM can be afforded for audio signal modulation (although AM is used in some countries). Its carrier is 6 MHz above the video carrier and the frequency modulated bandwidth is around 200 kHz, so there is no interference between the audio and video signals. The receiver contains two circuits tuned to frequencies 6 MHz apart to pick up the video and audio separately. The overall bandwidth then is around 7.35 MHz, and TV channels are separated by 8 MHz.

Figure 4.4

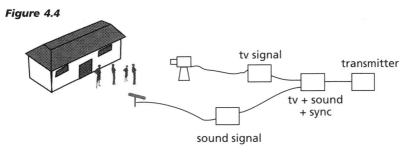

Television transmission. Sound and vision signals are combined with synchronisation pulses, and the carrier signal is then modulated ready for transmission.

Colour TV

The first colour television programmes appeared on BBC2 in July 1967. The operation of colour TV mimics the way humans perceive colour. Our eyes contain, in the retina, an array of light receptors, known as rods and cones. Rods are sensitive to the brightness of light, whereas cones are sensitive to colour. Each cone is sensitive to just one colour of light, either red, green or blue. These are known as primary colours; any colour can be separated into its primary components, and this is what the selective sensitivity of the cones does. The red cones respond to the red contained in the colour, the green and blue cones to their particular component. The nerve impulse sent to the brain depends on the quantity of light falling on each cone, so a colour which contains a lot of green but not much blue, for example, sends a stronger impulse from the green cones than the blue. It is the brain rather than the eye which re-interprets the combination of nerve signals into a colour, hence the use of the term 'eye-brain complex' in discussing vision.

This colour separation forms the basis of colour television production. A colour TV camera separates colours into their three primary components, red, blue and green, in exactly the same way as the cones in the retina. Dichroic filters or prisms are used to obtain a TV signal for each colour. Filters are materials which pass just one frequency of light (or, more accurately, a narrow range of frequencies). In a conventional tube camera, the light from the image is split by filters into three paths (one red, one green, one blue), each path directed onto its own target plate where it is scanned by its own electron beam. In effect the camera has three tubes, one for each primary colour, and so three separate vision signals are produced.

For reconstruction of the colour image in the receiver, the physiology of the eye-brain complex is again exploited. The limited visual acuity of human vision allows mixing of colour. If two separate colours are viewed from a distance, beyond the point of resolution, the perceived colour is the combination of the two components. This optical blending was used by artists at the end of the 19th century, particularly Seurat (1859–91), who developed a technique known as *pointillism*. He painted mosaic-like dots, separating elements of colour, and relying on the viewer's eye-brain tyo blend them. Exploiting the same phenomenon, a colour television screen is coated with adjacent dots or strips of different phosphors which each emit one of the primary colours, red, green and blue. Three separate electron beams strike the individual strips, each beam illuminating just

one colour of phosphor (Figure 4.5). Viewed from a distance, the primary colours emitted from the phosphors are mixed, and the resulting colour depends on the relative brightness of the three components. Go right up to a colour TV screen (taking a magnifying glass with you if you have one) and the separate phosphors can be seen.

The three electron beams in the TV receiver are each controlled by just one of the camera tube signals. Colour registration, ensuring that the three separate signals in the camera are in synchronisation with each other, is of utmost importance, as is convergence, synchronising the three signals in the receiver so that the colours are not offset from one another. This was a drawback of early colour sets – there might be green fringes around some images for example – and is still a problem with some large screen video projection.

The colour signal

The colour TV signal must satisfy two criteria if it is to be suitable for transmission: (a) it must be compatible with existing monochrome (black and white) receivers; (b) it must not take up any additional bandwidth.

To some extent, the second criterion is the reason for the first. If radio spectrum space were plentiful, there would be no problem in simply assigning colour transmissions to a different channel from monochrome channels. Then owners of existing mono receivers could continue to receive their broadcasts, and owners of new colour sets would tune to the new colour channels. However, as we know, the space required by a single TV transmission is already so large that the number of channels is limited. There was, in the 1960s, no question of allowing additional channels for colour broadcasting, or indeed allowing colour channels to be broader than the existing 8 MHz, hence the second criterion.

The solution to the problems posed by these demands was in part technological, taking advantage of continuing advances in electronics, but also, once again, exploited the limited acuity of human vision (see opposite).

Colour systems

There are three different colour signal systems in use around the world. Each employs a different technique for combining the colour signal with the

Figure 4.5.

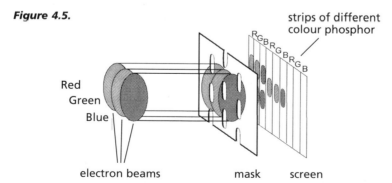

Colour television tube. Three separate beams, each controlled by the red, green and blue signals respectively, are directed at the mask. Because of the separation of the beams each beam only strikes the phosphor trip of the appropriate colour.

46

The colour TV signal
Compatibility – luminance and chrominance

The colour TV camera produces three colour TV signals, one each for red, green and blue (abbreviated to R, G and B respectively). Recombining them (encoding) produces the original brightness signal, which would be recorded by a single tube, black and white camera. This brightness is known as 'luminance', given the symbol Y, and forms part of the transmitted signal. The luminance signal is suitable for mono receivers; this is exactly the signal that was transmitted before colour broadcasting in 1967. In addition to the luminance, colour information is transmitted in the form of colour difference signals. These are signals representing the difference between the individual colour signal and the luminance (made up of all three). At the receiver the colour difference signals (R-Y), (G-Y) and (B-Y) are used with the luminance, Y, to recover the individual colour signals. In fact only two colour difference signals are required, since, by knowing Y, the remaining one can be worked out. The (R-Y) and (B-Y) signals are transmitted because green is, on average, the largest component of Y, so (G-Y) is the smallest of the three difference signals, and therefore most affected by electronic noise. These two colour difference signals are modulated by the encoding circuits into what is called the 'chrominance', or simply 'chroma' signal, which is then combined with the luminance signal for transmission. A colour receiver contains decoding circuitry to separate luminance and chrominance parts of the transmitted signal, whereas a mono set, lacking the decoder, is unable to separate the two signals. However, the colour signal generally causes little interference with the luminance.

Thus it was possible to begin colour transmissions for those with the new receivers without the vast majority of viewers noticing any difference in their black and white reception.

Luminance and chrominance bandwidths

The second restriction, that the colour signal should fit into the same channel bandwidth as the pre-1967 mono channel, seems on the face of it an impossible one. Since the signal contains the luminance (identical to pre-1967 transmissions) and additional colour information, it must surely require an increase in bandwidth. Certainly, if the luminance, with its baseband of 5.5 MHz, were accompanied by two colour difference signals of similar size, an overall bandwidth of at least 16.5 MHz would result. There are however two features which allow the colour signal to be contained within the existing 8 MHz bandwidth. First, the eye-brain system is not as sensitive to detail contained in colour as it is in brightness. In other words the definition of the colour part of the picture can be much lower than the definition of the brightness. When the brightness only is shown on a TV (ie the colour is switched off) the definition is reasonably precise. The colour information which is added on top can be relatively low-grade, without appearing to degrade the picture detail. So the colour information can be squeezed into a narrower bandwidth of about 2 MHz.

The second feature which helps further to restrain the bandwidth of the colour TV signal is the periodic nature of the luminance signal's frequency spectrum. Although the baseband of the luminance contains all frequencies from 0 to 5.5 MHz, most of the information by far is contained in the lower part of that range.

[continued on next page. ☞

> Towards the upper frequencies, not only does the size of the signal become less, it becomes concentrated only at certain frequencies (which happen to be harmonics, or higher multiples, of the line scan frequency). In other words, at the higher frequency end of the luminance signal there are gaps. By careful choice of a sub-carrier for modulation of the chroma signal, it can be arranged that the modulated chroma sidebands fall in the gaps of the modulated luminance signal. This is known as 'interleaving'. The way in which this choice is made and the techniques of modulating the sub-carrier with the chroma signal form the principal differences between the three systems of colour transmission, NTSC, PAL and SECAM.

luminance. NTSC (National Television System Committee) is the system in use in North and South America. It was one of the earliest colour systems, devised in the US in the early 1950s. It had problems with consistency of hue, and the initials NTSC came to be known unkindly as standing for 'Never Twice the Same Colour'. The PAL (Phase Alternate Line) and SECAM (Systeme Electronique Couleur avec Memoire) were developed in the 1960s, more-or-less in parallel in Germany and France, benefiting from the earlier American experience with NTSC. PAL is in use in the UK and most Western European countries, whereas SECAM is the system in France and Eastern Europe. The two systems are entirely incompatible, just as each is with NTSC, though programmes can be converted between systems.

Composite and component video

At its most basic, the video signal is made up of the three separate colour signals, which are then encoded into luminance and chrominance. Synchronisation signals are added. The resulting combination of these is a composite video signal, which contains all that is needed for transmission. On the other hand some special effects and other equipment act on just parts of the TV signal (eg chroma keys which lock onto just one primary colour) and it can therefore help to keep the various components of the signal separate. Of course the separate signals must eventually be combined before transmission, but this could take place at the end when all processing has been completed. This separate signal processing is called component video, and requires more wiring and sophisticated synchronisation to keep all signals in step. Some component systems keep all signals, R, G and B separate, others simply isolate chrominance and luminance. There is a general trend towards component systems, but obviously the two are incompatible, and therefore converting a whole studio from composite to component can be very expensive.

Camera tubes and CCDs

The traditional camera tube based on the 'cathode ray' electron beam and target plate is gradually being replaced with a different target, the charge-coupled device (known universally as the CCD), constructed from a semiconductor material which produces electric voltage in the presence of light. It is formed as a rectangular matrix of picture elements ('pixels'), the density of the pixels determining the resolution of the image, and the voltage produced by each pixel is read sequentially into an electronic memory. This sequence follows the normal

scanning pattern and rate of a tube camera. In effect then, the CCD operates in a similar way to the electron beam and target plate, but offers a number of advantages. First, it is compact. The CCD itself might be only a centimetre or two across, and since there is no need for an electron beam, there is also no need for heavy deflecting coils and related circuitry to steer the beam. Secondly, conventional pickup tube cameras suffer from a number of defects which CCDs overcome: for example, burning can occur in a picture tube when a particularly bright part of the image, over a sustained period, permanently damages the light-sensitive coating of the target plate; streaking occurs in high contrast images, so that when a camera pans across a floodlit football match, for example, the lights streak in 'comet tails' across the picture.

CCD cameras used to be expensive compared with pickup tube cameras. As semiconductor technology has in general become cheaper, so too have CCDs, and CCD cameras are nowadays almost universally specified by buyers of new equipment.

New developments in television technology

The latest developments in TV technology are provoking some of the same considerations which accompanied previous upheavals such as the launch of commercial TV or the change to the 625-line system. As ever, there is the difficulty of maintaining compatibility with users of existing sets, who are likely to remain the majority for many years. Some of these developments are highlighted here.

Widescreen TV

The existing aspect ratio (the ratio of picture width to height), at 4:3, is the same as that established at the inception of television, which corresponded more-or-less with cinema films of the day (on 8 mm or 16 mm film). It is a ratio which was felt to give an approximate replica of the way in which we view the world. Movies are, of course, now usually made on 35 mm or 70 mm film with a wider aspect ratio, which results in the 'letterbox' effect when they are broadcast on television: the appearance of the black bands at the top and bottom of the TV screen which are necessary to accommodate the width of the film. As a result the TV image is smaller than the TV screen size.

This, in part, has prompted some in the TV industry to consider a wider aspect ratio for all TV production, using a ratio of 14:9 or 16:9, in effect a picture between 16 and 33 per cent wider. Many TV cameras now have a switch which allows shooting in either 4:3 or 16:9 formats; a system for broadcasting widescreen TV, known as PALplus, has already been developed, and an increasing number of television programmes are being produced in widescreen format. These have so far tended to be drama serials, programmes which may well in fact be shot originally on film, and often have a long shelf life, with repeat showings likely for some years. There may also be more subjective, stylistic influences at work, with the widescreen format creating an association with the prestige of feature films. This last reason may also explain the growing number of advertisements which have adopted the format.

Of course, the result of making TV programmes in widescreen is that more and more TV programmes are being letterboxed for broadcasting (since almost no viewer yet possesses a widescreen receiver). Ironically therefore, the consequence is that a development which is being promoted as an enhancement to

the viewing experience is in fact the opposite, a reduced picture size. On the other hand, if the vast majority of programmes are to be made in 4:3 for the foreseeable future, why should anyone rush out to spend a large amount of money on a widescreen television set? As movie mogul Samuel Goldwyn is alleged to have said, 'A wide screen just makes a bad film twice as bad'.

High definition television

HDTV is not the same as widescreen TV, although all HDTV systems currently under development also use a widescreen aspect ratio (16:9). As its name implies, high definition television involves increasing the number of lines in the TV picture. The goal, voiced by some in the HDTV business, is to achieve a picture definition on a par with 35 mm film, though few argue that this has yet been achieved. Competing developments have been underway; the Japanese and US developments have favoured using 1,125 lines in place of the 525 lines in their present NTSC system. The European Union's Eureka programme has opted for 1,250 lines, twice as many as the present 625, raising again the prospect of a number of different standards in operation around the world. Some commentators argue that the reason for the agreement on a different standard in Europe is motivated by a fear of domination of the market for new HDTV equipment by Japanese electronics companies.

The problem which prevents the broadcasting of HDTV signals is the increased bandwidth which would obviously be required. Twice as many lines, each line being up to 30 per cent longer, results in much more information, and it is widely accepted that HDTV will not begin until digital television broadcasting is established with its bandwidth reducing techniques (see next chapter).

Again, the difficulty from the producers' and manufacturers' points of view is how to persuade viewers to buy HDTV receivers, which will inevitably cost more than 625-line sets. It may be that the availability of more channels through digital broadcasting will allow the dedication of specific HDTV channels, in the same way that the 625-line system's introduction was accompanied by the launch of a new service, BBC2.

Other developments

Other recent developments in television broadcasting technology include the new delivery systems, cable and satellite, and digital broadcasting, covered in a later chapter. Exciting though all these developments may be to TV companies and equipment manufacturers, there is less evidence that they are eagerly anticipated by the majority of the viewing public. Cable and satellite take-up has been much less than expected, and even when the service has been adopted viewing of satellite and cable channels is similarly low. Williams anticipated the emergence of many of these technological developments more than twenty years ago and warned then of a conflict between the aims of the 'tools of the long revolution towards an educated and participatory democracy...' and 'the tools of what would be, in context, a short and successful counter-revolution, in which...individual and collective response...became almost limited to choice between their programmed possibilities' (1990, p.151). That conflict continues today.

5 Digital signals

Digital communications technologies are increasingly replacing their analogue counterpart, from mobile phones to studio editing equipment, from domestic audio to broadcasting technology. Watkinson puts it bluntly: 'analog equipment can no longer compete economically, and it will dwindle away.' (1994, p.7). The term 'digital' is, however, being used increasingly to mean more than a mere technical description, it is assuming a cultural significance; 'digital' encompasses, in some views, not just up-to-the-minute technology, but also a host of implications for society, a new 'digital age'. So in the first UK edition of *Wired* magazine, Louis Rossetto feels able to write 'the most fascinating and powerful people today are not the politicians or priests, or generals or pundits, but the vanguard who are integrating digital technologies into their business and personal lives, and causing social changes so profound their only parallel is probably the discovery of fire'. This and others like it are indeed grand claims for a technological development that has now been around for several decades (the analogue-to-digital conversion process known as pulse code modulation was developed some 50 years ago). What do such commentators mean by 'digital technologies', and what is it in their digital nature that imbues them with such powers? It is worth examining exactly what this technology is.

Analogue and digital signals

Most physical phenomena, including sound and light which are fundamental to the communication process, are analogue in nature. Sound can convey an infinite number of variations in quality (tone) or quantity (volume). Light can be bright or dull, and can be 'any colour under the sun'. Equipment can be designed to reproduce this variability: the volume of the sound from a hi-fi can range from silence to very loud and can reproduce the whole range of frequencies in

51

music; the light in a room which is controlled by a dimmer switch can be set anywhere between its two extremes. Sound and light are thus analogue in nature in that they are infinitely variable (between maximum and minimum limits, in the case of their reproduction). On the other hand a light which is controlled by a simple switch can be in one of just two states – on or off. This is a digital arrangement – the light can not be set anywhere in between on or off.

In the same way, an electronic signal in an analogue communication system will take a voltage which can be any value in between some maximum and minimum. The value it adopts will in general reflect the state of the physical quantity it represents – a bright light would produce a bigger signal than a dim one, for example. The signal is thus an electrical 'analogue' of the physical quantity. The signal in a perfect analogue system can therefore represent every possible value of an analogue quantity such as light or sound.

The electronic signal in a *digital* system, however, is designed to take only one of a limited number of values (in fact, often one of only two). So obviously the digital signal can not directly represent the physical quantity in the same way as an analogue signal. Nevertheless, information communicated through a digital system does have advantages for processing and storage. These include speed of processing, less susceptibility to distortion by noise, any errors which do occur can often be detected and rectified, and, importantly, digital signals used in communications technologies are compatible with the digital signals used in computing technology. These advantages have provided an incentive to develop ways of communicating analogue information using digital signals.

Using digital signals to represent analogue quantities

Although a digital signal can not *directly* represent an analogue quantity, we all know that a digital device such as an audio compact disc is able to reproduce excellent quality sound, an analogue quantity. The process by which this is achieved is known as 'encoding', or just 'coding'. Coding was in fact used in the earliest days of electrical communication in the form of Morse Code, which uses a sequence of dots and dashes to represent letters of the alphabet.

To see how coding allows the digital representation of analogue quantities consider again the example of the room light controlled by a single on/off switch. In that example there were only two possible levels of light in the room. In most rooms however it is usual to find several lights, each with its own switch. In this case it is possible to select several different light levels by turning on a different number of lights, and the more lights there are the greater the number of variations in light level which can be set. With enough light switches, each one a simple on/off switch but independently operated, there would be enough light levels available that the variability could almost match the sensitivity of a dimmer switch. Thus a *series* of digital switches together can reproduce a variable analogue quantity – this is the essence of coding. Different combinations of on/off values (or switches) can be used to represent many different states (see Appendix 2).

Most electronic systems use a so-called binary system in which each signal (or 'bit', from binary digit) can, like a single light switch, take one of only two values, labelled 1 or 0. Again, a series of bits can, between them, represent a greater number of values. In the binary system, each bit in a sequence has twice the value in the coding process as the previous bit. (This is equivalent to each light switch in a room controlling a lamp which is twice as bright as the next

lamp.) This has the consequence that if there are eight bits used for coding then 256 different levels can be represented. (If there were eight light switches, 256 different light levels could be chosen.) With more bits used in the coding the number of levels increases rapidly – ten bits gives 1024 levels, and 16 bits allows 65,536 values. So a number of these signals, each of which can itself only have two different values, can *in combination* represent a vast number of signals, in a similar way to an analogue signal. CD audio, for example, uses 16 bit coding. So the sound that is processed at any one time can take one of 65,536 different sounds – enough variability to make it sound as good as analogue.

The advantages of digital signals

Obviously there must be good reasons for going to the trouble of turning analogue signals into digital. Digital signals offer a number of advantages. Many derive from the inevitability of 'noise' in electronic systems (see next page), others from the compatibility of digital signals with computer processing power.

The 'problem' of noise

Despite the theoretical technical treatment which can be given to electronic noise, it is in fact a very subjective matter. Certainly, if the noise included with a signal becomes so great that the information in the communication system is masked before it is received, then there is too much noise. But who is to say whether the noise associated with vinyl records is such a problem that people will now only accept CD quality audio, as some claim? Indeed not long ago it was a widely held view that any studio recording would inevitably debase the quality and realism of a performance because the use of splice editing allowed a reduction in noise and 'mistakes' (see Glenn Gould, 1966, for a response to this argument). Is it reasonable, therefore, that Peter Powell should find it 'a little sad that, with higher-definition television broadcasts but a few years away, the average viewer seems to be quite content with the picture from a well-worn VHS cassette' (Powell, 1994)?

Nevertheless, the reduced susceptibility of digital signals to corruption by noise has further advantages for the design and performance of digital communications systems over their analogue counterpart:-

Speed

It is easier, and therefore cheaper, to design an electronic system which will merely distinguish between two widely-spaced, approximate values than to discriminate between fine variations in signal level. It is a bit like being asked to guess someone's age – it is (usually) easier and therefore quicker to decide whether someone is closer to either their twenties or their fifties than it is to judge their age to the nearest year. Furthermore, if this guessing game operated in exactly the same way as a digital system processed electronic signals, one would never be asked to judge the age of anyone in their thirties or forties, making it easier still. So digital electronic systems can be designed to process information much faster than analogue.

Faithful reproduction

When an analogue signal is recorded it is inevitable that noise is recorded with it. If it is re-recorded, the original noise is indistinguishable from the original

What is noise?

Previous chapters have described some of the processes involved in electronic communication. The initial conversion at the input is followed by numerous electronic processes such as amplification, modulation and multiplexing. The actual transmission may be carried out over great distances before further amplification, demultiplexing and demodulation takes place on reception. Finally, there is a conversion process to render the electronic signal meaningful.

Unfortunately the system does not perform perfectly. The initial conversion into electronic form and final conversion into sound or image are not completely faithful. The devices used today are far better than in the early days of electrical communication, although the principles behind sound and light conversion are more or less the same. Other impediments to perfect performance arise from the fact that the electronic signals in the system are not the only ones around. There is a host of other sources of interference which can affect the quality of the communication process. These unwanted additions to the signal are known collectively as electronic 'noise'. This term is used because it can literally produce noise in an audio system – the hiss or rumble heard in poor quality tape and turntable systems, for example, or the interference in some radio reception from other stations or from lightning in thunderstorms. Noise also manifests itself in the visual quality of a picture: interference ('ghosting' or 'snow') in a TV image in areas of poor reception, the degradation of picture quality in VHS video compared with broadcast quality and so on. Noise affects an electronic signal at every stage of the communication process, and its effects are cumulative. In many parts of the system, the information signals are very small, and so it does not require much noise to corrupt the signal. It is not possible to eliminate the sources of electronic noise; some is inherent to electronic devices, others, such as lightning, are natural in origin and not controllable. However there are a number of technical measures which can be taken to reduce the effects of noise, either in the design of the electronic circuitry or by screening and shielding the circuits from the noise sources.

The use of digital signals gives a major improvement in noise reduction. Noise affects the value of a signal, whether that signal is analogue or digital. Noise on an analogue signal corrupts the value of that signal, because analogue quantities can present any voltage as a valid representation. A shift in that value due to noise would therefore also represent a valid, although distorted, signal level. In an analogue system it is not possible to distinguish a noise-affected signal from the original signal. On the other hand, a digital signal is confined to one of two electronic values, commonly 5 volts and 0 volts (abbreviated 'V'). Any noise will certainly shift the voltage away from these values, yet the voltage will still be easily recognisable as being either closer to 5 V than to 0 V or vice-versa, unless the amount of noise becomes excessive (Figure 5.1).

signal, and is effectively part of the new signal; further, on re-recording additional noise will also be recorded. Thus at each recording stage extra noise will be introduced into the system and multiple copying of an analogue signal invariably results in a loss of quality, to the point where it can become unacceptable. This is known as 'generation loss'.

When a digital signal is recorded it too will include noise which has been picked up somewhere in the system. However, a digital signal is clearly identifiable, even in the presence of noise, as either a high value or low one; for exam-

ple, in a typical system operating with 5 volt and 0 volt signals, a noisy 4.8 V is clearly a 'high' voltage which should really be 5 V. The electronics can be designed to identify the signal and regenerate an exact, noise-free signal before recording it; on copying *that* recording a similar noise removal process can take place. In this way each new recording is as accurate as the original, and new generation copies can be made indefinitely. As an example consider the traditional (analogue) photocopier. A photocopy of a photocopy of a photocopied document can become illegible, or at least degraded, whereas multiple copying of a similar document as a digital computer file causes no degradation at all.

At the root of all these advantages lies the fact that the signals in a digital system do not have to be precise; a voltage only needs to be identifiable as a digital 1 or 0 to be processed. If it is this feature which gives a digital communications system the advantages listed above, then the application of computer processing techniques to digital communications signals presents a number of additional possibilities which have no equivalence in analogue systems.

Digital signal processing

Computer technology operates using digital signals. Therefore if communications signals are digitised they can be processed using computer technology since it is relatively easy to adapt digital equipment to connect together (or 'interface'). Thus all the processing power which has been developed in computing over the decades is available to digital communications. Some of the processes which are possible will be discussed in the *Digital audio and video* section of this chapter, but one or two are mentioned here.

The first is error detection and correction. It was indicated earlier that, although digital signals are far less susceptible than analogue to corruption by noise, if the noise is great enough, the value of a digital signal could be changed. However, since a digital signal can only be a 1 or 0, if a bit is found to be in error, reversing its state must, by definition, correct it. This correction is impossible in an analogue system. There are various mathematical techniques available which (again, using computer processing) enable a sequence of bits to be monitored and checked for errors. This can involve including additional data with the signals, sometimes referred to as 'adding redundancy' since this data does not

Figure 5.1

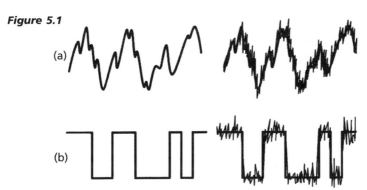

(a)

(b)

The effect of noise on (a) an analogue signal and (b) a digital signal. Some of the detail of an analogue signal can easily be masked by noise, limiting the accuracy of reproduction. A digital signal, however, can still be correctly interpreted even in the presence of a substantial amount of noise.

actually contain any additional information; indeed, Talbot-Smith indicates that as much as one-third of the working area of a compact disc is used for error correction, with the result that, 'in theory a hole some 2 mm in diameter could be drilled through the playing surface without being audible' (1990, p.184). Practical investigation by this author confirms this to be the case!

Similar mathematical processing allows encryption of digital signals. One of the selling points promoted by suppliers of digital mobile telephones is the security from eavesdropping which digital encryption grants.

Digital processing enables very fast switching of signals and, by adding extra data bits containing information about its destination, 'packet switching' can be employed in networks (see Chapter 9). This is an efficient and rapid way of sending information through communications systems.

Converting analogue information into digital signals

The representation of analogue quantities by digital signals employs a process known as pulse code modulation (PCM) which consists of three stages: sampling, quantisation and coding.

Sampling

An analogue electrical signal is just that, an electrical representation of the state of a physical quantity, so if that quantity changes the electronic signal should change in response. For example, the voltage produced by a microphone will be continuously changing in value according to the level of sound falling on it. Converting that analogue signal into a digital signal results in the transmission of a sequence of bits (a 'bitstream') instead of the continuously varying analogue electrical signal. The analogue quantity is measured at evenly-spaced time intervals and the conversion and transmission takes place during the time in between. This repeated measurement is known as 'sampling'. By only taking measurements at particular moments it might seem that any changes in between samples might be missed out. This would certainly be the case if insufficient samples were taken. However it is necessary to remember that all signals have a limited bandwidth – there is always some maximum frequency which needs to be recorded or measured; anything above that can be left out. So for a telephone speech signal, no frequencies above 3,400 Hz are transmitted. It is only necessary to sample at a rate which is at least twice the highest frequency present in the signal to be sure

Figure 5.2

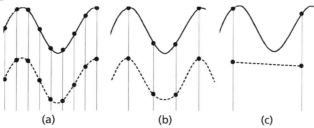

(a) (b) (c)

Sampling rate. (a) A high sampling rate allows the signal to be re-drawn by, in effect, joining the sample points. (b) The minimum sampling rate is twice the highest frequency that is required to be recorded. (c) If the sampling rate is too low for the desired frequency, variations in the signal level will not be recorded.

of recording all the changes (Figure 5.2). This is Nyquist's Theorem. Thus a telephone signal is sampled 8,000 times a second. The audio bandwidth for radio broadcasting is around 15 kHz, and so the sampling rate for broadcast audio applications is 32 kHz. High fidelity music, which can contain frequencies approaching 20 kHz, must therefore be sampled at a frequency of at least 40 kHz; in fact the standard for CD audio is 44.1 kHz. A further standard audio sampling rate of 48 kHz is used in some applications such as digital video (Watkinson, 1994, p. 37).

Quantisation

Once an analogue signal has been measured, or sampled, its value must be quantised. As stated earlier, a sequence of digital bits allows a number of different levels to be represented. The number of those levels depends on how many bits are used for each measurement. For example, if only three bits are used to code each sample, just eight different values can be represented by combinations of those three bits. So any measurement of an analogue signal would have to be allocated to one of these levels – the level that is closest to the measured value of the signal. This is quantisation – making the measured signal, which could take any value since it is analogue, fit one of the available levels. So if a microphone, for example, produced voltages which could be anything between 0 V and 4 V, it might be that a sampled voltage which measured between 0 V and 0.5 V would be allocated to the first level of an eight-level system; any voltage between 0.5 V and 1.0 V would be quantised to the second level and so on so that the whole range of the analogue signal could be allocated to one level or another (eight levels with 0.5 V gaps between them covers the total range of 4 V).

Quantisation error

The example given above illustrates a fairly crude quantisation process; the microphone voltage could vary by almost as much as 0.5 V without any change being registered by the quantisation process. This could represent a substantial variation in the sound, which would be missed out completely. Thus after processing, the sound reproduced from these quantised samples would be quite different from the original source. This is known as 'quantisation distortion' or 'quantisation error' since it is a direct consequence of the quantisation process.

Using more bits in the coding process increases the number of levels which are available to the quantisation process: eight bits offers 256 levels; 16 bits allows 65,536. If this many levels were used to quantise the 0 to 4 V range of the microphone, then voltage changes would have to be smaller than 0.00006 V before they might be missed. This 'error' represents a very low level of distortion, much less than that inherent in most analogue systems. Thus quantisation distortion is reduced as the number of bits used for the digital conversion is increased, to the extent that the actual value of the analogue quantity can be represented virtually exactly.

Nevertheless, some distortion might be acceptable in some applications; in the same way that analogue telephone signals are deliberately distorted by limiting their bandwidth in order to increase channel capacity, quantisation by four-bit coding might be used instead of the more faithful eight-bit coding on similar grounds of economy. Telephone speech is still intelligible after two-bit and even one-bit coding.

Coding

Each of the quantisation levels used in the conversion process is represented by a unique digital code. In the example above of the crude, three-bit process, the first level might be given the code 000 (low, low, low), the second 001 (low, low, high), the third 010, then 011 and so on. So the digital signal produced by the conversion process would consist of a sequence of digital pulses which were either high or low in value, and each string of three would represent the quantised value of one sample of the sound. This is illustrated in Figure 5.3. If this three-bit system was processing samples at a rate of 44.1 kHz, there would be three bits produced 44,100 times every second ie a total of 132,300 bits per second (bps). A higher sampling rate, or a system using more bits for coding, would require an even greater bit rate. The digital coding process then results in a large quantity of data, which requires an appropriately broad bandwidth for transmission, much greater than the original analogue signal's bandwidth. All the advantages gained by digitising analogue signals then are at the expense of a dramatic increase in bandwidth requirement. Nevertheless, there are ways of overcoming this problem and these will be described in the next section.

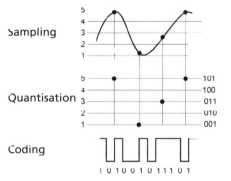

Figure 5.3
Analogue to digital conversion. The sequence of sampling, quantisation and coding produces a stream of on/off pulses. This diagram illustrates 3-bit coding of four samples, resulting in a stream of twelve bits, 101/001/011/101, representing the codes of the quantised sequence of samples values 5, 1, 3, 1.

This analogue-to-digital conversion can be operated in reverse: a digitised audio signal, for example from a CD, must be converted to an analogue signal to produce sound from a loudspeaker. A digital-to-analogue converter (DAC) simply reads the sequence of digital codes which have been transmitted, and generates the sequence of signal levels from those codes. It is clearly important that the DAC generates these signals at exactly the same frequency as the sampling rate which was used in the original recording process, hence the need for agreed standards between equipment manufacturers.

Digital audio and video

Analogue audio and video signals, like any other signal, can be digitised as described above, but it is only recently that digital audio and video equipment has started to become the normal specification in the industry. In the consumer sphere, the only widespread appearance of digital technology is the compact disc player which is slowly taking the place of the vinyl record playing turntable. Other equipment such as audio tape and video cassette recorders are still almost universally analogue.

One of the reasons for this is that digital data storage capacities and computer processing capabilities have only recently become sufficient to handle the

vast quantity of data produced by digitisation. Consider digital audio as an example: the sampling rate is 44.1 kHz, and 16-bit coding is used. Thus 16 bits are generated 44,100 times every second – a bit rate of 705,600 bits every second. Stereo audio will require roughly twice this and, with additional data added for the purposes of error detection and correction, the final bit rate could easily be around 2,000,000 bits every second, or 2 mega bits per second (Mbps). To transmit this bit rate would need a bandwidth of perhaps 1 to 2 MHz, an increase of a factor of about ten compared with a high quality FM audio bandwidth of approximately 200 kHz. Remember that bandwidth is already in heavy demand!

The problem is still more marked when considering video. To transmit full motion video using eight-bit coded digital signals would require a bandwidth approximately 30 times greater than the current 8 MHz channel width. The quantity of data produced by digitising video is enormous. A single frame lasting one twenty-fifth of a second of full motion video could take several minutes to transmit using a typical fast modem, so clearly transmitting real-time video in this way is impossible.

Data reduction

There are several possible solutions to the high bit rate required for digital video: one is to reduce the quantity of information in each frame; many video clips in, for example, multimedia computer systems are restricted to a small window simply to reduce the number of pixels (picture elements) per frame. The frame rate (the rate at which the picture is replaced on the screen) can also be reduced, so-called 'slow-scan video', which again reduces the quantity of data required. This is applied in videophone and video conferencing systems, and results in clearly noticeable jerky movement. The number of brightness levels and colours permitted can be restricted – eight bit coding allows 256 brightness levels, for example, whereas if only eight brightness settings are necessary, then three-bit coding may be employed.

Each of these solutions is crude, resulting in a significant deterioration in picture quality. This may be suitable for a short videophone conversation, or a few seconds of multimedia video, but would not be acceptable for full screen, full motion video. Some other method must be found of reducing the quantity of data. Several data reduction or compression techniques have been under development and standards are emerging. The essence of these techniques is that in any one frame, or in a sequence of frames, it can be more economical to record a sample of the frame and then merely record changes between pixels or between frames. For example, in a long, lingering landscape shot, half of the frame may be blue sky with only a few variations in hue, and this situation may persist for many frames. It is possible to sample the blue sky just once and then to send with that sample coded instructions defining the number of lines and frames for which to repeat this sample value. One sample and a few bytes of instructions (a byte is a combination of eight bits) could replace many hundred samples; compression ratios of more than 100:1 are possible without significant degradation in quality.

Compression standards: MPEG and JPEG

Standards for motion video have been developed by the Motion Picture Experts Group (MPEG), a group set up by the ISO (International Standards Organisation) and the CCITT (International Telegraph and Telephone Consultative

Committee). MPEG1 is a high ratio compression standard (up to 200:1) developed for storage of video on compact disc, offering a picture quality comparable with VHS; MPEG2 offers a 25:1 compression ratio for high quality digital video, which will be used in the industry. A similar group, the Joint Photographic Experts Group (JPEG), has developed compression standards for still images. Compression techniques for audio also exist, but, because audio produces much less data than video, compression is less critical and those techniques which do exist generally operate at low compression rates. For example CD audio uses no compression, yet allows over 70 minutes of playing time. Sony's Minidisc uses 5:1 compression resulting in a smaller disc with the same playing time. Philips' Digital Compact Cassette employs 4:1 compression.

Digital editing and digital video effects

Digitised audio and video signals can undergo post-production processing in the same way as their analogue counterparts, and are also amenable to manipulation in ways that are not possible with analogue equipment. The normal editing procedures are complemented by the Digital Video Effects (DVE) machines. Disk-based editing is rapidly replacing dub editing in video production. The digitised video material is stored in a framestore (usually temporarily rather than permanently) which contains an array of disks or RAM memory chips (see Chapter 7). These storage media are random access – the frames can be called up in any sequence, removing the continual spooling associated with video tape dub-editing. This is referred to as 'non-linear editing'.

A further advantage of digital editing is that there is no regeneration loss. Sequences of frames can be edited over and over without degradation of the image quality. There is no need, in principle, for separate on-line and off-line editing.

DVEs include contouring and posterising, which change the brightness or colour of an image, and effects such as morphing which alter its size or shape. The first category can be achieved by simply reducing the number of bits used in coding the video signal, thus imposing a much cruder quanitsation process. For example reducing the number of bits in the luminance signal from eight to three limits the brightness to one of eight rather than one of 256 levels, giving the image the appearance of a graphic (contouring); the same technique can be applied to the colour difference signals with the result that colours take on an unnaturally enhanced hue (posterising).

Effects which change the size or shape of an image are achieved by giving each pixel of the image a unique address (for instance each might be identified by its line number and column number). It is then possible to enlarge, reduce, rotate or distort that image. These effects are in fact implemented by a sequence of mathematical operations on the pixel addresses. These mathematical routines are stored in the DVE machine's software as standard effects in exactly the same way that a computer graphics package will have routines built into its software for drawing an object such as a box, or filling the box with colour. The operator can control the effect, for example the degree of distortion or the rate at which it occurs, without needing to call up a long list of commands each time.

The use of computer technology in video production is increasing all the time, with a consequence that many of the traditional broadcasting equipment manufacturers are finding themselves in competition with computer manufacturers. Computer software and hardware manufacturers now offer so-called desktop

video packages, which, based on a desktop computer, in effect emulate a simple digital editing suite. It is, however, important to recognise that the quality which results from video post-production is more a consequence of the skill of the operator than of the technology itself. Special effects are still special, whatever technology is used to produce them; they take a great deal of time, and therefore expense, to create. There are still many applications where digital video effects have little relevance. By far their most popular application has been in music video and advertising, where, from the producer's point of view, it is important in the short time available to make an impact on a viewer who is likely to be otherwise engaged (after all, not many of us *actively* seek out the advertisements on TV). It is also these types of material which are invariably chosen by the manufacturers to demonstrate their product.

Digital broadcasting

Digitally coded audio and video presents the possibility of digital broadcasting. This offers all the familiar advantages over analogue signals: improved resistance to noise as the signal strength declines with distance from the transmitter; error detection and correction techniques; the use of compression techniques to reduce the bandwidth required and therefore permit more channels. Digital data compression techniques also offer the only real means by which HDTV may be broadcast – its bandwidth would, at 30 MHz, be otherwise prohibitively large.

Appealing though these developments are to the industry (attracted not only by the increase in programming capacity, but also the opportunity to sell a new generation of television technologies to what is perceived as an eager audience) the lessons from satellite and cable take-up and viewing research suggest that, from that same audience's viewpoint, more does not necessarily mean better, a point acknowledged by some analysts (for example Marmion, 1995).

The digital future

Digital equipment is in widespread use in the communications industry, and virtually all new and replacement equipment will be digital. Nevertheless there is still much professional analogue equipment in service: much of the telephone system is analogue; radio and television broadcasting is analogue; in many radio stations editing continues to be carried out using razor blade technology. In the domestic arena the most widespread example of a digital technology is the CD player. Even so, in 1995 fewer than half (47 per cent) of households owned a CD player, compared with 77 per cent ownership of an (analogue) video cassette recorder and 99 per cent ownership of an (analogue) TV receiver (Central Statistical Office, 1995). So, while much of this analogue equipment will eventually be replaced there is still a long way to go before analogue technology becomes obsolete.

'Digital' is of course a metaphor adopted by those who claim that the current developments in communications technology (whether digital or analogue, presumably) represent a fundamental change in the nature of society. The electric telegraph of 150 years ago was, in essence, a digital communications device which similarly excited speculation as to the changes it would bring in its wake. Samuel Morse, for example, wrote in terms which anticipated by more than 120 years McLuhan's 'Global Village': he believed it would not be long 'ere the whole surface of this country would be channeled for those nerves which are to dif-

fuse with the speed of thought, a knowledge of all that is occurring throughout the land; making in fact one neighborhood of the whole country' (quoted in Carey, 1989, p.207). The telephone represented a significant advance over the telegraph in the contemporary technology of communications, yet it was an analogue device. The first digital computer was demonstrated to a television audience more than forty years ago (Shurkin, 1984, pp.250-252). It would therefore be mistaken to view 'digital technologies' as either conceptually new or necessarily uniquely powerful.

6 Audio-visual distribution systems

This chapter is about the three methods of television broadcasting: terrestrial, satellite and cable transmission. Other communications systems, such as radio, telephony or data communications use similar transmission methods, so much of the material is equally applicable to these. While all three distribution systems share the common facility of delivering television pictures to homes, and this is currently their principal function, the technical differences between them suggest a number of different possibilities for their future development as general information distribution systems.

Terrestrial transmission

This is the television delivery technique with which we are most familiar, and is used additionally in radio broadcasting and telephony. The signal is carried on radio waves which travel between transmitter and receiver via line-of-sight paths, or involving one or two reflections off the upper atmosphere in the case of some radio transmissions (see Chapter 3). The frequencies used for television broadcasts lie in the UHF band (the VHF and SHF bands are used for radio and telephony respectively), and only a limited number of channels can be accommodated. The limited range of UHF transmissions (typically 50 km, but this is very much dependent on terrain and transmitter power) means that in the UK around 1000 transmitters are used to provide services to 99.4 per cent of the population.

An advantage of the limited range is that it permits local programming, although in the UK television programming is more regional than local. The BBC operates separate television services for Scotland, Wales and Northern Ireland, while England is divided into three regions which between them broadcast a total of nine different early evening local news programmes. Independent

television (ITV, also known as Channel 3) is operated in 14 geographical regions by 15 television companies (two companies sharing the London region). Like the BBC, these companies broadcast regional news programmes, but also buy and sell programme material amongst each other, so that much of the output is in fact broadcast nation-wide.

Channel 4 (C4) is a national service, although S4C in Wales broadcasts a significant number of Welsh language programmes in place of C4 output. Unlike the other broadcasters, C4 makes none of its programmes itself, instead buying from other companies or commissioning from independent producers.

The successful bid for the licence to operate a new commercial UK channel was announced in October 1995. Channel 5 serves as a useful illustration of the limited bandwidth available for television broadcasting, sometimes referred to as 'spectrum scarcity' (Channel 5 will be the only UK terrestrial service which is not required to reach the whole population). It was originally allocated two unused UHF channels, 35 and 37, which would enable it to reach around 75 per cent of the population. However, in July 1994 the Department of National Heritage announced that channel 35 was to be reserved for digital TV broadcasting, and Channel 5 would only be broadcast on channel 37, reducing coverage to 50 per cent of the population. It is currently anticipated that, by reaching agreement with neighbouring countries, coverage may in time be extended to 70 per cent of the population. Further complication lies in the fact that the channel used by most home video recorders, channel 36, may be subject to interference from Channel 5 transmissions, and the licence holders have had to undertake to re-tune all such equipment in areas which would receive Channel 5 broadcasts.

Spectrum scarcity is also the reason why current terrestrial transmission is not seen as a feasible way of introducing high definition television. HDTV signals, under the existing PAL system, would require a bandwidth of up to 30 MHz compared with the current channel width of 8 MHz (Watkinson, 1994, p.2).

Digital terrestrial broadcasting

Digital television broadcasting (known as digital terrestrial transmission or DTT), will bring a number of changes to terrestrial reception. It will provide better picture quality in areas where reception is currently poor, such as hilly areas or isolated communities. It will also allow terrestrial transmission of HDTV signals, since digital techniques allow its bandwidth requirement to be reduced. For the same reason digital broadcasting will also increase the number of terrestrial channels. The original plan, to use channel 35 for DTT, was expected to allow up to twelve new TV channels; the current expectation is that six new frequency channels will be made available, each capable of carrying up to six multiplexed TV channels, which should ensure capacity for at least 36 new TV channels. The Department of National Heritage has agreed to allocate the BBC its own multiplex, which has announced that it intends to broadcast both BBC1 and BBC2 in widescreen format and introduce additional channels on its multiplex, beginning trial digital transmissions in the summer of 1996. The existing independent broadcasting companies (including Channel 5) will each control half a multiplex, and all existing terrestrial broadcasters will be required to transmit their analogue output simultaneously in digital format ('simulcasting'). The six new frequency channels have been found by 'interleaving' alongside existing analogue channels (the lower power transmissions possible with DTT allow the use

of these so-called 'taboo' channels without the danger of interference). This leaves channel 35 free for possible future use, avoiding for the present any potential interference with video recorders and other domestic equipment.

In a debate with echoes from the past, the issue of maintaining compatibility with users of existing receivers has arisen. If the existing PAL transmissions were switched off, a large number of television frequencies would become available, allowing for the possibility of more than a hundred terrestrial TV channels. Most of the industry is keen for the government to give a definite date for PAL switch-off. However, that would require all viewers to have replaced their receivers or at least obtained a set-top decoder in order to continue to receive broadcasts, and from a government's point of view, to name the day for the ending of PAL transmissions, and therefore to commit all viewers to significant expenditure, would not be a popular option. Indeed the size of the audience for the existing multi-channel satellite and cable services suggests that the majority of viewers are not clamouring for more television channels and so the rate of change may be slow. In an effort to speed up the changeover, the British Government, like that in the United States, is considering subsidising viewers' purchase of digital decoders (Bannister, 1996; US Plans, 1995).

Satellite broadcasting

Instead of transmitting a television signal direct from transmitter to a receiving antenna, satellite broadcasts travel an indirect route. The use of satellites for telecommunications has been covered earlier (Chapter 2) and their role in international television links for television production was also considered; the TV signal is transmitted from a source (either a studio or a mobile system) to a receiving studio, often for editing before subsequent broadcasting. In this capacity the satellite serves simply as a link, like any other, in a point-to-point communication process. Satellite broadcasting however differs in its aim; the role of the satellite here is to deliver the television broadcast ready for reception and viewing on TV receivers in exactly the same way as in terrestrial broadcasting. The TV signal is carried on a radio wave, as in terrestrial broadcasting, although a higher frequency band is used, the super high frequency (SHF) band rather than UHF. Radio waves at these frequencies are commonly known as microwaves.

The development of broadcasting by satellite began as a means of delivering programmes to cable TV companies. The US movie channel Home Box Office (HBO), some twenty years ago in 1975, was one of the first to offer this type of distribution. The cable company required a large receiving dish directed at the broadcasting satellite, and the received signal was then relayed through the cable network to subscribers. This was an efficient way of transmitting TV programmes to a large number of companies spread over a wide geographical area, exactly the situation in the United States where cable TV services were already in place in many cities, and this new type of service may well have helped spur the further growth of cable in the US (Mirabito, 1994, p.96). In 1977 there were 500 cable companies with suitable satellite receiving dishes, but by 1982 this number had increased tenfold; during the same period the number of US households connected to cable doubled (Negrine, 1994, p.180). A similar satellite cable arrangement, though on a smaller scale, might serve a smaller community such as the occupants of a block of flats. A single dish mounted on the roof would be sufficient for relay of the signal via cable to each flat. These systems

are known variously as common antenna or community antenna television (CATV) or satellite master antenna television (SMATV).

The more recent development of satellite broadcasting, and one which is more familiar in the UK than in the US largely because cable TV systems have not, until recently, existed on any significant scale in the UK, is direct broadcasting by satellite (DBS), sometimes known as direct to home (DTH) satellite broadcasting. In this system, there is no intermediate re-distribution of the TV signal by a cable company. The receiver is connected directly to its own small receiving dish, which is typically mounted on an outside wall or on the roof of a house. Satellite broadcasting can provide coverage of a whole country or a still greater area from a single source, although reception quality is affected by some weather conditions such as rain and snow. Since the frequency of the microwave carrier is much higher, DBS can deliver a larger number of channels than terrestrial broadcasting. In some respects therefore this form of distribution was originally seen as an extension to the terrestrial system and some of the first developments of DBS services were made by the BBC and later by other independent terrestrial TV companies (who formed the short-lived British Satellite Broadcasting company, or BSB). The main satellite programmer in the UK today is BSkyB, the product of the effective take-over of BSB by Sky TV.

In terms of the satellite technology there is no great difference between satellite transmission for reception by cable companies and broadcasting for direct reception on small dishes. This congruence was illustrated by developments in the US in the 1970s. Once companies like HBO had begun broadcasting over a wide area (a satellite's area of coverage is known as its footprint) to the cable companies, it became clear that any individual within the footprint who could afford their own dish and receiving equipment only had to point the dish at the satellite to receive the transmissions direct, avoiding the monthly subscription to the cable company. The demand for television receive only (TVRO) dishes and decoders grew, with around one and a half million dishes in private ownership in the US by the mid 1980s (Choate, 1994, p.79). These were not the relatively small dishes which can be seen in the UK (typically 50 cm in diameter), but around three metres (ten feet) across, and so were often in use in rural areas (where homes had more available space) rather than in densely-populated urban areas. These outlying communities were often precisely those which were not served by a cable operator. Nevertheless, the cable companies and the satellite broadcasters believed they were losing money and sued the TVRO industry, accusing it of 'signal theft'. From that point on, the satellite signals were scrambled (encrypted) to discourage this 'theft', though this merely prompted the sale of unscrambling equipment both legal and illegal. A flurry of lawsuits ensued as various vested interests were threatened.

By the time DBS came to the UK, the experience of the US satellite industry provided a comparison, if not a warning. It had introduced the possibility of different means of delivering television programmes from the traditional, public service terrestrial broadcasting, and with it an acceptance of the notion of commercialisation and deregulation of broadcasting, which fitted well with the philosophy of the Thatcher government of that time. Other developments helped its establishment in the UK. New satellites were broadcasting on a different subdivision of the microwave frequency band, the K-band (or Ku-band to be precise). These could be much more powerful than the previous C-band transmissions, since this latter band was already in use for terrestrial microwave

links, and low power transmissions were necessary to avoid interference. The higher power of the K-band satellites and advances in beam focusing and reception equipment meant much smaller dishes were required to 'scoop up' enough signal for decent reception. These could be mounted less obtrusively (although opinion varies!) on individual homes, something which would clearly not be possible with the three metre C-band dishes.

It is worth pointing out here the differences between satellite broadcasting in the UK and other European countries. The UK is unique in that most of its satellite TV homes have their own dish rather than receiving a re-distributed signal via cable. Negrine reports figures for 1990: of 28 million European homes receiving satellite broadcasts, more than 26 million received them via cable and only 1.8 million via their own dish, and of these, 70 per cent were in Great Britain (1994, p.184). This is largely due to the greater proliferation of cable systems in most other European countries.

Cable television

Cable television is unlike the other forms of TV delivery in that it requires a physical connection between transmitter and receiver. Just as telephone signals can be carried on high frequency electromagnetic waves down a telephone cable, television signals can also undergo modulation for transmission by cable. Because of the television signal's higher bandwidth the cable must have a higher capacity than a telephone line; co-axial and optical fibre cables are used. These offer the potential of high quality television pictures since cable signals are not susceptible to the atmospheric interference and geographical reflections which can affect terrestrial and satellite transmissions. The bandwidth of cable also allows many TV channels to be carried.

Cable systems have been installed extensively in the US. The number of homes connected to cable grew from under ten million in 1975 to 59 million in 1994, representing 63 per cent of all TV homes in that country (McCrystal, 1994, pp.21-25). Part of the reason for this growth was the relatively poor reception and limited coverage of the three main terrestrial networks in many areas, particularly in outlying communities which might be some distance from the nearest transmitter. A cable company could mount a single antenna in a prominent location for terrestrial reception and relay the network programmes through the cable system to subscribers, as well as offering its own programming. The emergence of satellite broadcasts to cable companies added to cable's appeal.

Cable TV has existed in the UK for many years, but on a small scale compared with other European countries. Typically, these older, 'narrowband' cable systems serve a block of flats and offer the four terrestrial channels plus satellite and radio transmissions. Around a quarter of a million homes were connected to such services at the end of the 1980s, but that figure has diminished as these systems have been replaced by the more recent broadband cables. The broadband systems currently being installed around the country offer more channels and, significantly, the vast majority offer telephone services. Unlike narrowband systems, they are switched networks, so that two-way communications can be carried, providing the potential for interactive facilities, a feature which is clearly not possible with terrestrial and satellite systems. Cable networks can in fact be considered as a part of a wider telecommunications infrastructure rather than

simply a television medium, but, for reasons which will be considered later, it is this latter function which is most widely acknowledged.

Television cables

Whereas a telephone signal can be carried on a simple twisted pair of copper wires, it will not currently carry a TV signal of baseband 8 MHz, although British Telecom are currently running trials which they claim can offer better-than-VHS quality video over ordinary telephone lines, making use of bandwidth reduction techniques (see Bannister, 1994). Co-axial cables, which have a much higher bandwidth than twisted pairs, are used for television as well as telephone trunk lines. The link between a TV aerial and the TV set is usually a co-axial line. However, television signals can not be carried very far in a co-axial cable before requiring amplification by a repeater. Early cable TV systems were entirely constructed from co-axial cable, and could carry a number of TV channels as well as radio programmes, although many repeater units were required. Most of the latest broadband cable networks also use co-axial cable for the final link to subscribers' homes, prompting some questions as to whether this allows sufficient capacity for a large number of interactive services as well as television.

The numerous advantages of optical fibres have been described in Chapter 2 and they are used for the main or trunk lines in broadband cable systems. Occasionally they make up the final link in a cable system (this is referred to as a fibre-to-the-home, or FTTH system) but, as stated, more often cable companies are using co-axial cable in a 'fibre-to-the-curb' (US spelling) or FTTC system.

The growth of cable in the UK

The recent history of cable television in the UK illustrates the way in which a host of different factors all play a part in the development and adoption of a technologically-based system. Governmental and industry enthusiasm for cable systems led to a report in 1982 by the Information Technology Advisory Panel, 'Cable Systems'. It was recognised that there was a general need for an upgraded national UK communications infrastructure, with greater capacity than the existing telephone network, to carry information and other services to homes and businesses. However, despite the interventionist strategy that this suggested, in keeping with government policy this upgrading would be financed by the private sector rather than the state. (British Telecom was at this time still a publicly-owned organisation, though by then operating separately from the Post Office.) It was decided that the best way to encourage the private sector to make the huge investment required for installing a national cable infrastructure would be to allow them to provide, and charge for, entertainment ie television and other services. This further required television to be deregulated, eliminating the obligations imposed on the terrestrial broadcasters, so that the cable television companies could supply whatever programming would provide the greatest profit.

The Cable and Broadcasting Act 1984 established the Cable Authority to award local 'franchises' to private companies or consortia, the award going to the highest bidder. These franchises cover a specific area (typically a town or city) and give the holder a monopoly on cable TV provision during the 15-year period of the franchise. By the time the Cable Authority's awarding powers passed to the Independent Television Commission (ITC) in 1991, it had allocated a total

of 135 franchises, covering approximately two-thirds of the British population.

These figures however do not reflect the true state of UK cable TV. The dramatic growth and penetration of cable TV in the US has not been replicated in the UK; work never began on many of the original 135 franchises and by mid 1995 there were still fewer than one hundred franchises in operation, with only around 20 per cent of all homes actually passed by cable. In addition to a slower than anticipated growth in the infrastructure itself, take-up of cable services (where available) has also reached something of a plateau at just over 20 per cent (see Figure 6.1). As a result, twelve years after the first franchises were awarded, just 6.5 per cent of TV homes are connected to cable.

There have been two significant changes in government policy which have affected the growth of cable. When the Cable Authority was created, to win a franchise a company had to be mainly British-owned. This stipulation was later dropped, and now the UK cable market is completely dominated by the big North American cable companies, with many of the franchises merging and subject to take-overs. One report points out that 'In 1993 40% of the industry changed hands as acquisitions and mergers reshaped the pattern of ownership'. It cites one company as typical of the UK cable operators; Telewest is a joint venture between US giants Tele-Communications Inc. (TCI) and US West, and has interests in 24 franchises covering 3.3 million homes (Williams, 1994, p.46).

A second influence in increasing the growth of cable has been the changing policy on telephony. In 1984 British Telecom (now known as BT) was privatised, in the interests of 'greater market competition'. However it was prevented from offering entertainment services down its own cables to subscribers, although is currently conducting a trial of a video-on-demand service. At the same time, cable TV companies were prevented from offering telephony services; although they were free to negotiate a commercial 'interconnection' agreement with BT and Mercury, in practice few did so. After the publication in 1991 of a government White Paper, the cable companies became free to operate their own

Figure 6.1

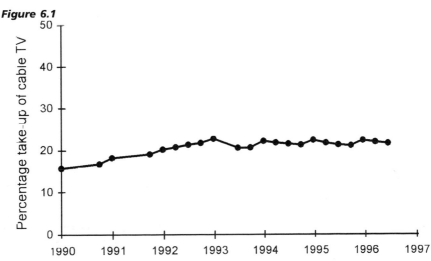

Cable penetration since 1990. Penetration is defined as the percentage of those homes capable of connection which actually do so. The slow but steady growth seen between 1990 and 1993 has levelled out to a steady figure around 20 per cent. (Source: ITC)

telecommunications switching systems, with the result that in 1996, 96 per cent of operating franchises also offered telephone services compared with 20 per cent in 1992. This has proved a significant factor in the appeal of cable services with increasingly large percentages of cable homes opting for telephone services, and virtually all cable franchise operators now offer telephone services (see Table 6.1). Significantly, at least one cable company generated more income from telephone services than television in 1995 (Telephones, 1995).

Despite these two inducements however, there is no denying that the growth of cable TV in the UK has been slower than many in the industry envisaged. If that were not enough disappointment however, viewing figures suggest that, despite the vast array of channels on offer through cable and satellite systems, audiences spend most of their time watching the four terrestrial channels. A survey of the month of October 1995 showed that in households which were connected to cable television, 60 per cent of viewing time was spent watching the four terrestrial channels, although paradoxically the total weekly viewing time in

Table 6.1 UK cable connections (source: ITC)

	January 1996	January 1992
Number of operating franchises	108	50
Number of connections to any cable service (thousands)	2,006	269
Franchises offering telephony	94	10
Cable homes with telephony, %	73	8
Cable homes with TV only, %	27	92
Cable homes with telephony only, %	29	n/a

those homes fell slightly compared with the previous year (ITC, 1995).

Regulation of the 'new' media

The increasing commercialisation of UK broadcasting has been accompanied by a shift in attitudes to regulation. The terrestrial channels must comply with a number of requirements concerning their programme output. The BBC must, under the terms of its licence, comply with certain codes of practice. The independent sector is regulated by the ITC which must fulfil a number of statutory obligations. In both cases, as well as complying with codes concerning political bias, the portrayal of violence and so on, the terrestrial broadcasters are required to maintain a balance between entertainment, news and current affairs output. There are also limits to the amount of foreign-made programming they may broadcast.

The deregulation which was felt necessary to encourage the growth of cable television (and to a lesser extent satellite) has already been mentioned. Thus although cable and satellite broadcasts are also the responsibility of the ITC, for these media 'regulation is as light as possible so as to encourage the development of a wide range of services and facilities, and flexible enough to adapt to changing technology' (Central Office of Information, 1993, p.46). So, while all cable programmers require a licence from the ITC, there is no obligation imposed

on their output, such as a balanced programming which includes news and current affairs; they must merely comply with the codes of practice on issues such as obscenity and political bias. Satellite programmes which originate outside the UK are, in theory, beyond the control of the UK regulators; the content of CNN's news coverage, for example, would not itself be regulated by the ITC, but any cable company which carried it would be bound under its ITC licence. Satellite broadcasters which originate in or transmit primarily to the UK are also required to be licensed by the ITC, though again there are few restrictions imposed compared with those upon terrestrial broadcasters.

Does more mean better? Commercialism and media ownership

The commercialisation and concomitant deregulation outlined above have prompted much debate about the future of broadcasting quality, both in the UK and elsewhere. The omission of any public service obligation on satellite and cable operators means that their only concern need be profitability when deciding programme content. Hence output tends to consist of a 'mixture of pop music shows, old American situation comedies, some children's programmes, old films, and sports programmes – or premium material such as films.' (Negrine, 1994, p.195). Some argue that this puts the current terrestrial broadcasters at a disadvantage in having to fulfil requirements on balanced programme output, sometimes at the expense of audience size. Should the share of the BBC and ITV audience fall, there could well be pressure on the BBC's exclusive right to licence revenue, and pressure on ITV revenue from advertisers, the latter already being exerted in 1995 (Summers and Snoddy, 1995).

The pursuit of profit has other implications for programming output. In July 1995 Rupert Murdoch's News International finally increased its ownership of Hong Kong based Star TV from 64 per cent to 100 per cent. This station will broadcast via satellite to a total of 53 countries in Asia, including China, India, Indonesia and the Middle East, representing a significant proportion of the world's population. The original Star package included BBC World Service Television. However, this was dropped by Murdoch because of objections by the Chinese government (Snoddy, 1994). Again, maximisation of audience size and therefore advertising and subscription revenues are the principal objectives.

Dominance of certain sectors of broadcasting by one (or two) large organisations has resulted in a virtual monopoly of control over satellite subscription technology. Similar warnings have been expressed about decoders for the new digital terrestrial channels (Culf, 1995). BSkyB's dominance of UK satellite broadcasting means that any new satellite provider has little choice but to use the Astra satellites (not because BSkyB own or control the satellites, but because most of the three million or so existing dishes already point towards those used by BSkyB), and further to operate the same subscription and decoding technology (so that the same receivers can be used for all satellite services). Hence one company has a potential stranglehold on the technology associated with UK satellite broadcasting, and the concern is that, if BSkyB begins digital transmission before terrestrial digital broadcasting, a similar control over access might result.

The concern over monopolistic control of hardware is also felt over programming. For example a number of sporting events which people have come to expect to see free of charge on terrestrial television are now available on sub-

scription or pay-per-view services only. Recent debate in the British Parliament has reflected these concerns, the Government being forced to concede the need to legislate in this area.

7 Data recording and storage

Data recording, as well as referring to computer data, includes video and sound recording. All three use tape or disk systems, and the same technology applies equally to each. The idea of using technological processes for storage and reproduction of information (in its broadest sense) is not confined to the era of electricity however. Still picture recording (or photography) developed in the 1830s with the techniques of permanent image fixing (the 'daguerreotype') and Fox-Talbot's 'calotype' process marked a turning point in allowing multiple reproductions to be made from a single negative.

Sound recording technology really began with Edison's phonograph patented in 1877. The phonograph's cylinder was gradually superseded by the more familiar (and more easily mass-produced) gramophone record from the early 1900s. Electronic amplification, which became possible with the development of thermionic valves in the first two decades of this century, made sound recording for subsequent playback a more significant development. In the cases of both the phonograph cylinder and the gramophone record, a groove is cut into the recording material, the undulations of the groove matching the vibrations of the recorded sound. On playback a needle follows the groove as the cylinder or record spins, and the vibrations imparted to the needle by the bumps in the groove reproduce the sound. The 'needle' in a record player is nowadays referred to as a stylus, and the cartridge is a device which converts the stylus vibrations into electric current.

The highest frequency which can be recorded (and played back) depends on the size of the groove (and the needle) and the speed at which the cylinder or disc spins – if it spins faster, then more vibrations per second can be imparted to the needle. But the faster it spins, the shorter the playing time. Consequently a vinyl LP record can record frequencies up to about 15 kHz (which is fine for audio) and has a maximum capacity of around 30 minutes playing time (on each side).

The same technology is not really suited to video recording, with its bandwidth of 5.5 MHz. Baird, in the early days of television, stored TV pictures on a 'phonovision' disc (basically a gramophone record) but the images were very low-definition (32 lines per frame).

The same problem persists with magnetic tape recording. Audio tape recording was developed in Germany during the Second World War. It was another decade before the technology could be applied to video recording.

How tape recording works
Recording

The connection between electric current and magnetism has already been described (Chapter 2). Figure 7.1 illustrates a length of magnetic tape passing a recording head. The head itself becomes magnetic when an electric current passes through the wire coil. If the coil current carries an information signal (for example, from a microphone) the magnetic field in the head will change in the same way as the signal.

Figure 7.1

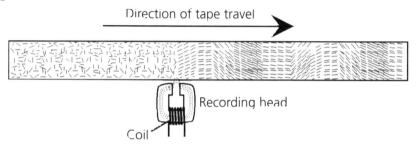

Tape recording. The randomly-ordered magnetic particles on the tape coating are re-arranged by the magnetic field in the head, which in turn is created by the electric current in the coil.

There is a small gap in the head, just where the tape passes by. If the tape is made of a magnetisable material (an iron oxide coating on a plastic backing tape is a common arrangement), then to by-pass the head gap the magnetic field passes out of the head and into the tape. That magnetic field then magnetises the tape coating. If the tape is moving, it will register the changing information signal in a magnetised strip (known as a track) along its length. The magnetisation along the track represents the state of the signal when that part of the tape was passing by the head. A stereo audio recording head is in effect two heads mounted one above the other, each receiving just one channel of the signal (left or right) and laying down two separate tracks on the tape. Professional recording equipment can be 24 track or more.

Playback

During playback, a reverse process takes place. As the tape passes the head, the moving magnetisation of the tape sets up a small magnetic field in the playback head, and this field creates a small electric current in the coil, which can then be amplified to drive a loudspeaker for example. Because the magnetic state of the tape represents the information signal, the magnetic field created in the play-

back head, and therefore the current in the coil, is a reproduction of the original electronic signal used in recording.

Bandwidth

The bandwidth of the tape as a recording medium depends on the speed at which the tape passes the head and on the size of the gap in the head. Each part of the tape spends a longer time by the head if it is moving slowly rather than quickly, or if the head gap is relatively large. This means that rapid changes in the information signal will not be recorded – the magnetic state of the tape will simply reflect the last state of the signal. So a higher bandwidth is achieved with a fast tape speed or a smaller head gap. Tape recorders sometimes offer a choice of tape speed: fast speed offers maximum quality, whereas a slower speed allows more recording time on the tape.

Audio tape recording

Professional recording systems normally use 'quarter-inch' reel-to-reel machines. The tape is 6.25 mm, or a quarter of an inch wide, standard tape speed is 38 cm (15 inch) per second, and there are two tracks, each around 3 mm wide, along the length of the tape. Most machines have a half-speed facility, which gives more recording time at the expense of quality. Accurate editing can be achieved by cutting the tape and splicing the ends together.

The compact cassette is now in widespread use, even for broadcast work. As head technology has improved, slower tape speeds have become possible. The compact cassette's speed is one and seven-eighths inches per second and the 3.175 mm (one eighth of an inch) wide tape carries four tracks, each around 0.75 mm wide. Cramming the same audio bandwidth into a smaller area of tape means that the signal-to-noise ratio is inferior to quarter-inch tape, but electronic noise reduction systems, such as Dolby, have largely overcome this drawback. The small size of cassette tape makes them especially useful in radio news reporting. The main disadvantage of cassette tape is that cut-and-splice editing is virtually impossible, and so the material is normally copied onto quarter-inch tape before editing.

Video tape recording

The larger bandwidth of a video signal compared with audio means that much higher tape speeds are required. The obvious solution, simply increasing the speed at which the tape moves, is in fact not a practical solution. A spool of tape would be used up very quickly if its speed was increased several hundred times. It was not until the mid-1950s that a solution was found. The American Ampex company launched a rotating head recorder, in which the tape travelled at normal speeds, but four recording heads were mounted on a rapidly rotating drum (Figure 7.2). A similar drum carried playback heads. Hence the equivalent tape-to-head speed was much faster than the actual tape speed. The video signal was recorded in a sequence of tracks laid across the width of the track. Each track recorded just a few lines of the field and was recorded by a different head, so complex electronic circuitry was required to switch between heads, both for recording and playback. The track direction allowed editing to be carried out by the physical splicing technique familiar in audio editing, although it was more complex.

Figure 7.2

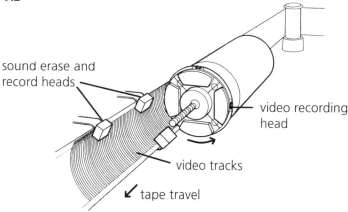

sound erase and
record heads

video recording
head

video tracks

tape travel

Rotating drum videotape recorder. The spinning drum carries four recording heads, and each track contains just a part of the picture.

Later machines employed helical scanning (Figure 7.3). The rotating drum carries two or four heads, and because of its slight angle to the tape travel, the video signal is recorded in long tracks laid at a slant across the width of the tape. This allows enough length in each track for a complete field of the TV picture to be recorded. There is therefore no problem with switching between heads, since this takes place during the field blanking interval and so does not affect the picture. In addition, audio tracks and a control track, carrying the field synchronisation pulses, can be laid along the top and bottom of the tape by conventional, stationary heads.

Editing by cut-and-splice in helical-scan format is virtually impossible, and dub-editing is universally used. Dub-editing makes use of another video tape recorder on which the original recording is selectively re-recorded. This invariably results in a loss of quality, since the video signal has to go through many electronic processes before being stored on the copy tape, and each of these processes introduces some noise (including the final storage on the tape itself). Broadcast-quality equipment must therefore be built to a far higher quality stan-

Figure 7.3

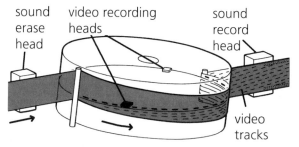

sound
erase
head

video recording
heads

sound
record
head

video
tracks

Helical scan videotape recorder. The rapidly spinning drum carries two or four heads. The narrow angle between drum and tape allows long tracks to be laid down, each capable of recording an entire field.

dard than actual broadcast output to allow for the 'generation loss' which occurs each time the video is copied to a new tape during editing.

A number of different video tape recording formats exist for broadcasting requirements, such as U-matic, C, Betacam, each using a different size tape. In addition a series of digital formats have been developed (see later section). Betacam uses tape cassettes which look similar to domestic VHS cassettes, although the tape speed is higher for better quality.

Problems with tape

Conventional audio and video tape is not a perfect recording medium, although developments in technology have overcome many of its drawbacks:-

(a) The relationship between the size of the electrical information signal and the magnetising force on the tape coating is not a linear one ie if the signal is twice as strong (because the sound is twice as loud, for instance), there will not be twice as much magnetisation on the tape. On playback, the relationship between the magnetisation and the signal current induced in the head is also not linear. These defects can be corrected electronically by bias and equalization circuits, though of course this adds to the complexity and cost of recording equipment.

(b) The tape itself can suffer from one or two defects. No tape production process produces a perfectly even magnetic coating and 'drop-outs' occur where the powder coating on the tape becomes thin, or even vanishes. The signal then fades or disappears altogether on playback when a drop-out is encountered, though it may be inaudible if the drop-out is small enough. Early cassette tapes suffered particularly from this defect, but it is nowadays far less common.

(c) 'Print-through' can sometimes be heard as a faint 'pre-echo' on a recording just before a piece of music starts. This occurs as a result of the stored tape being wound onto spools. The magnetisation on one coil of tape can exert a magnetic force on adjacent coils. This effect is normally masked by the size of the recorded signal, but in quiet or blank parts of the tape, the effects of print-through can be heard.

Digital recording

The problems listed above, and there are a number of others, in fact occur with analogue tape recording. Recording digital signals eliminates these deficiencies. Biasing and equalisation are not required since even though the relationship between magnetisation and signal current may not be linear, in a digital system, signal current is either a 0 or a 1, and it is only necessary to be able to distinguish between two magnetisation states. Drop-out is not a problem due to digital error-correction techniques. Even if a large quantity of data is lost, error-detection and correction can usually compensate. Finally, print-through is not heard, since the relative weakness of the print-through signal is not enough to make the genuine digital data bit unrecognisable.

Other potential analogue recording problems include wow-and-flutter, caused by slight variations in tape speed, which is eliminated in digital format by temporary electronic storage of data before playing out of the store at a fixed rate; crosstalk, when the proximity of one track's magnetisation influences adjacent

tracks (similar to print-through) is again not a big enough effect to completely distort a digital signal. Finally, though perhaps most importantly, digital recording allows multiple generation copying without degradation of the signal, allowing, amongst other things, any number of edits to be done.

The main drawback to digital tape recording is the bandwidth required. Digitising an analogue signal results in a large quantity of data and a requirement for a similarly increased bandwidth (see pages 58–59).

Digital Audio

For audio signals, there are two basic approaches to coping with this:

(a) Rotary heads: rotary head digital audio recording (RDAT or sometimes just DAT) makes use of the same technology as used in video tape recording ie two heads mounted on a rotating drum with helical scanning laying diagonal tracks across the tape. The earliest RDAT machines were in fact more-or-less standard analogue video tape recorders, with ADC and DAC interfaces, although dedicated machines are now in use.

(b) Stationary heads: digital audio stationary head (DASH) machines look much more like conventional analogue recorders in that tape of a similar size passes at a similar speed across a stationary head. However, unlike an analogue recorder, in which the signal is laid down in a single, continuous track, the DASH recorder spreads the data over several tracks, producing an effect equivalent to an increase in tape speed. Despite its superficial similarity, then, this format represents a major redesign of the head system to achieve the 24 tracks on a half-inch tape, or 48 tracks in the later DASH II format. Until recently, DASH machines have been the only access to multitrack digital recording and mastering. The arrival of digital video recording allows sufficient bandwidth for rotary-head technology to offer multitrack digital audio, a repetition of the original evolution of DAT from analogue video recording technology.

Digital video

Digital video recorders are very similar to their analogue counterparts, using helical scanning to record the video signal in long track across the tape. The huge data rate of digitised video means that a field is stored in more than one track (unlike the analogue recording system), but by playing the data into a temporary memory store for subsequent readout means that the switching between heads and tracks is invisible.

A number of different digital video tape recording formats are in use: D3, D5 and Digital Betacam are three of the most recent, all of which use half-inch tape (smaller than the earlier D1 and D2 formats); D3 is a composite system, whereas the others are component. They are largely incompatible, since they use different methods of coding and storing data, although D3 tapes can be played on D5 machines[1].

1 Some of the standards for digitising video are: CCIR 601 (since re-titled ITU-R 601) is an international standard uncompressed component video system, which uses 8-bit coding and is widely applied to both 625 and 525 line systems. Details of tape recording standards include: D1, which works to the CCIR 601 standard, using 19 mm tape allowing 94 minutes of recording time per cassette; D2, a composite system, again with 19 mm tape, giving 208 minutes recording time; D3, a composite system using half-inch tape cassettes, a similar size to tape used in camcorders; D5 using the same cassettes as D3 but in component mode, but able to play D3 cassettes and return component outputs; Digital Betacam employs data compression of around 2:1 and can record up to 124 minutes on half-inch tape cassettes.

To avoid some of the uncertainty and confusion which accompanied the simultaneous competitive introduction of several different and incompatible domestic video recording formats (VHS, Betamax, V2000) in the 1970s, and which left a large number of purchasers with obsolete equipment, the leading electronics companies reached agreement in 1994 on a common format for domestic digital video cassette recorders (Cane, 1994). The cassettes are smaller than present analogue tape cassettes, but offer around four-and-a-half hours recording time.

Magnetic disk[2] storage

Magnetic disks are most commonly encountered in computers in the form of floppy disks and fixed, 'hard' disks. They work by the same principle as magnetic tape, using a magnetic head with a wire coil wrapped around it, the electric current in the coil causing the area of the disk adjacent to the head to be magnetised. In the case of a floppy disk, the head actually touches the disk, which, to avoid damage, places a limit on the speed of rotation. On the other hand a hard disk rotates much faster, since there is a tiny air gap between the head and disk surface – the disk to head speed can be 100 miles an hour, so obviously, any contact would be catastrophic (Watkinson, 1994, p.290). This high speed reduces the data access time and increases the data transfer rate compared with a floppy disk. However, the introduction of an air gap (albeit a very small one) reduces the density of data which can be stored compared with the floppy disk.

Although computer disks are usually thought of as primarily for storing 'computer data', of course any digital data can be stored in exactly the same way. Magnetic disks are used for storage of digital audio and video signals for a number of applications. Digital editing systems (audio and video), video frame stores, audio samplers almost always store on hard disks, and never on tape. A radio station, for instance may well store commercials and jingles on disk. The advantages that disks offer are rapid and random access (there is none of the spooling that is necessary with tape), quicker start up than tape, and more efficient storage (in some senses) than tape – a tape system will continue to record 'data' even in the absence of a signal, using up tape, whereas a disk will not. Nevertheless tape is by far a more economical means (in terms of space and cost) of storing large quantities of data and is usually chosen for archiving purposes.

Optical discs
The compact disc

The audio compact disc (CD) is the most familiar example of optical disc storage, though at the same time as its introduction Philips used the same technology, less successfully from a commercial point of view, in its LaserVision video system. The CD mimics the function of the vinyl LP, which it was designed to replace, in that it is a 'read only' (ie not recordable) mass produced audio source. While it is smaller than a vinyl LP (its diameter, 12 cm or five inches, was determined by car manufacturers as suitable for dashboard mounted players) it can store more than an hour of high quality audio.

2 Disk is normally spelled with a 'k' when referring to magnetic disks, rather than with a 'c'.

The CD information is stored as a sequence of dents, or 'pits', in a reflective surface; the surface is scanned by a tightly-focused laser beam, reflecting different quantities of light when it falls on the flat surface or crosses over the edge of a pit. This is clearly a digital storage medium; the light is either reflected or it is not. The pits are arranged in a continuous spiral, like a vinyl disc, except that the CD's spiral starts from the centre rather than the edge of the disc. As the laser tracks outwards the CD's speed changes so that the speed of the track is constant.

A CD track has a width of 1.6 micron; a micron (symbol μm) is one-thousandth of a millimetre, smaller than the thickness of a human hair. Thus a CD track is tiny compared with an LP groove, and this requires the use of complex track following systems; around sixty CD tracks would fit into the LP's groove (Watkinson, 1994, p.330). To get a beam of light to focus this small requires the use of laser light, since a focusing lens affects the various colour components of ordinary white light by different amounts, resulting in a spread beam. Lasers emit light of just one colour (monochromatic light) so the lens just has one colour to focus. Until reliable and compact semiconductor lasers were developed, in the late 1970s and early 1980s, CD technology could not progress.

The actual reflective surface of the CD is coated with a relatively thick layer of plastic. Because of the strong focusing involved, the size of the laser beam on the plastic surface is much larger (around 0.7 mm) than on the reflective surface (Figure 7.4). Consequently, any small imperfections or dirt on the plastic disc surface do not actually interfere with the beam very much, so the data can still be read. This contrasts with a vinyl disc, where surface damage or dirt generally produce audible effects. In combination with error detection and correction techniques, the CD is capable of reproduction of excellent quality in the presence of surface damage, or even 2 mm holes (see pages56–57)!

The CD is also in use in computer data storage, as a read only complement to the floppy magnetic disk. In comparison with a floppy disk's capacity of 1.4 Mbytes, a CD-ROM can store around 650 Mbytes. Although it is not possible to write to a CD-ROM from a normal personal computer, the cost of optical writing equipment is falling to the point where many organisations can now consider the use of CD-ROM for permanent data storage and distribution.

The 'new CD' – DVD

The same optical disc technology is currently being developed to produce a CD with much higher capacity than the existing 650 Mbytes CD. In an attempt to avoid the problems of competing formats which beset the consumer video

Figure 7.4

Reading a CD. The tight focussing of the laser beam means that surface imperfections do not affect the reading of the disc.

recorder market, Sony and Philips agreed to develop the new format collaboratively (in contrast with their rivalry over consumer digital recording formats, described later). However, within a short time of its announcement, other electronics companies (Matsushita, Toshiba) claimed they were jointly developing a different format, offering still higher capacity. The high capacity is clearly intended to allow storage of video, although of course the same technology could be used for audio only, with far more playing time than a conventional CD. Agreement on a common format was eventually achieved after almost a year. Features of both formats are incorporated in the new CD, known initially as Digital Video Disc, but now less specifically (and less fluently) as Digital Versatile Disc; it can hold 4.7 Gigabytes of data, enough for several hours of audio or more than two hours of video. As well as technical differences, a significant consequence of the new format is that it releases CD manufacturers from payments to the Sony and Philips partnership which held the patent on the original CD format (Screen Digest, 1995).

Write once, read many times

The WORM disc, as it is known for brevity, is very similar to a blank CD with a smooth reflecting surface. Unlike a conventional CD, this disc can be written to. As it spins, a powerful laser beam is focused onto its reflective coating and switched on and off by the data signal. Under the laser beam the coating blisters or burns, leaving a sequence of damaged areas which act like a CD's pits. The disc can then be read using a lower power laser, though clearly, once written to, the disc can not be erased and re-used. WORMs are thus suitable for archiving, or must be considered to be disposable items.

Magneto-optical disks

These are genuinely read/write in that they can be erased or over-written. The magneto-optical (MO) disk structure is similar to a magnetic disk. Like a magnetic disk therefore, it requires a magnetic head to change the magnetisation state of the disk surface; unlike an ordinary magnetic disk, however, it also requires a laser beam for reading and writing.

It relies on a property common to all magnetic materials. When heated above a certain temperature (the Curie temperature) the magnetic surface becomes very easily magnetisable, and can therefore be magnetised by a very weak magnetic field, one which would not affect it at all were it below the Curie temperature. So to write to the disk, a weak magnetic field is permanently applied to the disk. When a high power laser is focused on the disk, the region under the beam is momentarily heated up, enough to cause it to be magnetised by the weak field. As soon as that area moves out of the beam, it cools, 'freezing in' the magnetisation. So the high power laser beam is modulated (ie switched on and off) by the digital signal, which is then recorded in the magnetic state of the disk (Figure 7.5).

To read from the disk a lower power laser is used, one which does not heat the disk up. The quality of the light reflected by the disk surface (its polarisation, to be precise) is determined by the magnetic state of the surface. The data is read, therefore, by measuring the polarisation of the reflected light as the disk spins.

In some ways the MO disk combines the best of both the magnetic and optical worlds. The magnetic layer is the storage medium, but the read/write

Figure 7.5

Writing to disk Reading from disk

Writing to and reading from a magneto-optical disk.

mechanism is optical. Thus, like a magnetic disk, it can be re-recorded over and over, but optical reading and writing takes advantage of the higher storage density of optical discs.

Solid-state storage

An alternative to storing data on disc or tape is to store in memory chips, sometimes known as 'solid state storage' to emphasise the point that this technique does not involve any moving parts, and so theoretically should prove more reliable. It also offers faster access since there are no heads or lasers which need to be moved about. This type of storage medium is just the same as a computer's RAM (random access memory) chip. A computer's RAM is used for temporary storage of data while processing applications software. A typical computer would have 8 Mbytes (megabytes) of RAM.

A RAM storage system for use in digital audio or video systems requires much more RAM than this; as a rough guide, uncompressed digital audio requires around 1 Mbyte for ten seconds of output; digitised video requires around 1 Mbyte for just one frame (lasting one twenty-fifth of a second)! The cost of solid-state memory has come down to around £15 per megabyte (in 1996), which makes RAM a feasible option for temporary data storage, certainly for audio applications. Nevertheless, RAM storage hardly compares with the several hundred megabytes offered by a single hard magnetic disk, or the gigabytes of a WORM or MO disk, but does offer very fast, random access. Some video framestores used in editing systems are based entirely on RAM storage, although the use of arrays of MO disks for long-term storage and RAM for processing is a more common arrangement. Disk arrays can typically give minutes or even hours of uncompressed video storage, RAM systems offering just seconds.

'Pretty funky' technology and the tapeless studio

Tape wears out, it can leave deposits and wear out heads. Occasionally it gets chewed up. For editing and playout purposes it has a relatively slow start up and, more importantly, it demands linear editing and lots of tape spooling. None of this applies to discs, which is not to say that they do not go wrong! Nevertheless there is a general assumption that broadcasting will move towards an almost tape-free system over the next few years. Already, disc-based cameras are available as are disc-based playout systems, and so it is conceivable that the video signal at every stage of the production process will be digital and disc-

based, and that digital video tape recording may be used for archiving purposes only. Apart from the technical advantages, Darryl Burton of Live TV claimed in an interview that this 'pretty funky' technology (his description) can give cost savings as well (Jones, 1995). Newsrooms, where programme material is inevitably produced under tight time schedules, are seen as the likely first users of disc-based production facilities.

It is still likely to be some time before most broadcasting uses these systems. The cost of disc storage is still very high compared with tape. It can take time to introduce and develop successfully the new ways of working which disc-only systems would require, a problem which is exacerbated in a time-critical operating environment such as in a newsroom.

Consumer choice – a tale of two formats

In 1992 two new digital audio recording formats were launched onto the consumer market. On the face of it, both formats offer the same thing, claiming to give CD-quality audio with the advantage of being able to record and re-record without degradation, given their digital nature. Sony's Minidisc uses a magneto-optical disk, which, with a diameter of 64 mm, is about half the size of a conventional CD. Philips's Digital Compact Cassette (DCC) records onto tape, which is housed in a cassette of similar size to a conventional audio compact cassette. The two formats of course are completely incompatible, and, with echoes of the same two companies' rivalry in the beginnings of consumer video recorders, each has attempted to get the electronics companies and the music companies and distributors to support their own format. Kugel (1994) lists the outcomes of some of this lobbying; the companies are fairly evenly split between which format to support, with few supporting both, for obvious cost reasons.

Sales of both hardware and 'software' (tapes and disks) have been low, to say the least, with both companies admitting to disappointment and considering a change in 'product positioning' (Rawsthorn, 1995). It is not clear whether this is because the rivalry between the formats is dissuading people from buying what could soon become obsolete equipment (many still remember redundant Betamax video recorders) or whether people are not in fact that impressed with the 'advantages' of digital technology. After all, most home recordings are made for use in personal stereo systems or in cars, environments for which existing technology provides adequate quality. It should also be remembered that both manufacturers priced their hardware and software for these systems significantly higher than their analogue equivalents, though these costs are now falling.

A word or two about film

It may seem anachronistic to include a section on film amongst all this high-tech talk about digital editing and disc-based storage. However it is important to remember that there is an enormous (and growing) stock of filmed material. Since the earliest days of television, there has existed the means of converting film to broadcast-quality video.

Telecine – film to video transfer

Put simply, this is achieved by pointing a TV camera at a movie projector (with a suitable lens between the two to focus the image), and the TV camera records

the film as it is projected. There are slight problems with synchronisation. The standard cinema frame rate is 24 frames per second (fps) whereas the TV frame rate is 25 fps (625/50 system) or 30 fps (525/60). For the 625/50 system this is not such a problem. Running the film slightly fast, at 25 fps, produces acceptable results. Synchronisation requirements are then simply that the TV scan starts at the same time as the projection of the film frame. The 525/60 system poses more of a problem. Thirty fps is 25 per cent faster than 24 fps, and so it would not be acceptable to speed the film projection rate up that much. Instead, the projector is designed to project each film frame more than once: the first frame is projected twice, the second three times, the third twice and so on. If there are 24 frames per second, half of them are projected twice and the other half three times, that works out at 60 projections per second, which matches exactly the field rate of 525/60 TV (60 fields per second equals 30 frames per second).

Flying spot scanners offer better quality film to video transfer but at higher cost. The film is scanned by a beam of light produced by a cathode ray tube (in exactly the same way as the beam is produced in a tube camera). After passing through the film a prism splits the light into its R, G and B colour components where it enters a pickup tube to produce the colour signals.

Film as a storage medium

While the need to be able to transfer film to video may be easily appreciated, it might seem odd to argue for film as an alternative to modern digital tape and discs as a *storage* medium. But for recording the moving image, it has a number of benefits.

Firstly, and perhaps most obviously, film records in widescreen format, whereas video camcorders and recorders are only just beginning to accommodate the format. In addition, the quality of a film image is superior to video: film has a much higher resolution (even than HDTV), higher contrast ratio (the difference between the darkest and brightest parts of an image) and better colour saturation than video.

Furthermore, and perhaps less obviously, film is considered to be the only truly 'future-proof' medium. At a time when video recording and storage technologies are changing rapidly, resulting in a sometimes bewildering array of incompatible formats and standards in use, one thing is certain – film will continue to be widely used as a storage medium, if only for making movies (although, in fact, a significant number of TV programmes are shot on film). So whatever video format finally emerges as the all-time favourite standard (until the next one comes along, that is) there will always be a requirement to be able to transfer film to that video. Some in the industry therefore argue, with great conviction, that, despite one or two disadvantages (vulnerability to scratches, sprocket wear), the best medium for archiving the moving image is film.

8 Multimedia and Virtual Reality

Perusal of advertisements for computers, especially those aimed at the consumer market, reveals that almost all are now sold as 'multimedia' machines. What normally distinguishes these from 'normal' (single-medium?) computers are small loudspeakers and a CD-ROM drive. Less obvious are an internal sound card and possibly a video driver. Multimedia has been defined as 'the seamless integration of data, text, images of all kinds and sound within a single digital information environment' (Feldman, 1994, p.4). However, there is no agreed definition; systems other than those based on a computer are also included under the multimedia umbrella by different commentators, so that interactive TV, the World Wide Web, Virtual Reality, and even video-on-demand and video conferencing systems have all been described as parts of the brave new multimedia world.

Background

Whatever definition of multimedia is adopted, some commentators' enthusiastic visions of the multimedia future are consequences, in part, of a number of recent technological developments. Computer processing speeds and graphics quality have increased dramatically, and will continue to do so; systems for digitising audio and video have now matured; compression techniques are beginning to be standardised; data storage technologies have greatly increased in reliability, capacity and speed of access; optical fibres make huge bandwidths available compared with copper lines.

As a consequence it is now possible to play audio and video (usually of a low quality) as well as the usual text and graphics on a fairly standard home computer (see next page). A multimedia application can be thought of as one which brings these different media together. Of course, this is not new – television programmes present all of these, and have done so for six decades. The

feature which distinguishes what most people mean when they refer to multi-media is a degree of interactivity. A TV programme traditionally plays in a linear manner, with no control available to the viewer (other than on or off) a feature which persists even in the days of home video recording. A typical computer-based multimedia application allows the user to choose, to some extent,

Computer evolution

Early computers – mid-1940s

ENIAC, one of the first machines, contained 18,000 valves and filled a room. It was in effect a very fast mathematical calculating machine. A number of similarly massive machines were built in the post-war years.

Mainframes – 1960s and 1970s

The replacement of valves by transistors meant that it became feasible for organisations to consider using computers for data processing, still primarily for complex mathematical calculations. Mainframe computers housed all the processing, memory and often output (printing, disk and tape storage) in one central unit, with a number of 'dumb terminals' (keyboard and monitor) providing access, often at remote locations. Early mainframes were large (still filling a climate-controlled room), expensive and consumed a lot of power. They were used by large research establishments, government departments and similar large organisations.

Today's mainframe computer systems are of course cheaper and more compact and continue to find application in large organisations.

Personal computers – 1980s onwards

Microprocessors contain the central processing unit essential to a computer's operation in a single chip. The increase in performance and reduction in size and production costs which result from this large scale integration meant that all of a computer's processing, memory and input/output could be housed in a single box which would sit on a desk (a large desk was required in the early years). One of the first 'personal computers' (PCs) was developed by Apple Corporation, but others such as Commodore and IBM soon followed. Whereas Apple used all its own hardware and software in its PC, the IBM design was licensed for manufacture by other electronics companies and soon the IBM PC format began to become a de facto standard.

The PC is now almost universally chosen by organisations employing computer systems, networking allowing the sharing of central facilities and software (see Chapter 9).

The 'multimedia' PC – 1990s

An early PC might have 128 kilobytes of memory for processing data. A typical specification today would be 16 Megabytes. Other aspects of computer technology (storage, monitors, software) have progressed at a similar pace, and so today's PCs can handle the processing demands of graphical displays, sound and video. 'Sound cards' and 'video cards' are simply circuit boards containing a few chips which can take digital computer data and convert it into sound or a video display on a monitor. These cards can be added to a PC or are often supplied already installed, in what has become known as a multimedia PC. Other than the addition of cards and high specification components, a multimedia PC is like any other PC.

the direction which the programme takes. An example commonly quoted (though rarely realised) is the interactive movie; at various stages through the movie it should become possible to indicate a choice (using the computer's mouse, for instance) as to which path the movie should follow from that point.

This interactivity is realised in other multimedia applications with the use of hypertext and hypermedia presentations. The 'Help' systems in many recent computer software applications are examples of the use of hypertext, in which certain words or phrases in a page (or screen) of text are highlighted, and clicking the mouse pointer on any of these takes you to a new page, with its own highlights or 'hyperlinks'. In this way it is possible to navigate through the array of text in a number of different ways.

More recent multimedia applications take the hypertext concept a stage further. A multimedia encyclopædia, usually supplied on CD-ROM for home computers allows links to graphics, images and sounds. This is sometimes referred to as 'hypermedia' to emphasise that it is not confined to text output. In many ways, 'hyperlinking' is the way in which we use print media – newspapers, magazines and books – especially reference texts such as dictionaries and encyclopædias which have their own cross-referencing systems; people might turn first to the crossword in a newspaper, for example, or flick through a magazine or book until a particular picture or title grabs their attention, rather than reading in a linear manner from first page to last.

Applications of multimedia

The CD-ROM encyclopædia, already referred to, is probably the most familiar application of multimedia, familiar because it is often given away with the purchase of a 'multimedia' computer. As indicated earlier, in addition to text entries, audio and short video clips are often included. There are a number of similar reference works available (for example, guides to the human body or to art history) for which the interactive nature of multimedia technology is highly appropriate (just as it is for the paper reference book). The marketing angle for these products stresses their supposed educational as well as entertainment value; they are particularly aimed at children (or at least, at parents on their children's behalf), with the claim that this new format will provide a more interesting and stimulating learning environment which can even become an alternative form of entertainment. An indication of the confusion over the precise role of this kind of software is the emergence of the awkward adjectives used to describe it, 'edutainment' and 'infotainment'.

Interactive multimedia learning software has been in use for many years as an industrial training aid. Feldman gives a number of examples, citing studies which claim their effectiveness over classroom-based training. From the industrial trainer's point of view, there is of course another advantage. Feldman quotes Margaret Bell, of British Telecom's Management College, from 1988 (1994, pp.71-72):

> With some 250,000 employees nationwide, British Telecom faced a massive communications job when they needed to explain the introduction of a new technical system to every manager in the company. Normally, this would have meant a day off work to attend a training session at a cost of at least £150 per head. By presenting the information on a videodisc which managers could view quickly, locally and

at a convenient time, BT reduced the cost of the exercise to £15 per manager.

Whatever the pedagogical arguments therefore, the reduction of training costs is clearly a particularly persuasive consideration in deciding on the adoption of multimedia or computer based training.

Feldman goes on to list a number of applications of interactive multimedia (or CBL, computer based learning) in education and training, concluding that its effectiveness is as yet uncertain partly because it is a relatively recent innovation and also because its adoption has not been particularly widespread. Evidence does suggest that it may be effective for the training of routine tasks, but less successful in conceptual training and education. Nevertheless, research and development of CBL continues, not least because of the anticipated demand in an educational world of increasing student to staff ratios.

One of the most rapidly growing areas of multimedia technology is the entertainment market. Sony claims that its new games console, PlayStation, sold 20,000 in the first weekend after its launch (Schofield, 1995). The storage capacity of CD-ROM enables games to become more sophisticated and to use much improved graphics compared with previous magnetic disk or cartridge systems, and the entertainment market is seen as by far the most profitable sector for multimedia technology. The eventual agreement on the DVD standard as a high density CD format has paved the way for storage of movie-length video, making the prospect of interactive movies perhaps a little more real. (The massive bit rate of video signals has meant that multimedia video has traditionally been of limited quality, with either a poor resolution, slow scan rate or confined to a small window on the computer monitor.) Other multimedia entertainment products include interactive story books (using hypertext links, sometimes in conjunction with audio and video) and magazines supplied on CD-ROM.

CD-ROM database storage is being increasingly used for bibliographic purposes. For example newspaper indexes, and indeed the full text of newspapers, are available in this format. These offer keyword searching functions which present significant advantages over their paper equivalents. Similar advantages apply to reference texts like the Oxford English Dictionary, which in its CD-ROM format allows word searches which would be all but impossible in any other form. (It might be argued of course that these are not 'multimedia' products, since they are almost entirely text-based, and this again illustrates the confusion between the accurate use of the word to describe the medium itself and its more common association with the technology used in its delivery. Many believe that, because of its inadequacy and inaccuracy, the term 'multimedia' will soon fall from use in this context.)

The implications of multimedia

Ventures such as CD-ROM publishing have prompted some to predict the death, or at least decline, of conventional, paper-based publishing. Similarly some producers of educational software (or, more often, the hardware producers) have suggested that didactic, classroom-based teaching may become a thing of the past, and that movie-watchers of the future will control how a film progresses by means of interactivity, choosing from a vast range of possible directions.

Those who predict this technological take-over are missing the point (see opposite). Their focus on the technology itself (which unquestionably is novel)

tends to obscure the fact that the aims with which the technologies are being used are often not new, and neither is the content. Therefore the differences between the 'old' media and the 'new' become more trivial than fundamental (a CD-ROM encyclopædia weighs less and takes up less space than its paper equivalent, that is unless you include the computer which is required to read it). A school student who has a computer with CD-ROM drive at home might occasionally choose to use a reference disc rather than book to help with homework, but there is no evidence to suggest that the learning experience is any more effective for having done so; it may be that the skills being most developed are simply those which are practised in any computer game!

However, while it is almost certainly not the case that these new multimedia technologies are destined to replace their non-electronic counterpart, one should not argue that there is no place for them. Once again, it is worth remembering

Traditional versus new media

The argument that the 'old' media will disappear in favour of the new tends to take a quantitative view of information – comparing for example how much there is and how fast it can be delivered. One or two fairly obvious comparisons will illustrate the short-sightedness of this view.

Print media

Newspapers and books will not disappear for obvious reasons: print media can easily be read on the train or in the bath, and no-one (presumably) wants to carry a laptop to the beach. Furthermore, as Stoll reminds us, paper products are more future-proof than CD-ROM (1995, p.181); digital formats and standards have a habit of changing, eventually rendering older material unreadable unless it has been regularly re-archived. (How many writers have documents becoming increasingly inaccessible on five-and-a-quarter inch floppy disks, or even on the three-inch disks which were used with some early word processors?) Apart from these concrete arguments, most people prefer to read print from paper rather than off a screen; even when searching electronic archives, readers prefer to print articles out, ready to be spread haphazardly over the floor or desk.

Education

Bowen remarks on the ability of the new storage hardware, such as the CD-ROM, 'to bring education and training alive...' (1994, p.10), missing the obvious irony that no-one is better placed to bring it 'alive' than a live teacher or instructor. He goes on to be more specific: one of the advantages, he claims, of a computer based language learning system is that students are 'taught to understand several voices, rather than one teacher' (p.95). Of course language teachers have provided this experience for more than twenty years, using video and audio tape; in this respect, at least, nothing new is offered by the new technology.

Films

MacGregor (1994) indicates the problems associated with interactive movies. He points out that the minimum ratio of production time to screening time for feature films is around 1000 to one for conventional, linear programming. An interactive movie, with its many sequences of parallel routes, would require a much higher ratio, at considerably greater cost.

that we were told that the video recorder was going to kill off the cinema; it did not. Both exist side-by-side and to a certain extent complement one another – apart from anything else, the sale of video rights provides around 40 per cent of film finance (MacGregor, 1994, p.124). The same is undoubtedly true of the new technologies. There is certainly a role for computer based learning, but that role is complementary to other roles such as formal classroom tuition (the Open University, for example, has offered for several decades a different, very successful mode of learning, but not one which has replaced other methods). CD-ROM books and magazines are different from their paper counterparts, and should be seen as such. Interactive movies can also be seen as an entertainment medium in their own right, perhaps akin to computer games; meanwhile many people prefer to observe the result of someone else's experience and creativity, that of the film's director and writer, in choosing the ways in which a story unfolds and develops, thereafter to judge and consider their response.

Virtual Reality – a technology looking for an application?

Virtual Reality, or VR, has been defined as a set of technologies which 'gives users a compelling sensation of presence of being in a circumambient environment created by a computer' (Biocca, 1994, p.223). The same author describes it, somewhat less exotically, as 'a technology in search of an application'. It is a 'multimedia' application in the true sense of the term. Again, relying on the technological developments in computing performance which have been cited for other multimedia applications, VR aims to create an impression for its user of being in a different environment. By providing a sufficient number of sensory inputs to the user, for instance sounds, moving images and pressure to give a sense of touch, and changing those inputs according to the user's response, advocates of VR systems argue that people can have 'real' experiences of situations without physically being present in that situation. An obvious comparison is with a flight simulator, where a trainee pilot can 'fly' an aircraft using all the normal controls and being exposed to all the usual hazards, but without the obvious consequences in the event of a mistake.

In its most complete, and fanciful incarnation, VR would require the user to wear a headset, containing a high resolution video display, and a glove or even a body suit, which would be controlled by a computer and could exert pressures or forces on the wearer's body, creating an impression of touching or being touched. At the same time sensors in the suit and headset would record the user's movements and feed these back to the computer, which would adjust the view in the display and the pressures applied to the body in response to those movements. Hence the scene displayed would change according to where the user looked, or moved to, giving a sense of moving through a real landscape. Audio outputs and voice recognition software might also be incorporated.

The application of VR has not been particularly focused. While there are obvious applications, once again in entertainment, providing a new dimension to computer games, some foresee its most useful role as being in training and industry. It would be possible for surgeons to practise operations on 'virtual' patients, for example; engineers could make a virtual exploration through hazardous environments to carry out safety inspections. Other VR commentators see a role in retailing: rather than prospective home-buyers making an appointment to view a house, it would be possible to wear a headset and 'walk' round

the virtual house, and even to see how it felt when decorated in one's chosen style; car buyers could try different models of car by choosing from a virtual showroom, taking a virtual test-drive and comparing details such as comfort, performance and colours.

The current practice of VR is of course far removed from these scenarios. Much of its present application eschews the headset in favour of a conventional computer monitor; computer graphics still look like computer graphics rather than 'real life'; the VR glove and suit are still at very early stages of development. In many ways therefore, VR applications today continue to be more like sophisticated computer games than the promised fully-immersive virtual environment. As with the term 'multimedia', Virtual Reality lacks a rigorous definition. Some games manufacturers are offering head-mounted displays for their products, and calling them Virtual Reality games; sophisticated three-dimensional visualisation software is in use in medical and technical research; more mundane applications, such as the kitchen sales representative's design software which runs on a laptop computer, have even been held up as prototypical examples of the potential of VR. Therefore, VR encompasses a number of different technological developments which, rather than suddenly presenting a host of previously unimaginable new applications, instead proceed over a period of time to offer new ways of doing familiar things, as well as perhaps some genuinely novel options.

A multimedia future

It should be clear from this chapter that the terms multimedia and Virtual Reality do not in fact define any particular set of technologies, nor even any set of audio-visual or textual products. So, in the absence of any restriction imposed by definition, there can be little argument with those who assert that multimedia will play an increasing role in future communications. The range of products which are made available on CD-ROM will increase and diversify; more of this type of material will become available on-line, via cable television networks or the telephone network, either to the home or to public spaces such as libraries; and it is likely that there will be more development of communications technologies which are capable of conveying audio and video material. Whether or not there is a parallel demand for such services is of course another matter, one which is often overlooked in the promotion of these technologies. For example, there has been no great public clamour to purchase the latest videophones; many people would like public libraries to update and expand their collection of printed publications before concentrating on getting 'on-line'; they would also prefer to visit a house they were considering buying rather than walk around an estate agent's office wearing a headset.

It would be unfair to suggest that these arguments are completely ignored by the technologies' advocates; nevertheless, a number of commentators display a tendency to assume that the advantages of new multimedia technologies are self-evident and indisputable. There is no doubt that new and valuable possibilities are presented by the latest developments. However, so often any expression of doubt or scepticism about these technologies is met with accusations of 'Luddism' (that much-maligned label!) or similar. Accordingly, multimedia's seers and prophets themselves run the risk of being dismissed as soon as it becomes clear that their predictions and reality remain as far apart as ever.

9 Data Communications and the Internet

While the technology for the transmission of sound (telephony, radio) and picture (television) is now well-established, the transmission of information in another form, text, is rapidly developing. Of course, in a sense the telegraph was a form of text data transmission, but it required the use of operators at each end, which removed the message originator from direct 'contact', and which introduced a delay in transmission and reception, which was subsequently eliminated by the telephone. Data communications is taken here, therefore, to mean a further development of the telephone's qualities, enabling the instant, point to point transmission of text and images. Whilst it is true that the origins of data communications systems can be traced back to the pre-telephone era, one must be prepared to acknowledge that the 'printing telegraphs' of the time were cumbersome, notoriously unreliable and consequently not extensively deployed. Widespread use of text communication began in the 1930s with the advent of teletype machines and telex (from *tele*printer *ex*change) networks. Even though the telex system is a low speed data network, and is limited to the use of capital letters and just a few punctuation marks, it continues to be widely used today throughout the world. It is now joined by the fax machine and electronic mail as point-to-point data communications systems.

These communications systems are usually arranged as networks of varying sizes; rather than having just two data terminals permanently connected together, it makes more sense for a number of terminals to be interconnected, permitting any single terminal on the network to connect to any other by means of a switching system, just like the telephone system. So, while the earliest telex installations linked just one or two businesses, or often several offices of the same business, it was not long before it grew into a large international network, with the number of UK subscribers quadrupling in the six years to 1960 (Barton, 1968, p.4). Similar

growth has occurred over recent years in computer networks: just a few years ago a computer network was small scale, merely allowing sharing of facilities such as processors or printers; computers are now interconnected on a global scale, enabling data exchange to take place over large distances. The development of these networks has prompted intense speculation recently about the potential role of the Internet and 'Information Superhighway' in the organisation of society.

Equipment for data communications

A data communications system, like any other communications system, needs suitable transmitting equipment, a channel and a receiver.

Data terminals

Like the telephone, data communications terminal equipment is usually capable of both transmission and reception, since most data networks are two-way systems. Thus a fax machine can send as well as receive messages; a bank's 'hole in the wall' cash dispenser (an automatic teller machine, or ATM) requires messages to be sent as well as received before it will issue money. Computers of course are used for extensive data processing purposes, the results of which can be transferred directly through data networks without any need to print them out first; they are also increasingly being used as communications terminals in their own right. Many predict a major expansion of computer mediated communications (CMC) with a number of implications for industry and the development of consumer 'information markets'.

Channel

The channel usually consists of cable and radio or microwave links. These may be private circuits, owned or leased from a telecommunications company, or public data and telephone networks can be used. The choice of channel depends on the extent to which they are to be used: an organisation which has a number of buildings spread over a large site may well install its own private network linking all buildings for data and internal telephone traffic; a company's head office is likely to need to send data to and receive data from a number of branch offices all over the country, and may well lease its lines from a company such as BT or Mercury. If there is a large quantity of data traffic then leased lines may work out cheaper and they can of course also be used for ordinary telephone calls. There is always the telephone network (PSTN) to fall back on when the leased lines are busy. On the other hand, if there is only occasional traffic, or communication with a large number of separate destinations, it can be most effective simply to use the PSTN, even though its data transmission capacity is limited.

If the PSTN is to be used, then the signals which are transmitted obviously must be compatible with PSTN requirements. Fax machines are designed to generate suitable signals. Computers, which produce digital data which in general is not compatible with the PSTN, must be converted; the computer must be connected to interfacing equipment for connection to the PSTN and the interface is known as a modem.

Switching in networks

There are three principal methods by which information may be switched and routed through a network. Circuit switching is employed widely in the PSTN

and involves a complete circuit being temporarily connected between caller and destination. This can sometimes take a few seconds to establish, which is no problem for a telephone conversation, which usually lasts a few minutes at least. However to transfer a data message, a few words or numbers for example, the actual 'call' time is only a few seconds, or sometimes fractions of a second, in which case the setting up time is significant, and so circuit switching can seem wasteful. Since a complete circuit is established, however, circuit switching does permit fully interactive, 'real time' conversation, again a necessity for a voice call.

An alternative for data transfer is message switching, a 'store-and-forward' system, in which relatively short circuits are set up not between caller and destination but between a succession of switching nodes. The node contains a memory store, and the message is held there until the next piece of circuitry is available and set up, when it is forwarded on the next stage of its journey. This means that only a part of a complete circuit is in use at any one time, and makes more efficient use of the network.

A third and more recent development is the packet switched data network (PSDN). This is also a store-and-forward system but it overcomes one disadvantage of message switching: the requirement in a message-switched system to forward the whole message at once between nodes can 'tie-up' sections of circuit for a relatively long time. This may result in delays before a section of circuit becomes available, making it unsuitable for 'interactive' data transfer. Packet switching overcomes this by not sending the whole message between nodes, but dividing each message up into a series of 'packets', each a few hundred bits in length, attaching address information in a 'header', and forwarding the message packet by packet. Since the individual packets are much smaller than the whole message it is easier to slot them into a circuit in between packets of other messages. The effect is a much more efficient use of the network infrastructure and faster message transfer, so that data transfer can approach the speed of a truly interactive facility. The use of digital switching systems allows not only the attachment of address information to each packet but also error correction routines to ensure accurate transfer.

LANs, MANs and WANs

A data communications system can be small scale and dedicated to a specific purpose. For example, a workplace security or clocking in system is a straightforward data collection process where an employee 'swipes' his or her card through a reader, which then sends data such as the employee's name and the date and time to a central data bank. In a system such as this data traffic is one way only and usually very local. Other local networks may be more diverse in function, allowing two way traffic and a range of tasks to be performed at any terminal. A system in a large organisation might, for example, allow searching of a central database, electronic accounting procedures permitting financial transactions between departments and central administration, and provide internal electronic mail. A network like this, which serves a small geographical area such as a single organisation in a few buildings, is called a local area network (LAN). It is common for an organisation to install its own LAN with its own dedicated cabling, which can provide fast data transfer rates.

Other organisations operate over a much larger geographical area. For example banks and the financial institutions which operate credit cards have international communications networks which allow cash to be withdrawn from ATMs

or credit card purchases to be made all over the world. This obviously involves the rapid transfer of vast quantities of data, and cables, terrestrial microwave and satellite links all make up parts of the network. Not surprisingly, a system like this is referred to as a wide area network (WAN). As explained earlier it is often not economical for the operators of a WAN to build a dedicated system, using its own cables, and extensive use is commonly made of leased lines and the public networks, with consequent limitations on the maximum data transfer rate.

In between these two designations comes the Metropolitan Area Network (MAN). As its name suggests this is likely to serve an area the size of a town or city, and might be used to describe the networks built by cable companies for the provision of cable television. These smaller networks (LANs and MANs) can serve as gateways to wider area networks, or to the Internet; while most time might be spent operating within the local network, suitable connection can be offered outside the network often via the public telephone or public data networks provided by the telecommunications organisations.

Making the connection: interfacing, data rates and protocols
Interfacing

The telephone network is a bandlimited system ie the channel bandwidth is deliberately restricted. Audio frequencies below 300 Hz and above 3,400 Hz are blocked. Many stages of the system use analogue signals. Computer data, which is digital and whose data rates do not always fall within the 300 – 3,400 Hz range, is not therefore suitable for direct connection to the PSTN. A modem provides the interface. The modem (from *modulator-demodulator*) uses the digital computer data to modulate a carrier wave within the telephone frequency band and to perform the reverse operation on reception. In effect the process is exactly the same as the modulation of high frequency carrier waves used in radio broadcasting (see Chapter 3). The digital data signal modulates the amplitude, frequency or phase of the carrier. In amplitude shift keying (ASK), like amplitude modulation, the carrier's amplitude varies to reflect the size of the data signal. Obviously, since the data is digital, the modulated carrier's amplitude can adopt just two levels representing the 1s and 0s of the data signal. Figure 9.1 illustrates the processes of ASK, frequency and phase shift keying (FSK and PSK).

Data transfer rates

Since, as in all forms of modulation, the carrier wave has to be of a higher frequency than the modulating signal, it follows that if the carrier is restricted to a maximum of 3,400 Hz, then this limits that maximum rate of data transfer. The rate at which data can be transferred is known as the bit rate, measured in bits per second (bps). So a simple modulation process involving one of ASK, FSK or PSK would result in a maximum bit rate of around 3,400 bps. More complex modulation techniques use advanced PSK or a combination of ASK and PSK (known as quadrature amplitude modulation, QAM); instead of just allowing the carrier to take one of two levels, or the phase to swap between one of two angles, a greater number is allowed. For example if the carrier is allowed to take one of two amplitudes *and* one of two phase angles each time it changes, one of a total of four levels can be represented: systems offering four, eight or even sixteen levels are available. The effect of this multilevel coding is that each

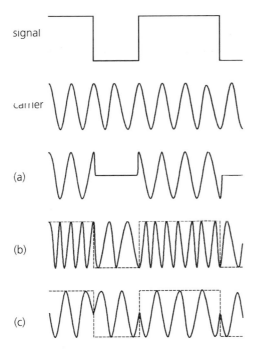

signal

carrier

(a)

(b)

(c)

Figure 9.1.
Shift keying. A carrier wave can carry digital signals by a process similar to modulation. The digital signal changes either the (a) amplitude, (b) frequency or (c) phase (where the wave starts at different points in its cycle) of the carrier wave to represent the two possible states

change in carrier signal can represent two, three or four different bits – if the signal can take one of sixteen possible levels, for example, then four bit values can be represented at each change. So the actual rate at which bits are transferred (the bit rate) is higher than the rate at which the carrier signal changes state (the baud rate). Thus at the time of writing modems can transfer data at speeds of up to 28,800 bps within the telephone bandwidth.

Protocols

With a number of different modulation techniques available for data transfer over the PSTN, and other methods for transfer over private networks, there needs to be a set of recognised standards so that manufacturers can build equipment which can be connected together and software designers know what type of signals will operate in the network. A number of standards for communication have been drawn up by the International Telephony and Telegraphy Consultative Committee (CCITT); these are designated, for example, V22 or V27. Similarly, standard hardware protocols have been drawn up, for example the Electrical Industries Association RS232 standard interface protocol, which define the signal levels, pin connections and maximum bit rates used in equipment given that designation.

A more recent protocol which has come into widespread use is known as TCP/IP. This stands for Transmission Control Protocol/Internet Protocol, and defines the mechanisms by which messages are transferred between computers. Its widespread adoption has enabled the increased interconnection of computer networks (via the public data and telephone networks) resulting in the emergence of the global network known as the Internet.

Data communications in use

While the electric telegraph can be considered to be the earliest example of an electrical data communications system, current understanding of the description encompasses a wider diversity of functions. The following examples are grouped in terms both of chronology and of function.

Telex and facsimile

A distinct benefit of the telephone compared with the telegraph (other than the obvious one of interactive audible communication) was promoted at its inception by Alexander Graham Bell in his letter of 25th March 1878, reproduced in Pool et al (1977, p.156):

> The great advantage it possesses over every other form of electrical apparatus consists in the fact that it requires no skill to operate the instrument. All other telegraphic machines produce signals which require to be translated by experts, and such instruments are therefore extremely limited in their application, but the telephone actually speaks, and for this reason it can be utilized for nearly every purpose for which speech is employed.

The telephone's usage was therefore not dependent on the services (or availability) of a skilled telegraph operator. The same applied to the telex machine: not only was it faster than a telegraphic communication (although at 50 to 100 words per minute, not much faster than the speed of a good typist), it was also independent of external agencies and so it could be used day and night, requiring a relatively low level of skill for its operation. Amongst other uses it rapidly became a routine means for news journalists to file reports to their newspapers' head offices. Telex systems continue to be in extensive use around the world. However, in many industrialised countries, the number of telex lines is decreasing. Part of the explanation is the emergence towards the end of the 1980s of a successor to telex, called teletex, which can use the existing switched telephone or data networks (unlike telex, which requires its own dedicated lines). A teletex terminal is very much like a computer terminal and data transfer is much faster than telex. The quality of the output is also improved, with upper and lower case letters and many additional signs and punctuation marks. However, the widespread adoption of fax machines and personal computers with modems, as well as prompting the decline of telex, appears to have stalled the introduction of teletex, if not prevented it altogether (eg see Jeppesen and Poulsen, 1994). Indeed, in the UK British Telecom stopped offering the teletex service in 1988.

The facsimile (*fax* or *telefax*) machine has its origins in early printing telegraphs which used a system of scanning an image or text and transmitting a series of signals along telegraph wires to a receiving printing terminal. This used the signal levels to create a reproduction of the image, scanning down a sheet of paper in synchronisation with the transmitting scanner. The electronic fax machine uses the same principle of scanning and is rapidly becoming a standard item of business equipment. The speed of fax machines is much greater than telex, and furthermore, fax machines can send hand-written copy as easily as typed print; it can also transmit and receive graphics (a company can include its logo or letterhead on a fax communication). Consequently fax communication is in increasing use in business. Many machines have telephone number storage and multiple destination facilities so that mailshots-by-fax rather than via the postal system are increasingly common.

A growing number of public libraries and shops offer fax facilities to the public for a relatively small fee. However, fax traffic is heavily dominated by business users, most 'private' users happily relying on postal services for printed communication, which, it is sometimes forgotten, can normally be relied upon to deliver within 24 hours in most industrialised countries.

Teletext and videotex

Whereas telex and fax machines offer instant one-to-one data communication, the emergence of electronic technology in the 1960s and 1970s, and in particular the increasing power of computers, prompted trials of a new kind of data communication facility. On line database facilities had been available since the early 1960s (Williams, cited in Aumente, 1987, p.76). Typically, these were text-based bibliographic reference databases for the academic community, who could access the data via a computer terminal connected to a mainframe. By the early 1980s a number of more open information systems were aimed at a public audience. These carried information such as news reports, stock market prices, weather and traffic information, which could be updated regularly throughout the day yet be accessible on demand, offering a distinct advantage over other sources of information such as newspapers, radio or television. In the UK, British Telecom (while still part of the General Post Office) conducted trials of its Prestel videotex system in 1976.[1] In parallel, the BBC was developing Ceefax, its teletext system.[2] France was developing its nation-wide videotex service based on the Minitel terminal, while, in the US, a number of separate viewdata providers were launched.

British Telecom's Prestel is an interactive system, which allows information to be both received and sent from dedicated terminals. This enables services such as hotel bookings or flight reservations to be offered. The intended market was business users, public libraries and educational establishments. Teletext on the other hand is a one-way system, with coded data being included with the broadcast television signal. The teletext signal is carried in a number of the blank lines of the video signal (a 625-line TV picture only uses 575 lines for its actual picture information, the remaining 50 blank lines serving other functions) and a decoder is required to convert these signals into a display containing text and crude graphics. From its earliest days Ceefax (and its IBA equivalent, Oracle) carried pages with information of specific broadcasting interest (eg subtitles for hearing impaired viewers), and like Prestel its pages could also display information about flight availability and so on. Unlike videotex systems, however, teletext could do no more than provide a telephone number should the viewer want to act upon the information. Prestel also carried teletext pages, and, to complete the overlap, it was possible to buy a converter to allow a television set to be used as a Prestel terminal. Prestel was a chargeable service, whereas Ceefax was free (once the decoder had been paid for). Thus by the early 1980s the UK had two relatively inexpensive public information services readily accessible to a potential audience of millions.

1 'Videotex' is the accepted spelling, although 'videotext' is also in use. 'Viewdata' is yet another term.
2 Teletext, with a final 't', refers only to the information systems broadcast over the air, designed for viewing on a television receiver. It is quite different from teletex, without the 't', which has been described earlier.

Despite their promise however, the fortunes of Prestel and Ceefax (and Oracle) have been quite different. Prestel is widely regarded as a failure. Administration of charges for the system was clumsy: to access a number of databases would require individual subscriptions to each of the information providers, and another payment to be made for call charges. The quality of the information provided via Prestel was also variable. Teletext, on the other hand, is growing in popularity, albeit slowly. One explanation for this growth is that, compared with many other countries, the UK has a high proportion of rented television sets, and so replacement with one which includes a teletext decoder is relatively cheap. Almost 40 per cent of households in the UK have a teletext set, and over 7 million people use the service daily (Central Office of Information, 1993, p.47).

In the early 1980s France began the development of its national videotex installation. The first application was to place the telephone directory for the entire nation on an electronic database. This could be accessed from a dedicated videotex terminal known as Minitel. In contrast with the approach in the UK, the French telecommunications authority chose to issue Minitel terminals free to telephone subscribers. This was justified by arguing firstly that it would replace the need for conventional telephone directories (which required continual replacement) and secondly that, with a large installed base of terminals, the system would prove attractive to other service providers who could then be charged for access. A further advantage of a separate, dedicated terminal from telephone subscriber's point of view was that the television set was not tied up while Minitel was in use. This policy initially proved attractive to telephone subscribers: between 1983 and 1985, the number of terminals increased from around 10,000 to nearly one million. The development of videotex in France is often contrasted with that in the UK, where the Prestel service has largely disappeared. The offer of free terminals, centralised billing, and easy access to several databases through a single account are cited as reasons for the relative success of Minitel. Nevertheless, Minitel has not matched its early expectations. The original target of 30 million installed terminals by 1990 was reduced by a factor of around five (Aumente, 1987, p.38); studies of usage showed that once the novelty had worn off there was a sharp decline in the amount of use made of Minitel (Raulet, 1991, p.56). Not everyone wanted a computer terminal in their front room, yet the potential replacement of the conventional telephone directory implied a degree of compulsion. Although the terminals were provided free, many of the services provided were chargeable: in 1985, Minitel generated an extra $70 million for French Telecom; one national newspaper made $300,000 through its information services during a single month in the mid-1980s (Aumente, 1987, p.38). Thus there were sometimes good reasons why the public might not welcome Minitel with open arms.

Computer based communication

The computer-based communications mechanisms which were developed in the 1960s were based mostly on interconnection of large computer mainframes (in which a central computer housed all the processing power, and to use it a terminal had to be permanently connected to the facility). The late 1970s saw the development of compact 'personal computers' which were self-contained, or 'standalone' in the jargon of the day. Unlike mainframe systems, PCs could do their own processing and be used independently of any other equipment. However, there would be times when a number of PCs might need to share a

common facility such as a printer. Thus it became necessary to interconnect PCs and computer networking technology, hardware and software (eg Ethernet) was developed. Most organisations now interconnect their computers in this way. Networked computer systems allow data to be exchanged between terminals (and therefore their users) very quickly.

The increasing use of computer technology has allowed the growth of a number of information providers offering on line services designed specifically for use with a computer. A number of these began in the United States, the biggest and perhaps most well-known being CompuServe, which now offers its services in the UK. While primarily aimed at the business sector, with the growth in ownership of home PCs (around one third of US households and a quarter of UK households currently have a computer) they have begun to include the consumer market as well. In some respects similar to a videotex system, with access provided to a network of databases offering, for example, news and travel information, these organisations offer additional features such as electronic mail and, more recently, access to the Internet and World Wide Web. Electronic mail (or e-mail) is a text-based messaging facility which allows users to send mail to another individual, or group of people, the transfer taking a very short time. It is sometimes possible to transfer graphics and formatted text via e-mail using coding, provided that the recipient's mail facility has a suitable decoding function. The information service provider stores incoming mail in sequence on its host computer, until the recipient connects to the host and reads their mail, which can then be saved on their own computer or printed out. In some respects therefore, e-mail combines the features of a fax machine and a telephone answering machine.

A further advantage of these on line services over videotex is that there is a near universal standard for home computers, that is the IBM PC clone running Microsoft Corporation's Windows. Different videotex systems are not mutually compatible, so subscribers are generally restricted to information sources from one country. With computer-based on line services, standard protocols allow information to be exchanged between countries all over the world through the Internet.

A modem is required to connect a personal computer to the on line service via the PSTN, and although any necessary software is normally provided free by the service provider for installation on a subscriber's machine, there is normally a monthly flat-rate fee, plus a charge for connect time above a certain number of hours. The subscriber must also, of course, pay the telephone line call charges (and possibly the installation costs for an additional telephone line if the facility is to be used extensively). So, in comparison with videotex and teletext information systems, a considerable capital outlay is required to connect to these services, and recurrent costs can also prove relatively expensive.

The growth in the numbers of these service providers, and the increase in the number of subscribers, has led in recent years to a number of claims about the potential of these new communications services, and in particular the Internet. Some of these claims will be explored in the following chapter, but, as the preceding paragraphs have shown, it should be remembered that the means of moving large quantities of data around the world at high speed and of accessing vast quantities of information have existed now for almost two decades.

ISDN: the Integrated Services Digital Network

The ISDN is a developing system which takes into account the fact that the existing PSTN was originally designed to carry voice communication, an objective which it successfully achieves. Nowadays, different demands are made of the PSTN. In the US, for example, voice communication produced less traffic over the telephone network than data communication in 1992. The ISDN is part of an attempt to match the PSTN to these new requirements. In essence, ISDN replaces the analogue parts of the PSTN with digital technology. Already large sections of the PSTN are digital; the local loop (the link between the home or business and the local exchange) however remains analogue. Installation of an ISDN line completes the digital circuit, and thus represents but one stage in a process of development of the existing PSTN.

In its basic format an ISDN line offers two 'voice' or data channels, and an additional slower channel for control data or slow data transfer. The three channels are multiplexed onto a simple twisted pair wire. Higher data speeds are offered: the two voice channels operate at 64 kilobits per second (kbps) and the data channel at 16 kbps. If all channels are simultaneously used, this gives a data rate of 144 kbps, compared with a typical modem rate of 28.8 kbps. Up to eight terminal devices can be connected to the ISDN, so, for example it would be possible to send a fax or data down one channel while speaking on the phone at the same time, using the other channel. The slow data channel is also available for additional data transfer.

While the ISDN data rate is sufficient to carry compressed or slow-scan video for video telephony and videoconferencing purposes, it is not fast enough to allow full motion video to be carried. Broadband ISDN has been proposed as an alternative to the ISDN, which in this scenario is seen as a mere intermediate stage of development. B-ISDN, being based on entire optical fibre networks, would offer vast bandwidth, sufficient for video as well as full telecommunications applications. However there is likely to be an even longer delay before B-ISDN becomes a real possibility, given that most existing PSTNs are only slowly upgrading to 'mere' ISDN capability, in what might be referred to as a process of evolution.

Why has the growth of ISDN been so slow when the advantages seem clear? The first response is that there may in fact be no advantage to domestic telephone subscribers, most of whom use the telephone solely for its original purpose and are not particularly interested in any additional function. For businesses, there are clear advantages: there is no need for a plethora of modems to connect data terminal equipment to the PSTN; since up to eight items of terminal equipment can connect to the ISDN, it may be possible for small companies to dispense with PABX systems (Private Automatic Branch Exchange, a company's own 'switchboard'); and, obviously, fewer lines are needed for a business's various voice and data communications requirements. The primary reason for ISDN's slow adoption must come down to pricing structures: it is still possible to install a number of conventional analogue telephone lines for the cost of installing a single ISDN, and the rental charge for an ISDN line is similarly several times that of an analogue line. A company would also need to buy suitable equipment to interface existing terminal equipment with the ISDN. The uncertainty over the future of ISDN and its possible succession by B-ISDN, compounded by the new telephony services offered to business by the cable TV companies, both conspire to prevent a rationally planned installation of this upgrade in the national telephone service.

The Internet

While the preceding sections have described how electronic communications technologies have been used for many decades for the transfer of data, both text and image, the last few years have seen the emergence of a new phenomenon. What makes this phenomenon new is not so much the technology, but the use and awareness of it, and especially the degree of speculation about its possible implications. The Internet has become shrouded in a mystique which was never accorded the introduction of teletext, videotex or, before those, telex. The information age is upon us, a new 'Athenian age of democracy' (US Vice President, Al Gore) courtesy of the 'digital revolutionaries' (*Wired* magazine).

In fact, the technology which comprises the Internet is the result of a steady process of evolution, in contrast to the level of commentary made about it.

What is the Internet?

A succinct description is 'an interconnection of computer networks'. Some of the earliest computer networking systems were developed in the 1960s and 1970s by the US Department of Defense, and involved linking computers in the defence department and research establishments across the US together in a wide area network (WAN). The Transmission Control Protocol/Internet Protocol (TCP/IP) was developed for this purpose.

During the 1980s the number of local area networks (LANs) around the world was steadily increasing with the development of personal computer networking software, so that for example, universities, large businesses and libraries would each have their own network. However these LANs could not always be connected to each other, since they used different protocols, so that no common set of rules operated. By incorporating TCP/IP into the LAN's networking software it became possible for widely-dispersed LANs to be connected to each other; by the mid-1980s TCP/IP had become a standard protocol for interconnection of LANs in the US academic world. In Europe similar developments were taking place and university networks were linked together via the Joint Academic Network (JANET). Although this operated on a different protocol for many years, it now supports TCP/IP. Now government departments, businesses and similar organisations have incorporated the Internet protocol into their networks, and new businesses are setting up as access providers offering Internet connection to the public. An increasing number of staff in these organisations are devoted to maintaining the operation of these 'host' systems, which store data which is to be made accessible via the Internet.

Thus within the last few years the number of networks which can be interconnected, and therefore the number of people who can access the information stored on those networks, have increased dramatically. The emergence of *public* access via Internet service providers such as CompuServe and Demon potentially makes this information available to anyone (provided, of course, they have access to a PC, a modem, and the requisite knowledge and funds for their use). It is perhaps this *potential* (rather than the reality) which excites the imagination of so many current commentators.

What can you do with the Internet?

While people make use of the Internet in many ways, their activities can be grouped mainly into a number of areas. Most people's use of the Internet is to:

- search for information: it is possible to connect to databases stored on computer systems around the world eg the library catalogues of most universities are available for searching (using 'telnet' links). Tools for navigation around the Internet allow keyword searching for links to items in a chosen category;
- send and receive electronic mail: the Internet offers a common platform for e-mail between different networks;
- download data: using the file transfer protocol (ftp) data can be downloaded ie copied from a remote Internet host computer to the user's own desktop machine. This is widely used for the transfer of public-domain computer software ('shareware');
- join discussion groups: Usenet, Newsgroups and Bulletin Board Systems, are ongoing e-mail discussions, which are grouped under particular items of interest. Every member of the group can read what anyone else has written to it and can send their own contributions, and many groups' discussions are also available on the Internet to be read by non-members.

The information is not always in the form of text: increasingly it is conveyed through graphics, audio or video material. These make greater demands on the hardware – it takes much longer to download graphics, longer still for audio and video, but connection speeds are continually increasing, making such transfers possible. The range of information available is growing all the time. In addition to university departments making research material available, traditional paper media such as newspapers and magazines can be found; radio stations (including their audio output) can be downloaded; galleries put text and pictures on the Internet; Usenet or news groups cover a vast range of topics (from the general to the particularly idiosyncratic). Thus while some of the information available is a mere adjunct to the traditional means of dissemination (academic journals, paper newspapers, 'real' art galleries etc.) some of it does not have an exact parallel in any other medium (for example, newsgroups differ in some respects from conventional clubs and societies; some art projects available on the Internet claim to be exploring novel forms of expression offered exclusively by these technologies). This has led to some commentators to see the Internet as a new and unique cultural medium and they therefore refer to the existence of a 'virtual' life and a 'real' life; thus in 'virtual galleries' it is possible to view works of art which are drawn from various parts of the world; a 'virtual community', 'meeting' and chatting via the Internet, is no longer constrained by geographical definition (as it is in real life, or 'IRL' as the virtual citizens would have it). The echoes of McLuhan's 'global village' are there for all to hear, and these issues will be discussed in Chapter 10.

How to connect to the Internet

The cheapest way to obtain access to the Internet is to become a member of staff or a student at a university or similar institution, or perhaps a journalist! Organisations such as these, and an increasing number of other businesses, make

extensive use of the Internet and therefore make it available to their employees (or at least certain categories of employee). Failing this, most other users connect via a dial-up service provided by organisations such as CompuServe or Demon. In the same way as connection to any of the on line services (see above) the cost of the equipment and connection charges mean that access to the Internet is not necessarily cheap. An alternative is to visit one of the growing number of outlets which offer access to an Internet terminal, and which charge by the hour. Many of these sites are located in cafes, or 'cybercafes', which allow you to let your coffee go cold while you 'surf the net'.

The World Wide Web

The World Wide Web (WWW) is a platform which allows navigation through the Internet via a 'hypertext' system. Almost all Internet access providers offer World Wide Web access. In conjunction with so-called 'browser' software such as Mosaic or Netscape, in effect it replaces a system of typed commands (telnet and gopher) with a graphical user interface which allows commands to be executed using a computer mouse. In a sense, from the user's point of view, it is comparable with using Microsoft's Windows rather than MS-DOS. The text (or graphics) is displayed as 'hypermedia': sections of the text or picture inserts are highlighted, identifying them as 'hyperlinks' to other Internet sites, sometimes referred to as 'web pages'. Clicking the mouse on one these links would call up pages related (in the opinion of the page's author) to that section of text. For example, if this paragraph were part of a WWW page, it may be that the words 'Mosaic' and 'Netscape' above would be highlighted, serving as links to sites where those pieces of software might be described or downloaded. In this way, these browsers make Web navigation somewhat simpler. Nevertheless, one of the enduring complaints amongst both new and many experienced users is the difficulty of finding one's way to a particular piece of information, finding the useful article which is the proverbial needle in the haystack of useless information.

Who uses the Internet?

Statistics on Internet use are somewhat meaningless: data is almost impossible to gather, and once compiled is invariably out of date. Nevertheless, the following statistics might give an indication of the use of the Internet.

According to Mark Lottor's surveys (cited in Schofield, 1995) there were 6.6 million host computers world-wide in July 1995 (up from 3.2 million the previous year). Almost two thirds of those hosts were in the United States. On his assumption that each host serves ten users (an assumption which has little empirical basis, and which some believe is conservative, others believe optimistic), that equates to 66 million users. This, however, reveals little about the amount of usage individuals might make of the Internet, and nothing about the purposes for which it is used.

A Nielsen/CommerceNet survey in 1995 profiled those users (Screen Digest, 1995a): it found that there were 24 million users in the United States aged 16+, who used the Internet for an average of 5.5 hours per week. It compared Internet usage with television viewing. The results are shown in Table 9.1.

An indication of the unreliability of such figures is given by a similar survey in the same year by New York based consultancy Find/SVP. It claimed that there

Table 9.1 Breakdown of Internet users, 1995

Percentage of users who:	TV	Internet
are male	44	77
aged 18 – 34	28	53
have an annual salary of $80k+	10	25

were 9.5 million US users, 1.1 million of whom were under 18, and 35 per cent of whom were women (Screen Digest, 1996).

Some insight into users' satisfaction with Internet services is provided by still more statistics, this time the 'churn rate' (ie the number of subscribers who sign up for a service but later cancel, or fail to renew their subscription). Of subscribers to major US Internet providers (CompuServe, America On Line, Prodigy, Delphi and Genie), 6.2 million tried the service and cancelled, which actually exceeds the number of subscribers who have stayed connected, at 5.6 million (Screen Digest, 1995b).

Conclusion

For more than half of the lifetime of the telephone network there have been electronic data networks allowing the transmission of text and pictures. The growth of this usage has been greatest during the last decade – for example, in the four years to 1991, the number of fax machines increased more than fourfold in at least twelve major European countries, and in some cases by a factor of ten or more (United Nations, 1994). The gradual upgrading of public telephone and data networks enables this pace to continue, and the falling relative costs of computers and associated communication equipment means that more people are using data communications facilities for an increasing variety of purposes. Some of the more visionary claims about the Internet reflect and often extrapolate from this.

Data communications technology has undergone a gradual process of development over the decades, in a similar manner to the other electronic technologies discussed in this book. This has resulted in the ability to shift more data more quickly than ever before. But one consequence of this increase in capacity is that more and more is demanded of those technologies. So there are still complaints that transmission rates are not sufficient: for instance it is not possible to get full motion video down a telephone line; downloading graphics off the Internet continues to be a painfully slow process; sometimes even the time taken to send or receive an e-mail message can seem to be too long. It will probably always be the case that data handling capacities will never be enough for some, while being more than adequate for the majority of people. Whether the ability to shift ever-greater quantities of data and information is leading to the development of a new kind of society is a question considered in the next chapter.

10 The Internet and the Information Society

Two Case Studies on the Role of Technology in Society

While descriptions of technical systems are useful for an appreciation of 'how they work', an *understanding* of technology must also include consideration of its role in society. Much of this book has concentrated on the workings of the technology, yet time and again instances have been shown of technical development being dependent on other agencies, such as governmental policy or business interests. However, a widespread perception of the role of technology is that it is itself largely neutral, that its further development is inevitable and that it acts as the central force in determining how society progresses. Just as commentators write about the 'profound impact' which the telegraph, the telephone and broadcasting are claimed to have had on society in earlier times, so cable systems, the Internet and mobile communications are all currently predicted to have their own dramatic consequences. It is as though Bell and others at the time simply stumbled upon the idea of the telephone, but once it had been invented, there was no stopping the effect it would have on businesses, on jobs and on our daily lives.

Yet this was not the case. As we have seen, after a race to patent the idea, Bell very quickly went to big businesses to back him, and had to describe the commercial application of the telephone to win that backing. All technologies go through a similar test. Some technologies will be supported, some will not. Business owners could see potential value in the telephone and therefore a market for it and profits for them. To understand the social role of a technology it is necessary to look at who owns it, who uses it, what it is used for, and importantly, who decides these things.

Unfortunately, these questions are rarely asked. Instead the technology itself is focused on, and its potential considered in isolation from any other agencies in society. So steam power is seen as having brought about the industrial revo-

lution and the railways, causing the decay of the canals; the internal combustion engine led to the development of the car, in turn beginning the decline of the railways. Nowadays, information and communications technologies are expected to continue this trend, and the Internet, some argue, is likely to lead to a reduction in car travel! Similarly the arrival of the 'information society' is an inevitability, and the Information Superhighway will 'touch all of our lives', according to US Vice-President Al Gore.

This view can appeal to 'common-sense' reasoning – yes, before steam power more people worked on the land and canal boats were drawn by horses, whereas after steam (leap-frogging more than a century of change in society) people worked in factories in large towns and railways were used for transporting goods. Thus, the argument concludes, the invention of the steam engine created these changes in working and social conditions. The implication is of a direct causal relationship – the changing technology led to the social consequences. But, like the telephone, the steam engine was also not simply stumbled upon. An alternative view recognises the wider context in which it emerged. Steam power technology developed precisely at a time of industrial expansion when more and more people were being driven off the land into cities, and it served that transition rather than causing it. It is the former, 'technology first and foremost' view, often labelled technological determinism, which seems to be more evident today in commentary about the emergence of the new communications technologies.

To illustrate the different approaches, two examples will be considered: the Internet and the related idea of the 'Information Society'. Both examples reveal a number of arguments which can be applied to technology and society in general. First, the arguments for and against technological determinism will be discussed.

Technological determinism

According to this theory the direction in which any technology develops and to a large extent the pace of that development are automatic or autonomous. Therefore the social consequences of that development are largely inevitable. There is little option for society to take an alternative path. The technological determinists see change as inherently progressive, pointing out the benefits, as they see them, which naturally follow in the new technology's wake. However occasionally they acknowledge that there may be an element of choice about the social consequences of new technology: some effects might be problematic, but they are none-the-less unavoidable, and society must learn how best to cope with them. For example the 'inevitable' unemployment (and, more importantly, potential for social unrest) which would result from the introduction of microelectronics to the workplace might generate debate about how to occupy, retrain or sustain those without work. At best, therefore our priority should be to choose the most advantageous (or least disadvantageous) of the various options which the technology places before us.

This kind of thinking tends to feature in the speeches of politicians or industrialists, who, perhaps, stand more than most to benefit from the argument that the consequences of technological progress are in some way inevitable. Thus government policy describes as self-evident the essential requirement for increased training and education in the new technologies in schools and colleges. New satellite and cable television technologies naturally mean that broadcasting can no longer be protected from market competition. Employers making

large numbers of their workforces redundant point to the 'inevitable consequences' of new technology; consider, for example, a recent national newspaper headline, 'Banks profit from high-tech job losses', which could be taken as implying that technological developments alone have caused the workforce reduction (Bannister and Atkinson, 1995).

Ironically, the same kind of reasoning can also influence the ideas of people who are opposed to the consequences of technological change. For example increasingly sophisticated surveillance systems are seen to further restrict individual liberty; if television has made its audience passive, more television (via satellite and cable) would only make matters worse. Thus those who criticise aspects of technology may equally regard technological change and its consequences as inevitable, though in this case with increasing pessimism. Again, the most we can hope for is to develop strategies for coping with the technology. While it is reasonable to criticise the earlier positive outlook as naive and simplistic, the pessimistic view can equally be criticised. Both imply an acceptance of an almost predestined set of outcomes of technical change (predestined, on the one hand, because of the supposed nature itself of science and technology and on the other because of the existing power structures in society). Both therefore deny any possibility of broader social factors in deciding the 'effects' of technological development.

Technological determinism therefore contains a number of characteristic arguments:

- technology develops autonomously and progressively;
- technology, and the science upon which it is presumed to be based, are themselves therefore socially neutral or value-free;
- its social impact is inevitable;
- society must therefore adapt to the changing technology.

Technology in its social context

An alternative starting point is to recognise that technology develops in a particular social context. No technology evolves in a social vacuum – for a start, technological progress is produced by people, who are themselves members of a particular society.

The direction which technological development takes depends on a complex relationship of social, political and economic factors. It depends on vast amounts of funding, and so this immediately restricts the range of organisations which can choose to promote technological change to large businesses and corporations and government agencies. Further, the competition inherent in a capitalist economy means that industry will only fund that research from which it can anticipate making a profit. This inevitably places constraints on technological development: there must be a market for the new technology. Sometimes this can mean companies take risks with novel technologies in order to seek competitive advantage (often disastrously from a business point of view) but more often, means that cautious evolution is the favoured route. Webster cites a former editor of *Computing* magazine who asserts that most 'new' technology is in fact 'old' in that it is merely a development of existing technology. Webster concludes, 'it is striking that most informational products for the home [video recorders and cameras, computers, satellite and cable systems] are actually enhancements of the television set. Why offer anything radically different when

television has shown itself to be the public's favourite leisure technology?' (1995, p.83). In fact, rather than technological change being a result of inspired leaps of inventors' imaginations, as is popularly promoted through television programmes such as *Tomorrow's World*, new technology 'typically emerges... from existing technology, by a process of gradual change to, and new combinations of, that existing technology. Even what we might with some justification want to call revolutions in technology turn out to have been long in the making.' (MacKenzie and Wajcman, 1985, p.10)

Economic imperatives are therefore inseparable from technological development. The most visible demonstration of this is perhaps in the workplace, where there is a clear relationship between technology and profitability. Hence, in the article referred to above, in discussing the job losses in banking Bannister and Atkinson (1995) argue that 'the new banker, rather than new banking technology, is the key to understanding the huge staff cuts'. If the expense of a technology can be recovered through the reduction in labour costs it produces, then it is likely to accelerate development; if labour costs are cheap, however, then technological progress is likely to be slowed.

Cowan illustrates this with two examples: cigar making in the US in the latter half of the 19th century was predominantly done by skilled male workers. When they went on strike in 1869, the manufacturers rapidly developed new production technologies which enabled them to use unskilled, cheaper female labour (women have traditionally been paid less than men, employed more in unskilled labour, and are seen as more transient members of the workforce and therefore less organised in and protected by trades unions). The possible replacement of relatively expensive skilled labour was an incentive to technological development. On the other hand, if there is already an abundant supply of cheap labour, there is no incentive to introduce technological change; the garment industry is a case in point where the technology of sewing has changed only slowly, largely because the predominantly female workforce responsible for sewing is paid low wages, while associated processes such as cutting, pressing and pattern-making have developed (Cowan, 1979). Thus economic considerations are responsible for the rate and direction of technical change. This economic reasoning results in an inevitability of change, as is also predicted by technological determinism, but rather than being autonomous or neutral, the *direction* of that change is dependent on the nature of the society in which it occurs. As MacKenzie and Wajcman put it (1985, p.14):

> Paradoxically, then, the *compelling* nature of much technological change is best explained by seeing technology not as outside of society, as technological determinism would have it, but as inextricably part of society. If technological systems are economic enterprises, and if they are involved directly or indirectly in market competition, then technical change is forced on them. If they are to survive at all, much less to prosper, they cannot forever stand still. Technical change is made inevitable, and its nature and direction profoundly conditioned, by this. And when national economies are linked by a competitive world market, as they have been at least since the mid-nineteenth century, technical change outside a particular country can exert massive pressure for technical change inside it.

While there are influences and constraints on technological progress at the stage of its inception then, there are further variable factors in its consumption. The

identification of potential profitability, and consequent decisions on the direction of development, are not guarantees of success. It is not the case that a manufacturer (or government for that matter) is able to define goals, create the appropriate technology and then sell it to the market. While strategic decisions largely define which technologies are developed (and certainly any technology starved of investment will not develop, whatever the social need for it), and while these same manufacturers (and governments) are able to influence markets, there is a host of examples, particularly of domestic or consumer technologies, which demonstrate how market predictions have proved hopelessly wrong (the Sinclair C5 electric trike, the videophone, the combined computer/television receiver for instance); alternatively, there are cases where manipulations of a competitive market have resulted in an inferior technology succeeding over a superior competitor (see Cusumano et al., 1992, on how a domestic video recorder format, Betamax, widely regarded as better than its rival VHS, failed in the market; Cowan, 1989, reports why domestic refrigeration technology is based on electricity when a gas appliance offers consumers distinct advantages). So, as Raymond Williams puts it, 'while we have to reject technological determinism, in all its forms, we must be careful not to substitute for it the notion of a determined technology' (1990, p.130). In other words, those who are in the strongest position to influence the direction of technological development nevertheless do not always have it their own way.

These are the characteristics, then, of the approach which places social factors first:

- the technological knowledge is not, on its own, the cause of its effects;
- the technology does not evolve in an autonomous manner, but results from a complex set of relationships between economic, political and social forces;
- the technology will be developed with an aim or set of aims in mind;
- the uses to which the technology will be put can not always be accurately foreseen.

Technological determinism, despite its pervasive nature, has been widely criticised as a flawed theory (or set of theories); technology must be seen in its social context. Nevertheless, when we are repeatedly warned by governments, manufacturers and other commentators of the 'fundamental restructuring' that society faces from the Internet and related technologies, determinist ideas become all too readily apparent. Those who adopt such ideas invite a number of questions, and these will be explored in the two case studies which follow.

Case Study – The Internet

Here are a few predictions about the potential effect of Internet:

- There is a world where governments have next to no power, and where children are equal, if not superior, to adults. It is a world of philosophers and bandits, of big business and science. It is a place where pornographers and Nazis roam unchecked and anarchy reigns. And it is the place where, perhaps, the future of the human race is being decided. It is real, it is here right now – and Britain is a growing part of it. (Freedland, 1994)
- We temporarily have access to a tool that could bring conviviality and understanding into our lives and might help revitalize the public sphere. The same tool, improperly controlled and wielded, could become an instrument of tyranny. (Rheingold, 1994, p.14)

- I believe that we are entering an era of online democracy in publishing, and I believe the Internet will be the place where the necessary tools are forged. (Wiggins, 1995, p.xvii)
- The electronic revolution could significantly alter the effectiveness of UK democracy by ensuring that ordinary people could constantly access information and input their views using the new technology. (Labour Party Shadow Minister, Graham Allen, 1995)

While some of these predictions are more cautious than others, acknowledging an element of choice, they all share a common expectation that the Internet (or its associated technologies) will be the cause of *something*; one way or another, there will be major consequences. Some of the most profound changes are deemed to be most likely in areas such as the democratic process, work and education.

Democratic process

The ability to access and transfer information suggests that politicians and their constituents will have new avenues of communication between each other. There is a belief (commonly-held and often repeated both in the media and by politicians themselves) that popular faith in the conventional political process is at an all-time low, and that the distance between electorate and elected is assuming chasm-like proportions. So party leaders of left and right and national presidents happily publicise their e-mail addresses in order to make themselves accessible and therefore, they say, more accountable to all. Government departments make documents available on the World Wide Web. Thus, the argument goes, increasing the availability of information leads quite naturally to a better-informed electorate, which will enthusiastically engage with this more open era of political dialogue.

In a slightly different vein, some protagonists (such as Wiggins, quoted above) suggest that the Internet enhances the democratic process by allowing access to a wider range of information sources. Rather than be restricted by the ideas and opinions of the press owners, whose editorial power restricts the type of news made available, information can be placed on the Internet by all kinds of individuals and organisations, with a variety of political persuasions and interests. The usual informal processes of censorship (editors, publishers, market forces and so on), and some of the formal means, do not apply to the Internet.

Work

Similarly, the effects of Internet technology on work are anticipated to be no less fundamental. However, in contrast with the overwhelming utopianism of commentary on 'electronic democracy', there is a more polarised debate between those who are optimistic about the possibilities of 'teleworking' and the pessimistic view which foresees deskilling, wage reduction and job losses as the most likely outcomes. Teleworking, the use of communications technologies to enable people to work away from a central workplace, is a growing practice. With a modem connected to a computer terminal, computer-based work can be sent to and from a remote office. An employee might therefore work from home, or a separate office, connecting to the conventional workplace only when necessary to transfer data. According to some claims, this opens up new possibilities for employment: rural communities can be linked to city centres; for example, 15 residents of the Western Isles off the Scottish mainland, where unemployment

is twice the British average, won a contract in 1995 to process information for a company based in mainland Britain, feeding the results of their work down the 'electronic superhighway' to the head office (Murray, 1995).

On a more global scale, companies can 'contract out' their data processing to countries where wage costs are lower – for example much of the processing of British Airways' flight bookings is carried out in India where salaries are a fifth or less of those in the west. Bannister (1994) gives another example of the claimed potential for not only job creation but also national economic prosperity: 'The World Bank, for example, has trailed the idea of security cameras in shopping malls [in the US] being monitored by people in Africa. "There is potential for African countries to come into the global economy through these types of technologies," a spokesman said.' Critics argue that the increasing power of data communications technologies will result in large scale unemployment in the relatively high waged Western economies with profound social consequences such as growing divisions between rich and poor, and a developing 'underclass' which will become completely disenfranchised.

For the individual worker, teleworking is claimed to offer a number of tangible benefits, and also more widely to society as a whole. For example:-
- travelling to and from work is eliminated;
- working hours can be more flexible, fitting work around child-care for example, which is claimed to appeal to, or even open new opportunities to, women who traditionally bear that responsibility;
- the working environment (ie home) can be more friendly, comfortable or simply more familiar;
- with less commuting, the environment will suffer less pollution.

Some arguments go further than these few examples: office hierarchies and prejudices such as racism and sexism will not apply when communication is anonymous; reward and promotion will therefore be based more on merit than subjective impression. Thus the application of technology is seen to solve many of the problems often associated with the daily routine of going to work. Of course, while there may be benefits for the employee, the advantages of a 'teleworkforce' to an employer (of not having to provide office space, canteen, childcare facilities, disabled access and so on) may be a more significant factor in the predicted growth of teleworking.

Education

Given that the Internet's origins lie in the academic and research institutions, it is not surprising that it is seen as having a role to play in the process of education. Universities are beginning to make some course materials available for distance learning via the World Wide Web, although currently only on a very small scale. The Internet is also being used increasingly as a teaching tool, with students using it (much like any other database) to search for information. Both of these applications are expected to increase in scope, with some predicting a vast increase in the numbers of students pursuing remote courses in this way. They speak, in effect, of a 'global market' in education, since it would be as easy to study a module provided at a university in New York as one in York.

Some of the claims about the liberating potential of the Internet go further still. The proliferation of information available will remove the institutional barriers to knowledge which exist within higher education, knowledge which is currently jealously guarded by academics, it is argued. One senior industrial

technologist is reputed to have told members of an academic audience that the technology which would make them redundant was already in existence.

A more pessimistic prediction of the consequences of the new technologies is that fewer teachers will be required in the future, and that small, 'minority interest' subjects will disappear since they will no longer be able to compete in the new, global education market.

Both optimistic and pessimistic forecasts presume the same logic of technological development: the new technologies will continue to develop, and the consequences of that development (which are very similar, whichever standpoint is taken) will inevitably follow.

A critique of deterministic views of the Internet

The first point to make is that those who predict optimistic and pessimistic scenarios both overstate the pervasiveness of the Internet. Despite the amount of attention given to it, there are still very few regular users of the technology. Even of those who do use it regularly, many use it simply for one-to-one e-mail, a function which could be performed equally effectively in most cases using a fax or telephone answering machine (or even, in some instances, by walking down the corridor)! Certainly e-mail is convenient for those with a PC to hand, but, used in this way, does not constitute any sort of fundamental break with previous methods of communication.

Democracy

Many of the more popular claims about the potential of the Internet are in fact responses to the hype, responses which in turn further feed the hype. How e-mailing the leader of the British Labour Party rather than writing a letter or sending a fax represents a breakthrough in democracy is anyone's guess. Suggestions that the technology alone enables a more participatory democracy (ignoring, for now, any worries about access not only to the technology, but also to the skill to operate it) reflects a belief that democracy is merely about access to information. Governments are fully aware from opinion polls that time and again certain of their actions are unpopular with the vast majority of people. Expressing this same view instead in an electronic plebiscite at the 'virtual civic hall' does nothing to alter the balance of power in a society – a government's interests often lie in supporting a minority against the majority. At the same time, those who argue that exaggerated claims about the democratic potential of the Internet represent a cynical attempt to dupe the voters into believing that society is more democratic while it is actually less so, are probably underestimating the ability of the electorate to see beyond the superficial and to make their own minds up.

Telework

Perhaps less benign are the effects of the growth of teleworking. Working from home is hardly a new phenomenon. Representatives, selling anything from insurance to encyclopædias, or 'outworkers' stuffing envelopes, making Christmas crackers, or sewing garments, have formed a substantial section of the labour force in certain industries for many years. Outworkers or home workers are often highly exploited, with no contract of employment and therefore no entitlement to benefits such as sick pay or holiday pay, are paid on piecework rates and consequently suffer low wages and long working hours. Home workers have tradi-

tionally been women with child-care responsibilities, which turns on its head the claim that teleworking could increase employment opportunities to child-carers. Developments in communications technologies allow these existing workers to be joined by new groups, such as telephone directory enquiry operators. The advantages of this 'flexible' workforce to the employer are obvious – Wheelwright (1995) cites a report in which 92 per cent of employers involved in telework schemes saw its benefits in terms of reduced costs and increased productivity; workers need only be taken on when there is work and laid off immediately demand slackens; 'productivity' increases (largely a result of the aforementioned low pay and long hours) can be as great as 25 per cent (Kraut, 1989).

From the employee's point of view, however, the isolation of working at home means there is no opportunity to discuss conditions with fellow workers, compare rates of pay, or organise together to challenge the employer. Telecommunications technologies extend the range of workers who may be exposed to these disadvantages, including some traditionally less-exploited groups. Journalists, computer programmers, data operators may well be increasingly employed on a freelance or consultancy basis, with similar loss of the entitlements which go with contractual employment, and vulnerability to exploitation through isolation from other workers and union organisation.

Even when teleworkers are employees rather than freelances there is erosion of working conditions. Bibby (1995) reports a number of examples: teleworkers in a BT trial were set higher performance targets than their office-based counterparts; a company which employed teleworkers to prepare electronic databases offered no paid holidays and only reduced pay if work was unavailable owing to technical problems. While Bibby concludes that these companies are not 'consciously taking part in some sort of deliberate process of exploitation', (p.112) any company which can derive a competitive advantage (ie greater productivity from its workers) through the use of a particular technology will nevertheless do so, consciously or not. Again, economic considerations rather than technological progress direct how a social activity (work) progresses.

Some of the predictions about telework and the traditional mode of employment have been wildly inaccurate ('some experts estimate that 15 million U.S. employees will work at home by 1990.' Rogers, 1986, p.188). Many jobs are simply not amenable to teleworking, and will always remain so. Even if teleworkers form an increasing section of the workforce, they will remain a minority; estimated figures for the United States include 1.3 million, or 1.6 per cent of the workforce (Kraut, 1989) to 9 million (Wheelwright, 1995) though figures vary enormously according to definition of 'teleworker'. Thus rather than seeing the technology as responsible for the inception of new and potentially exploitative, unstable (or 'flexible') ways of working, it is important to recognise that employers already have the power to control and exploit their employees, and had that power long before the introduction of the modem or similar technologies. The technology merely offers employers one more method, amongst the many other non-technological means, of extracting greater productivity from its workforce. While this is not to dismiss any role of technology in *enabling* changes in working patterns to be introduced, it is to emphasise that that role is subordinate to the relationships which already exist in society, and which will not be eliminated single-handedly by the technology.

Education

Much of the same argument applies to the claims made about the potential of the Internet in education. Again, the first thing to say is that there is virtually no possibility at present of studying a major degree course (or its equivalent) over the Internet. Courses which are 'accessible' in this manner are usually part of larger programmes, of which one aspect may well be a course on 'How to use the Internet'. While there is no doubt that colleges will make more and more course information available via the Internet, this serves primarily to publicise the college and its courses rather than to offer teaching to a global audience. Some courses may require students to download teaching material from specific World Wide Web sites, for example, but this is not what is meant by those who laud the Internet's potential for broadening access to education. Indeed, used in this way, downloading from the WWW is just an alternative to the more familiar means of delivering distance-learning materials, ie broadcast media and the postal service. The Open University in the UK is exploring the possibilities of delivering learning material via the Internet, just as it is considering the possibilities of CD-ROM, but this is a development of, rather than a fundamental break with, its current practice.

Case Study – The 'Information Society'

It has become fashionable during the last decade or two to talk of the 'Information Society'. The phrase is often used interchangeably with 'Postindustrial Society', a term coined by Daniel Bell in the late 1950s. Most argument, it seems, centres on the identification of information, or knowledge, as the key commodity defining modern society, and therefore information processing as the key function of businesses. The ramifications are held to be great: the disappearance, or at least decline, of manual labour; transfer of production from advanced industrialised countries to underdeveloped countries; growth of service industries; the disappearance of class (in 1982 Andre Gorz wrote *Farewell to the Working Class*); enhanced participatory democracy; further cultural imperialism... the list goes on. The postindustrial, or, in Toffler's terms (1980), 'third wave' society is commonly seen as a natural progression following the earlier transition some two centuries ago from an agricultural society to a manufacturing or industrial society. Not surprisingly, as the previous section would suggest, the Internet has revived many of these arguments.

Technology and the Information Society

The claim that society has emerged (or is about to emerge) into the 'information age' hinges crucially on the role played by technology: computer technologies, rather than producing goods, are being used for the collection, processing and distribution of more and more information, and this is replacing traditional heavy industry with its massive manufacturing plant. Greater access to information allows smaller-scale, 'just-in-time' production techniques and better knowledge of potential markets for goods and services; national and international optical fibre cable networks offer global expansion of existing markets and the development of new ones as information becomes a commodity in itself. Information networks, based on cable TV systems linked to home computers, are expected to bring new opportunities for leisure (eg video on demand, home shopping) to people in their homes. Webster quotes John Naisbitt, writing in

1984: 'Computer technology is to the information age what mechanization was to the industrial revolution' (1995, p.8). Figures are regularly quoted listing the number and capacities of computers in homes and businesses or the number of modems sold each year, leading naturally to exhortations for more and earlier training of school students in computer skills. If concern is ever expressed, it is over access to these resources and the potential divide between the 'information rich' and the 'information poor'; this emphasis on the apparent value of information has even led a shadow Chancellor of the Exchequer to argue that what is important in today's economy 'is less an individual's ability to gain access to capital and far more his or her ability to gain access to knowledge and to use it creatively' (Brown, 1996). Thus one of the primary aims of social reformers is to ensure that information terminals are available to all in public places. For example, Chris Smith, Labour Party spokesperson on IT, said, 'I want to see the cable network placed in every school, library, hospital and doctor's surgery because of the massive potential this could have for our nation's health, and re-skilling our workforce.' He added, 'In hospitals you can imagine a surgeon in Aberdeen being guided by a top surgeon in New York' (quoted in Wintour, 1994).

Again, this reflects technological determinism on a grand scale: the growing use of computers, a trend which itself is seen as inevitable and therefore independent of society, is destined to wreak great changes on that society, indeed transform it into a new kind of society, and, the argument goes, we must make ourselves ready for it. Other arguments for the information society theory are made on economic grounds (for example, by measuring the proportion of Gross Domestic Product which is attributable to 'information' rather than goods), or on employment statistics (comparing the number of employees in manufacturing and services). This kind of quantitative analysis is fraught with problems of definition. For example, a company whose primary purpose is manufacturing also produces information in its R & D department to further its manufacturing aims – how is this to be counted? A newspaper journalist and the street sellers and delivery drivers of that same newspaper are lumped together as 'information workers'.

Problems with the Information Society idea

As Webster points out, while there is no doubt that computer and related technologies are increasing the quantity of information being collected, processed and distributed, this in itself does not justify the claims of the 'information society' theorists (1995, pp.7-10). In the same way as Naisbitt's 'mechanization' did not just happen overnight to create the industrial 'revolution', there will be no sudden transition to the information age. How much of this technology must be installed before a society can be considered 'informational'? What type of technology? At what point is the distinction made between an 'information society' and a mere 'advanced industrial society'?

Even taken at face value, statistics in themselves do not prove the theory of the information society. Alex Callinicos points out that manufacturing has never accounted for a majority of the workforce, even in the heydays of the 1950s (1989, p.122). More significantly than numerical challenges, he argues: 'The fact that much of [wage-] labour now involves interacting with other people rather than producing goods does not change the social relations involved: one striking feature of contemporary industrial relations is the spread of trade unionism to the 'caring professions' (health, teaching, social work, etc.)...' (p.127). So it

matters little whether you are employed on a production line producing widgets, or in a computer-based job producing digits, your most significant concerns (working hours, conditions, unfair treatment by the boss etc.) are the same. Thus any quantitative study of information production or producers tells us little about the power relations and hierarchies in that society, and therefore provides no justification for some of the claims referred to above.

A more qualitative approach involves asking whether access to more information necessarily leads to a better informed society. Much of what is posted on newsgoups is highly opinionated (almost by definition) and anonymous (in the sense that the reader has no knowledge of the author's background or intentions); for many, in fact, this is a particularly valued aspect of newsgroup 'debate'. However, the anonymity raises questions of authentication and interpretation. Commentators who see the Internet as a democratising instrument rightly highlight the institutional bias which exists in existing media such as broadcasting and the press. However most people's opinions are not formed purely by what they experience in this way; they recognise potential bias precisely because they are aware of the origin of the information. For example, studies show that most readers of the popular press, especially those involved in political or trades union activity, do not trust what they read in these papers, or are selective in their reading and are therefore not easily influenced by them (cited in Negrine, 1994, p.3; Nineham, 1995, p.119). It would therefore be wrong to argue that the Internet is in some way superior as a source of information, offering value-free information, or allowing interpretation of that information to be neutral and 'objective'.

It is important therefore to ask questions about the nature of this increasing quantity of information: what kind of information is it, who is using the information, for what purpose and to what effect? In many cases the information being accumulated is of a type that has always been gathered. Governments and business organisations store data, process that data and produce new information from that data. They have always done so. They also buy and sell information, but, again, have traded in this way for many decades. Focusing on the technology involved will certainly reveal increases in the quantity of information and the numbers of ways in which it might be processed, but no real change in its purpose or its primary users. For governments it is often used to keep tighter control on political and economic power. Many of the recent changes in the running of state institutions such as education and healthcare have reduced local autonomy and accountability; while these changes could not have been achieved without developments in information gathering and processing capabilities, the growing concentration of political power in central rather than local governments is not a new phenomenon. Businesses use information to identify, predict and even influence markets to gain advantage over competitors. The more powerful the business, the greater is its ability to do these things and the more likely it is to succeed while its competitors fail. This has always been the nature of capitalism. Again, increases in information capacity do not change the purpose or use of that information. Some adherents of the information society idea see a qualitative difference in who has access to information. An increasing though still small number of individuals and community organisations can exploit cable networks and the power of personal computers to access information via the Internet. But Internet use by most individuals is not for gathering of high-quality information, downloading official records or querying international data-

bases (information which has in any case long been available in paper form through libraries and the like) but more for swapping anecdotes or insults on newsgroups, a similar quality of information as can be found in the letters pages of specialist magazines at any newsagent. Campaigning organisations are making more and more use of the Internet (or at least e-mail) for keeping in touch and exchanging information, but this went on before via fax and postal systems. Such organisations continue to find themselves relatively powerless when confronted by the state.

So it seems reasonable to conclude by rejecting the notion of an 'information society'; while developing technology allows the quantity of information moving around the world to be greater than ever before, if one looks beyond the technology to how society is structured and who continues to run it, one sees far more similarities than differences between present and past and a continuing tendency for greater concentration of power and wealth.

A word on the Information Superhighway

Alongside the Internet and the 'Information Society', another phrase consistently used in the media is the 'Information Superhighway', a term coined by US Vice-President Al Gore in 1994. The allusion to similarities with road transport was intentional, and reflected the belief that while industrial society is (or 'was' as the post-industrialists would have it) chiefly concerned with the production and transport of goods and raw materials, leading to the development of appropriate infrastructure (railways and real highways), the new 'information society' requires a similar investment in infrastructure for the transport of the new commodity, information. Road and rail systems form part of a huge national network, which can then be interconnected with those in other countries – the same should apply to information networks. For some, therefore, the Internet forms a part of that vision: it is international and allows many networks to be interconnected.

It is an idea which has initial appeal – wherever connection is made, each terminal has equal access to the same information as any other. Thus geography becomes irrelevant – there is no reason why the countries of North America should enjoy any advantage over those of South America. But as we have seen, the sort of information which is available is that which, by and large, has always been publicly accessible. Just as access to raw materials and products of those materials is not equally accessible (despite the global coverage of air and sea transportation) information will continue to be controlled and those processes which confer advantage on rich and powerful organisations are likely to be retained in order to maintain that position. Gillespie and Robins (1989) have identified a tendency for new communications technologies to increase concentration rather than disperse information capabilities more widely. If nothing else, one must consider the cost of actually installing an information infrastructure across the globe – if, after 120 years, a capitalist society has not seen fit to install a global *telephone* system with universal access, is it likely to feel any different about a global information system?

Conclusion

Some might accuse this chapter of adopting a negative approach to the potential of the new communications technologies. Far from being negative, however,

it has attempted to locate some of the wilder claims within a social and political reality. Technologies by themselves do not change the world. This is as true of the new communications technologies as it was of the old ones. Technologies have a role in changing society, but what technology is and what it is used for are fundamentally linked to the structure of that society. Much commentary about the possible benefits of the latest developments in communications technology fails to recognise this, and appears fixated purely on the *technological* capability of communications systems. Even then, a limited understanding of the technological processes devalues that commentary.

While it is certainly not my intention to deny that these technological developments do offer a number of potential benefits, I would contend that these represent incremental progress rather than a quantum leap, and whether or not even that limited progress is realised is not a foregone conclusion, but is subject to a range of social pressures, forces and structures which pre-date and largely subsume the technology.

Predictions about how future societies will be are notoriously inaccurate, and it is safer to offer them as science fiction. Schiller refers to a number of current prophecies, and responds, 'None of these appalling prospects is a future certainty... There is certainly enough historical experience to draw on and, one would hope, to learn from' (1996, p.86). As we have seen, a number of different uses was originally envisaged for the telephone, and one-to-one calling was certainly not always the most popular of those. Similarly, 'radio' would not mean what it does today if the early expectations had not been wrong. Why should predictions about the new technologies prove any more reliable?

Nevertheless, making predictions has always been a popular pastime. Studies of the telephone's 'impact' on society reveal a number of prophecies which strikingly mirror those of today: for example, from 1898, '...the 'private wire' will make all classes kin'; or from 1930, 'it will be feasible once more to revive that form of democracy which flourished in the city states of Ancient Greece' (quoted respectively in Young, 1991, and Carey, 1989). It is tempting, and certainly easier, to focus simply on the technology and its promise, rather than looking at the history and social context of that technology; it would also be very satisfying to be able to identify a simple solution to the world's problems, and perhaps this explains why some look forward to the idea of information becoming the new wealth, since the existing system has clearly failed to create an even distribution of the 'old' wealth. However, as this chapter has argued, the development of technology, including communications technology, far from undermining existing inequalities of wealth and power, actually reflects and tends to reinforce those inequalities. It is to be hoped that, whilst appreciating their benefits, a growing awareness of the true nature of the new communications technologies will lend a little more balance, perhaps even some scepticism, to debates about their potential and role in a future society.

Appendices

Appendix 1
Units and symbols
The unit of frequency is the Hertz (Hz); 1 Hz means one vibration per second. Other units are:

	Symbol	Meaning	
kiloHertz	kHz	1,000 Hz	
MegaHertz	MHz	1,000 kHz or	1 million Hz
GigaHerz	GHz	1,000 MHz or	1 billion Hz

Appendix 2
The number of different states which can be represented by a combination of different switches, or signals, is illustrated in the following tables showing the possible combinations of (a) two switches, representing four possible states and (b) three switches, with eight possible states:

(a) State	Switch A	Switch B
1	off	off
2	off	on
3	on	off
4	on	on

(b) State	Switch A	Switch B	Switch C
1	off	off	off
2	off	off	on
3	off	on	off
4	off	on	on
5	on	off	off
6	on	off	on
7	on	on	off
8	on	on	on

Acronyms and abbreviations

ADC	Analogue to digital conversion
AM	Amplitude modulation
ASK	Amplitude shift keying
ATM	Automatic teller machine (also asynchronous transfer mode)
bps	Bits per second
CATV	Common (or community) antenna TV
CCD	Charge coupled device
CCITT	International Consultative Committee for the Telephone and Telegraph
CD-ROM	Compact disc read only memory
CMC	Computer mediated communication
DAB	Digital audio broadcasting
DAC	Digital to analogue conversion
DASH	Digital audio stationary head
DAT	Digital audio tape
DBS	Direct broadcast by satellite (see also DTH)
DTH	Direct to home (see also DBS)
DTT	Digital terrestrial television
DVD	Digital versatile disk
DVE	Digital video effects
FDM	Frequency division multiplexing
FM	Frequency modulation
fps	Frames per second
FSK	Frequency shift keying
FTTC	Fibre to the curb
FTTH	Fibre to the home
GHz	GigaHertz

HDTV	High definition TV
HF	High frequency
Hz	Hertz
ILR	Independent local radio
ISDN	Integrated services digital network
ITC	Independent Television Commission
JPEG	Joint Photographic Experts Group
kbps	Kilo bits per second
kHz	Kilohertz
LAN	Local area network
LEO	Low earth orbit
LF	Low frequency
LW	Long wave
MAN	Metropolitan area network
MF	Medium frequency
MHz	Megahertz
MO	Magneto-optical (disk)
MPEG	Motion Picture Experts Group
MW	Medium wave
NTSC	National Television Standards Committee
PAL	Phase Alternate Line
PC	Personal computer
PCM	Pulse code modulation
PSDN	Packet switched data network
PSK	Phase shift keying
PSTN	Public switched telephone network
RAM	Random access memory
RDAT	Rotary head digital audio tape
SECAM	Systeme Electronique Couleur avec Memoire
SHF	Super high frequency
SMATV	Satellite master antenna TV
SW	Short wave
TCP/IP	Transmission control protocol/Internet protocol
TDM	Time division multiplexing
TVRO	Television receive only
UHF	Ultra high frequency
VHF	Very high frequency
VR	Virtual reality
WAN	Wide area network
WORM	Write once read many times
WWW	World wide web

References

Allen, Graham (1995) 'Information Superhighway the Key to Reinventing Democracy.' Letter to the *Guardian*, 24th February, p.25

Aumente, J (1987) *New Electronic Pathways: Videotex, Teletext and Online Databases* Newbury Park, Ca., Sage

Bannister, Nicholas & Dan Atkinson (1995) 'Banks profit from high-tech job losses' *Guardian* 3rd April, p.3

Bannister, Nicholas (1994) 'Networks tap into low wages' *Guardian* 15th October, p.40

Bannister, Nicholas (1994) 'BT challenges cable with home services trial' *Guardian* 16th November, p.2.

Bannister, Nicholas (1996) 'Radio rationed to fund digital viewing' *Guardian* 18th June, p.17

Barnes, John (1976) *The Beginnings of the Cinema in England* Newton Abbott, David & Charles

Barton, R W (1968) *Telex* London, Pitman

Berendt, A. (1994) 'Pioneer of the 'Ruggedised' Cellular Payphone' *Intermedia* 22 (6) 42

Bibby, Andrew (1995) *Teleworking: Thirteen Journeys to the Future of Work* London, Calouste Gulbenkian Foundation

Briggs, Asa (1961) *The History of Broadcasting in the United Kingdom*. Vol. 1: *The Birth of Broadcasting* London, Oxford University Press

Brown, Gordon (1996) 'In the Real World' *Guardian* 2nd August, p.13

Buckingham, Lisa and Dan Atkinson (1995) 'Radio proves costly turn-on' *Guardian* 29th July, p.36

Bussey, Gordon (1990) *Wireless: the Crucial Decade* London, Peter Peregrinus

Callinicos, Alex (1989) *Against Postmodernism* Cambridge, Polity

Carey, James W. (1989) *Communication as Culture* New York, Routledge

Carey, James W. and Quirk, John J. (1970) 'The Mythos of the Electronic Revolution' reprinted in Carey, James W. (1989) *Communication as Culture* London, Routledge

Central Office of Information (1993) *Broadcasting* London, HMSO

Central Office of Information (1994) *Telecommunications* London, HMSO

Central Statistical Office (1996) *Social Trends* 26 London, HMSO

Choate, Robert (1994) 'Direct Broadcast Satellites' in Grant, August (ed.) *Communication Technology Update* Boston, Focal

Cowan, Ruth Schwartz (1979) 'From Virginia Dare to Virginia Slims: Women and Technology in American Life' *Technology and Culture* 20, 51-63

Cowan, Ruth Schwartz (1989) *More Work for Mother: the Ironies of Household Technology from the Open Hearth to the Microwave* London, Free Association Books

Crisell, Andrew (1994) *Understanding Radio* 2nd edn, London, Routledge

Culf, Andrew (1995) 'Adviser warns of TV stranglehold' *Guardian* 5th September, p.6

Cusumano, Michael, Yiorgos Mylonadis and Richard Rosenbloom (1992) 'Strategic Maneuvering and Mass-market Dynamics: the Triumph of VHS Over Beta' *Business History Review* 66 (1, Spring), 51

Department of National Heritage (1995) *Digital Terrestrial Broadcasting: the Government's Proposals* London, HMSO

Fischer, Claude S. (1992) *America Calling: A Social History of the Telephone* Berkeley, Ca., University of California Press

Flichy, Patrice (1995) *Dynamics of Modern Communication* London, Sage

Freedland, Jonathan (1994) 'A network heaven in your own front room' *Guardian* 30th April, p.23

Geddes, Keith and Bussey, Gordon (1986) *Television: the First Fifty Years* Bradford, National Museum of Photography, Film and Television

Gillespie, Andrew & Kevin Robins (1989) 'Geographical Inequalities: The Spatial Bias of the New Communications Technologies' *Journal of Communication* 39 (3) 7-18

Gombrich, E. H. (1978) *The Story of Art* 13th edn, Oxford, Phaidon Press

Gould, Glenn (1966) 'The Prospects of Recording', reproduced in Page, Tim (ed.) (1984) *The Glenn Gould Reader* New York, Alfred A. Knopf

Harcup, Tony (1995) 'Good for the Few and Bad for the Many' *Free Press: Journal of the Campaign for Press and Broadcasting Freedom* 87 (July-August), 3

Hecht, Hermann (1993) *Pre-Cinema History: An Encyclopaedia and Annotated Bibliography of the Moving Image Before 1896* ed. Ann Hecht, London, Bowker-Saur

Inglis, Fred (1990) *Media Theory: An Introduction* Oxford, Blackwell

ITC (1995) 'Viewing of cable channels on the increase', News release 93/95, 23rd December

Jeppesen, S E and Poulsen, K B (1994) 'The Text Communications Battlefield' *Telecommunications Policy* 18 (1) 66-77

Kraut, Robert E (1989) 'Telecommuting: The Trade-Offs of Home Work' *Journal of Communication* 39(3) 19-49

MacGregor, Brent (1995) 'Our Wanton Abuse of the Technology: Television News Gathering in the Age of the Satellite' *Convergence* 1 (1) 80-93

MacKenzie, Donald & Judy Wajcman (1985) *The Social Shaping of Technology* Milton Keynes, Open University Press

Marmion, Alan (1995) 'Invested Interests in Digital Television' *Broadcast* 13th October, p.15

Marvin, Carolyn (1988) *When Old Technologies Were New: Thinking About Electric Communication in the Late Nineteenth Century* New York, Oxford University Press

McCrystal, Skip (1994) 'Cable Television' in Grant, August (ed.) *Communication Technology Update* Boston, Focal.

McLuhan, Marshall (1964) *Understanding Media* London, Routledge & Kegan Paul

Mirabito, Michael M. A. (1994) *The New Communication Technologies* 2nd edn. Boston, Focal

Moore, James R. (1989) 'Communications', in Chant, C. (ed.) *Science, Technology and Everyday Life 1870-1950* London, Routledge.

Murray, Ian (1995) 'Isolated islands lead way in home working' *The Times* 9th January, p.6

Negrine, Ralph (1994) *Politics and the Mass Media in Britain* 2nd edn, London, Routledge

Nineham, Chris (1995) 'Is the Media All Powerful?' *International Socialism* 67, 109-151

Pool, Ithiel de Sola (1983) *Forecasting the Telephone: A Retrospective Technology Assessment of the Telephone* Norwood, NJ, Ablex

Pool, Ithiel de Sola; Decker, Craig; Dizard, Stephen; Israel, Kay; Rubin, Pamela and Weinstein, Barry (1977) 'Foresight and Hindsight: the Case of the Telephone' in Pool, Ithiel de Sola (ed.) *The Social Impact of the Telephone* Cambridge, Mass., MIT Press

Powell, P. (1994) 'Compression: the Acceptable Face of Quality?' *IBC 94 Daily News* 17th July, p.11

Raulet, G (1991) 'The New Utopia: Communication Technologies' *Telos* 87, 39-58

Rheingold, Howard (1994) *The Virtual Community* London, Secker & Warburg

Robinson, Ernest H. (1935) *Televiewing* London, Selwyn & Blount

Rogers, Everett M. (1986) *Communication Technology: The New Media in Society* New York, Free Press

Schiller, Herbert I. (1996) *Information Inequality: the Deepening Social Crisis in America* New York, Routledge

Schofield, Jack (1995) *Guardian* (OnLine) 17th August, p.3

Screen Digest (1995a) 'US: Profile of Internet users', December, p.288

Screen Digest (1995b) 'High churn for on-line service subscribers', November, p.257

Screen Digest (1996) 'Fresh numbers put on US Internet market', February, p.32

Shurkin, Joel. (1984) *Engines of the Mind*, New York, Norton

Snoddy, R. (1994) 'Concern over Channel 5 plans' *Financial Times* 15th July, p.16

Snoddy, Raymond (1994) 'Murdoch cut BBC to please China' *Financial Times* 14th June, p.6

Stratford, Brian E. (1984) *British Telecom in the Community* London, British Telecom Education Service

Summers, Diane and Raymond Snoddy (1995) 'Advertisers hit out at ITV over cost of airtime' *Financial Times* 10th June, p.18

Talbot-Smith, Michael (1990) *Broadcast Sound Technology* Oxford, Focal

'Telephones earn Videotron more than television' (1995) *Broadcast* 10th November, p.3

Tiltman, R. F. (1933?) *Baird of Television* London, Seeley Service

Toffler, Alvin (1980) *The Third Wave* London, Collins

Tracey, Michael (1994) 'A Civics Model or a Circus Model: Which Will Prevail?' *Intermedia* 22 (3) 40-43

Trotsky, Leon (1927) 'Radio, Science, Technology, and Society' reprinted in *Problems of Everyday Life*, 1973, New York, Pathfinder Press

United Nations (1994) *Statistical Yearbook* New York, United Nations

'US plans subsidy for digital set-top boxes' (1995) *Broadcast* 15th December, p.9

Watkinson, John (1994) *An Introduction to Digital Audio* Oxford, Focal

Watkinson, John (1994) *An Introduction to Digital Video* Oxford, Focal

Webster, Frank (1995) *Theories of the Information Society* London, Routledge

Wheelwright, Geoffrey (1995) 'US sets the pace in telecommuting' *Financial Times Review of Information Technology*, 6th December, p.v

Wiggins, Richard W. (1995) *The Internet for Everyone: a Guide for Users and Providers* New York, McGraw-Hill

Williams, Granville (1994) *Britain's Media: How They Are Related* London, Campaign for Press & Broadcasting Freedom

Williams, Raymond (1990) *Television: Technology and Cultural Form* 2nd edition, London, Routledge

Winsbury, Rex (1994) 'Distributive Justice: Will Digital Community Wireless Telephony be the Smart Card To Play?' *Intermedia* 22 (6) 38-41

Wintour, Patrick (1994) 'Blair plans national information grid' *Guardian* 28th November, p.5

Young, Peter (1991) *Person To Person: The International Impact of the Telephone* Cambridge, Granta Editions

Zelizer, Barbie (1992) 'CNN, the Gulf War & Journalistic Practice' *Journal of Communication* 42 (1), 66-81

Zeman, Z. A. B. (1973) *Nazi Propaganda* 2nd edn, London, Oxford University Press (Originally published 1964)

Index